CHARLES SHEELER:

THE PHOTOGRAPHS

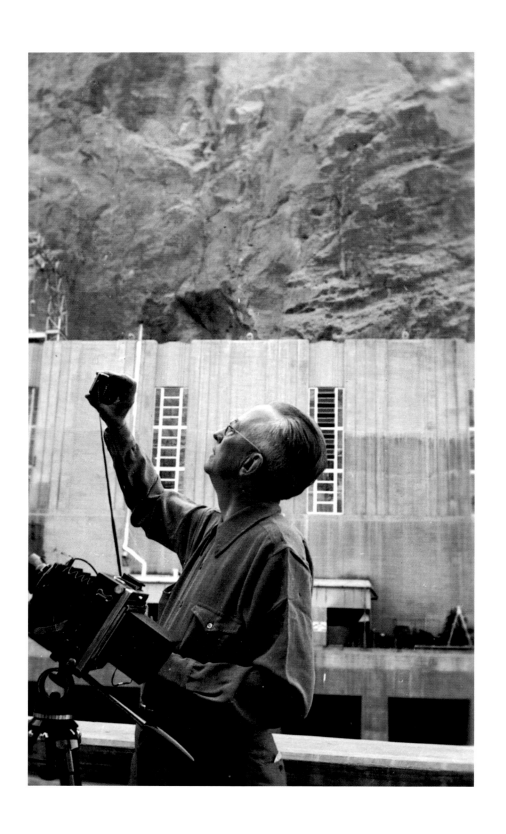

CHARLES SHEELER:

THE PHOTOGRAPHS

Theodore E. Stebbins, Jr., and Norman Keyes, Jr.

MUSEUM OF FINE ARTS, BOSTON

Charles Sheeler: Paintings, Drawings, Photographs was organized by the Museum of Fine Arts, Boston and is supported by a grant from the National Endowment for the Arts. The Luce Fund for Scholarship in American Art, a project of the Henry Luce Foundation, made possible the research for the exhibition and catalogue and supported a portion of the publication. The H. John Heinz III Charitable Trust made a grant in support of the catalogue.

Text and illustrations, Copyright Museum of Fine Arts, Boston, 1987

Library of Congress catalogue card no. 87-042966
ISBN 0-87846-285-6 (cloth)
ISBN 0-87846-289-9 (paper)

Typeset and printed by Acme Printing Co., Wilmington, Massachusetts

Bound by Acme Bookbinding Co., Charlestown, Massachusetts

Text edited by Janet G. Silver

Tritone negatives by Richard Benson

Designed by Carl Zahn

Cover (and jacket)
Doylestown House: Stove, Horizontal, 1917 (cat. no. 12)
The Lane Collection

New York, Towards the Woolworth Building, 1920
(cat. no. 34)
The Lane Collection

Frontispiece:
Musya Sokolova Sheeler (?), *Sheeler at Boulder Dam*, 1939, gelatin-silver print.
The Lane Collection

Exhibition Itinerary

Museum of Fine Arts, Boston
October 13, 1987 - January 3, 1988

Whitney Museum of American Art, New York
January 28 - April 17, 1988

Dallas Museum of Art
May 15 - July 10, 1988

This book is dedicated to BILL and SAUNDRA LANE,

friends of Charles Sheeler and champions of his work

Contents

Preface

The Museum of Fine Arts is pleased to present "Charles Sheeler: Paintings, Drawings, Photographs." This is the first major survey of this great American artist's work since 1968, and it is the first ever to present the full range of his extraordinary achievements as a photographer along with the best of his paintings and drawings. The photographic component of the exhibition has been made possible entirely by the Lane Collection, which lent eighty-nine of the ninety photographic prints included in this exhibition (the ninetieth, *Wheels*, is from the collection of the Museum of Fine Arts, Boston, which received it as the gift of Mr. and Mrs. Lane), and which cooperated with this project in every conceivable way. Thus, our greatest debt is to Bill and Saundra Lane, who have done so much — on this occasion and many others — to further understanding of Sheeler's work and that of other American artists in the twentieth century.

A decade ago, the critic Alfred Frankenstein wrote: "We all know that Sheeler was one of the greatest of American photographers," and he added, "Somebody ought to put out a book devoted solely to Sheeler as an artist of the camera." The present study, by Theodore E. Stebbins, Jr., John Moors Cabot Curator of American Paintings, and Norman Keyes, Jr., Research Assistant, fills this request, and we hope it will find an important place in the growing scholarly literature on American photography. It is one of two volumes that catalogue the exhibition, the other being a study of Sheeler's paintings and drawings by Carol Troyen and Erica E. Hirshler.

I want to extend special thanks to my predecessor as director of the Museum of Fine Arts, Dr. Jan Fontein, who took special interest in Sheeler's work and in this project, and who guided its progress over the past three years with great energy and skill.

The exhibition has been subsidized by a grant from the National Endowment for the Arts, a federal agency. The Luce Fund for Scholarship in American Art, a project of the Henry Luce Foundation, made possible the research for the exhibition and catalogue and provided partial support for the publication. In addition, the H. John Heinz III Charitable Trust, through the courtesy of Senator H. John Heinz, has given generous support for this publication.

Alan Shestack, *Director*

Acknowledgments

Our study of the work of Charles Sheeler truly has been a cooperative effort, and it has been made possible only by the generous and immensely gratifying assistance of many people. First, mention should be made of the important 1967 monographic study of Sheeler's photography made by Charles W. Millard III, which provided a firm foundation for our research. Several scholars have shared with us their important unpublished research on Sheeler's photography: in this regard we are particularly grateful to John Driscoll, former curator of the Lane Collection; Jan-Christopher Horak, Curator of Film, George Eastman House, Rochester, N.Y.; and Wendy W. Belser, formerly of the Metropolitan Museum of Art. We express special thanks to John Szarkowski, Director of the Department of Photography, Museum of Modern Art, New York, and Diana Edkins, Archivist at Condé Nast Publications, Inc., New York. We are also indebted to the following for their kind assistance: Prof. Monni Adams and Kathleen Skelly, Peabody Museum of Archaeology and Ethnology, Harvard University; Peter Binzen, *Philadelphia Inquirer*; Cynthia Cathcart; James L. Enyeart, Lawrence Fong, and Amy Stark, Center for Creative Photography, University of Arizona, Tucson; Barbara Galasso, Rachel Stuhlman, and David Wooters, George Eastman House; Raymond J. Horowitz; Susan Kismaric, Grace M. Mayer, Sarah McNear, Rona Roob, and Richard Tooke, Department of Photography, Museum of Modern Art, New York; Patricia Kreitz, Library, University of California, Berkeley; Hans P. Kraus, Jr., Inc.; Mrs. Pare Lorentz; Alfred Lowenherz and Anthony Troncali, Camera Club of New York; Karen Lucic, Vassar College; Anthony Montoya, Director, Paul Strand Archive, Millerton, N.Y.; Paul Needham, Morgan Library, New York; Annamarie Sandeki, N. W. Ayer and Sons Company, New York; Kate Schlesinger, *Vanity Fair*; Andrew J. Vadnais, Mt. Lebanon Village, New Lebanon, N.Y.; and Susan Vogel, Center for African Art, New York. Finally, great appreciation is extended to Thurman Naylor for sharing with us his vast expertise in this field, and to Señor Don Rodrigo de Zayas for his reminiscences regarding his father.

This book has been designed and its production guided by Carl Zahn, who has brought to this project his usual great ability and good humor. We are grateful to Janet G. Silver for editing the manuscript in a timely and most helpful fashion, to Jayne Yaffe for reading the galleys, and to Richard Benson for his superb photographs of Sheeler's prints. Carol Troyen has provided useful insights, and Erica Hirshler and Michelle O'Malley have assisted importantly with research and other contributions too numerous to mention. Harriet Rome Pemstein supervised many details, and Wendy Moran and Marci Rockoff prepared the manuscript. We are especially indebted also to our colleagues in the Department of Prints, Drawings, and Photographs, Clifford S. Ackley, Sue Welsh Reed, Roy Perkinson, Elizabeth Lunning, Gail English, and Christopher Foster. Janice Sorkow and the staff of the Department of Photographic Services, including Thomas Lang, John Lutsch, Gary Ruuska, and John Woolf have worked long and hard to provide us with fine copy prints for our text illustrations. The exhibition was installed by Tom Wong and Judith Downes, and we are also grateful at the Museum of Fine Arts to Linda Thomas, Registrar, and Patricia Loiko, Operations Coordinator in the Department of Paintings, for their assistance. We are grateful too for the assistance of Nancy Allen and her staff in the Museum of Fine Arts Library. Finally, we thank Cornelius Vermeule, Jonathan Fairbanks, Edward S. Cooke, Jr., Denise Leidy, Anne Morse, Nancy Netzer, and Joellen Secondo for their help.

Our greatest debt is to Mr. and Mrs. William H. Lane, whose dedication, generosity, and love of quality made this exhibition possible.

T.E.S., Jr. and N.K., Jr.

x

Charles Sheeler:
The Photographs

Photographer of Art and Architecture

Charles Sheeler was a painter before he was a photographer. Trained first at Philadelphia's School of Industrial Art in commercial design, then at the Pennsylvania Academy of the Fine Arts under William Merritt Chase in the years 1903 to 1906, he learned that "brilliance of execution" – bravura paint handling – ranked "first and last" in importance. Traveling with Chase's class to London and Holland in 1904 and to Spain in 1905, meeting Lord Leighton and John Singer Sargent, and studying the work of Hals and Velazquez firsthand all reinforced the young painter's faith in his "newly acquired dash and fluency."[1] His quickly painted *plein air* sketches were exhibited at the Pennsylvania Academy and elsewhere; one was sold, and in 1908 he was given a one-man show at McClees Gallery in Philadelphia.

At the Pennsylvania Academy, Sheeler became friends with his classmate Morton L. Schamberg, also a painter. Beginning in about 1907, they began to share studio space at 1626 Chestnut Street in Philadelphia, and shortly thereafter they began to rent a little house in the country near Doylestown, where they painted and vacationed on weekends. The two young artists thought very much alike: they discovered modernism together, and they progressed artistically together, supportive of each other and at times working almost in tandem.

Sheeler and Schamberg traveled to Europe several times to study the work of old masters. They had toured with Chase in 1904 and 1905, and they returned to Italy in December 1908, visiting Rome, Florence, Siena, Venice, and Milan. From there they went to Paris, where all at once they were introduced to the shocking new art of the twentieth century – the work of Cézanne, Picasso, Braque, and Matisse, and the objects in the collection of Sarah and Michael Stein.[2] Neither artist claimed to grasp modernism quickly or easily, but their eyes were opened, and their direction radically changed. As Sheeler reported, "We began to understand that a picture could be assembled arbitrarily with a concern for design, and that the result could be outside time, place, or momentary considerations." Later, he said, "I had an entirely new concept of what a picture is, but several years were to elapse

Fig. 1. Charles Sheeler or Morton Schamberg, *Charles Sheeler,* c. 1916, gelatin-silver print, The Lane Collection.

Fig. 2. Charles Sheeler, *Charles R. Sheeler, Sr.,* c. 1915, gelatin-silver print, The Lane Collection.

before a picture of my own could break through."[3]

Shortly thereafter, in about 1910, Sheeler and Schamberg both took up photography, apparently at Schamberg's suggestion.[4] Sheeler had long owned a Brownie camera for casual snapshots, but photography had not been a medium he took seriously. Now, for him and for Schamberg, it offered a way to earn a living at a time when their paintings were experimental and not in great demand. Sheeler bought "a large camera," presumably an 8-by-10-inch view camera, and began to work for Philadelphia architects, photographing houses they had recently finished. By 1911 Sheeler had begun corresponding with Alfred Stieglitz, the great "moral autocrat" of American photography, in New York.[5] Schamberg, too, by that year had made progress in the medium. His portrait photographs of 1911 are good ones, considerably above the amateur level. By 1912, Schamberg could write to his friend Walter Pach: "I think I have gotten my photographic work on to a paying basis" – then adding, "but of course it hasn't been very profitable on the side of my real self."[6] It is likely that this statement speaks for Sheeler as well: by 1912, he was probably making a go of his architectural photography and may well have shared Schamberg's feeling that this was only a craft, done for practical reasons, and had little to do with the growth of his real, artistic self.

Sheeler apparently made many architectural photographs during this period, from about 1910 to 1915 or so, but only a handful of them are known today. Illustrating both the exteriors and the furnished interiors of large new stone houses in the Philadelphia area, of the type one finds on Chestnut Hill and on the Main Line, his prints are technically well finished and well composed (see fig. 3). Sheeler was very much a journeyman photographer in these years, and he soon began to photograph not only the houses but their contents as well, making prints of family paintings (including several portraits by Robert Henri), silver, and statuary. He moved easily into art photography, recording private collections and making prints of classical and Oriental objects from the John T. Morris Collection at the Pennsylvania Museum (now the Philadelphia Museum of Art). By 1914-15 he was confident enough in

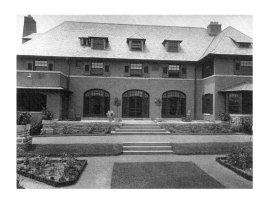

Fig. 3. Charles Sheeler, *House Exterior*, c. 1912, gelatin-silver print, The Lane Collection.

his craft to send Stieglitz a gift of his prints of Chinese and Roman sculpture, while exchanging notes with him about photographic papers.[7] Apparently he was reading Stieglitz's magazine *Camera Work* regularly. He tore out of the August 1912 issue a gravure by Stieglitz of Picasso's great bronze *Head of a Woman*, which he mounted and hung on his studio wall for many years; it provided an important model for him, being a photograph – by a master photographer he admired – of a great modern work of art (fig. 4). He also kept the March 1914 issue, with its important article by Marius de Zayas on modern art, all of his life.

It was Schamberg who had studied architecture at the University of Pennsylvania, but when he took up commercial photography it was as a portrait photographer, while Sheeler's subjects became art and architecture. Schamberg's portraits – especially of young women friends such as Fannette Reider, who would later marry a rival[8] – are lovely, direct, and engaging, while somewhat sentimental and soft-focus, perhaps owing to the influence of Edward Steichen. Sheeler and Schamberg learned photography at the same time, and both became accomplished at it. For Schamberg, however (excepting a small group of New York scenes from 1916), photography remained entirely separate from his painting, which became increasingly abstract; in Sheeler's case, on the other hand, photography exactly suited him and would come to *be* his art, merging with his painting and drawing, forming

his vision, and defining his interests for the rest of his life.

In 1912 Arthur B. Davies invited both Sheeler and Schamberg to exhibit their paintings at the Armory Show, to be held in February 1913 in New York. This was enormously gratifying to the two young Philadelphians, for, as Sheeler said, "It was the first notice that had ever been taken that we were even in the world … at least, in the world we wanted to be in."[9] Over the next three years, both artists made steady progress, and for both 1916 was a year of accomplishment. Early that year Sheeler had his paintings selected for the "Forum Exhibition of Modern American Painters" by a six-man jury including Stieglitz and Robert Henri. One of Sheeler's entries in that show, *Lhasa* (fig. 5), is one of the earliest examples in which the artist used a photograph as inspiration for a painting.[10] From this time on, he increasingly merged different media in his art as he came to recognize that photography, painting, and drawing represented equal ways of seeing, and that one medium could inform another. Schamberg made great strides of his own at this time, beginning with his series of paintings of machine elements in 1916, and the two artists worked together during the year to organize, with Arthur B. Davies, Philadelphia's first show of avant-garde painting (including works by Duchamp, Matisse, and Picasso), held at the McClees Gallery.

In 1916 Sheeler also made his first visit to Stieglitz at his home. Afterward he wrote to him, "For the first time I saw a large and comprehensive collection of your photographs, which strengthened greatly my belief that they are absolutely unparalleled."[11] Sheeler offered his friendship, and Stieglitz responded a few days later, "I cannot tell you how glad I am that you feel as you do about me…. And as you know this feeling that you have could not exist if I did not have a similar feeling towards you. And I have always had it. From the first moment that you came into 291."[12]

Late in 1916 Sheeler won another success when Marius de Zayas asked if he could show two of his paintings at the Modern Gallery. A member of a prominent Mexican family, de Zayas was already a leading member of New

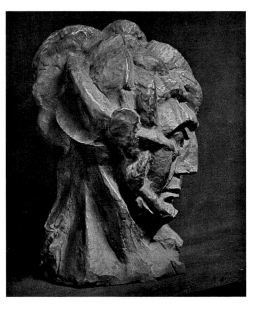

Fig. 4. Alfred Stieglitz, *Picasso's Head of a Woman*, 1912, gravure, The Lane Collection.

York's avant-garde. His caricatures had been shown at Stieglitz's "291" gallery in 1914, and he was closely associated with the elder photographer, writing about Picasso and modern art for *Camera Work* and organizing exhibitions for him. De Zayas's extraordinary memoir, "How, When, and Why Modern Art Came to New York" gives full credit to Stieglitz for his accomplishments and also provides a detailed history of de Zayas's own gallery, which was founded as a branch of "291" with Stieglitz's blessing in October 1915. His first exhibition – "Paintings by Picabia, Braque, Picasso; Photographs by Alfred Stieglitz; African Sculpture" – suggests the range of his interests.[13]

During these years Sheeler was increasingly in demand as an art photographer. By 1916 he was making photographs for both Stieglitz[14] and de Zayas, and shortly afterward for several of the major New York gallery owners, including Joseph Brummer, the French dealer-collector who had opened a New York branch in 1914, and Knoedler, one of the preeminent dealers in painting from the Renaissance to the nineteenth century, and also for

Fig. 5. Charles Sheeler, *Lhasa*, 1916, oil on canvas, Columbus Museum of Art, Ohio. Gift of Ferdinand Howald.

Fig. 6. John Claude White, Untitled (*Lhasa*), from John Claude White, *Tibet and Lhasa* (Calcutta 1907-8).

the Parish-Watson Company, specialists in Oriental art. Moreover, by 1916 or so Sheeler was on good terms with Walter and Louise Arensberg, the outstanding avant-garde collectors (Duchamp recalled seeing Sheeler and Schamberg together at the Arensberg apartment; see fig. 7)[15] and shortly thereafter he met the important New York lawyer-collector John Quinn and began to make photographs of works in Quinn's collection.

Through his photography, Sheeler learned to see. Photographing hundreds of objects – including Chinese bronzes, jades, stone sculpture, and paintings; pre-Columbian sculpture; North and Central American Indian pots (fig. 8) and paintings on hide (fig. 9); medieval sculpture; Renaissance paintings; African sculpture; and modern paintings and sculpture by Duchamp, Derain, Duchamp-Villon, Picasso, Braque, Rousseau, and especially Cézanne – he came to understand the universality of form and structure. Sheeler believed that "good art has got to be in the thread of the great tradition.... All the arts we revere came out of the main trunk. An underlying current goes through all the way to Renaissance, Egyptian, Chinese, back to cave painting."[16] Moreover, his photographic skills gained him entry into the most important modernist art circles in New York. Collectors such as the Arensbergs would employ him as a photographer, then would buy his paintings or drawings and frequently became his friends and correspondents as well.

De Zayas, with his great knowledge of modernism and his central position in the avant-garde, became especially important to Sheeler. De Zayas believed in him and backed him, and it surely is not a coincidence that a number of Sheeler's most successful photographs of art objects were made for him. Thus, both the French Gothic figure (fig. 10) and the Chinese stone bodhisattva (fig. 11) were de Zayas objects, and the latter was the subject of one of Sheeler's first series of photographs: in nine prints he studied it from all angles and with various kinds of direct and raking light.

De Zayas's broad collecting interests included an enthusiasm for African sculpture, perhaps gained from his friend Picasso, who with the Fauves had made the modern discov-

Fig. 7. Charles Sheeler, *Arensberg Apartment*, c. 1918-20, gelatin-silver print, The Lane Collection.

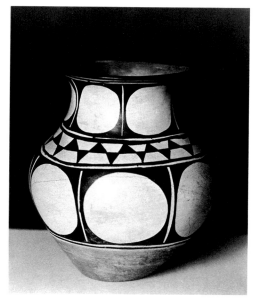

Fig. 8. Charles Sheeler, *Santo Domingo Water Jug*, c. 1916-18, gelatin-silver print, The Lane Collection.

ery of this field in 1906-7. In 1914 de Zayas organized for "291" an exhibition of eighteen objects of "Statuary in Wood by African Savages: The Root of Modern Art." Installed in Stieglitz's gallery by Edward Steichen, this show was the first anywhere to present African sculpture as art. Two years later, de Zayas wrote a lengthy essay for a book he produced called *African Art: Its Influence on Modern Art*. The volume included documentary photographs. Then in 1917 de Zayas's friend Paul Guillaume, the Paris dealer who was his source for African objects, produced an illustrated book entitled *Sculpture Nègres*, which included twenty-four fine photographs of African and Oceanic work. These earlier efforts led up to de Zayas's asking Sheeler to collaborate on a book, *African Negro Wood Sculpture*. A superb

volume, it appeared early in 1918 and included twenty tipped-in original photographs by Sheeler, nearly all of West African sculpture, such as the modern-looking two-headed sceptre from the Congo (cat. no. 2). Sheeler was highly inventive in this work, which far surpassed the quality of the Guillaume photographs. One moving image shows a number of de Zayas's pieces, gathered like a quiet family in shadow, in the storeroom at his gallery (cat. no. 1).

De Zayas and Sheeler planned to make twenty-two copies of the book, but no more than eight or so seem to have actually been assembled and sold, despite a favorable newspaper notice.[17] Stieglitz apparently wrote that he wanted a copy but was short of cash; Sheeler responded by asking Schamberg to take

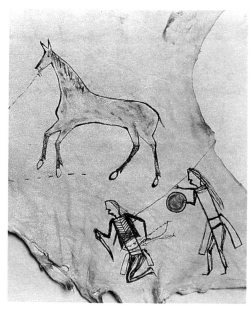

Fig. 9. Charles Sheeler, *North American Painting on Hide*, c. 1916-18, gelatin-silver print, The Lane Collection.

5

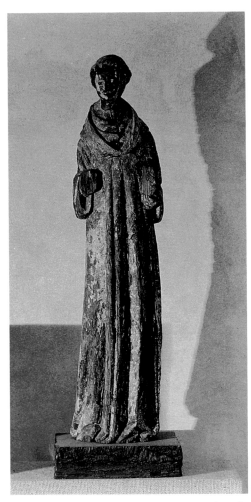

Fig. 10. Charles Sheeler, *French Gothic Figure*, c. 1916-18, gelatin-silver print, The Lane Collection.

one to him, writing, regarding payment of the $50 price, "a year from now will do — that you should want it is the important part to me."[18] John Quinn was among the other purchasers.[19]

Photographs for *African Negro Wood Sculpture* were printed on a smooth grade of Eastman Royal Bromide paper, and most show the dark objects against a light background. Later on, perhaps during the following year, Sheeler went on to make a second group of African pictures, an extraordinary series of prints of Dan masks (cat. nos. 3-5), where he employed a slightly more textured paper and dark backgrounds. These are the most telling of Shee-

ler's African photos: the objects are a step further removed from mundane reality than those that appear in the de Zayas book, and they take on a mysterious, evocative life of their own. As with later work by Sheeler, one forgets reality here and sees simply abstract forms perfectly placed, with wonderfully delicate and expressive edges and curving surfaces. There is no evidence as to whom these fine masks belonged or who commissioned the photographs, though it is tempting to connect them to John Quinn, who corresponded with Sheeler in mid-1919 about making photographs of his own African collection. Sheeler suggested making four sets of twenty-seven photographs each and wrote, "I propose to put them in book form (similar to my Negro book without text)" and suggested a price of $387 for the four.[20] Quinn responded by ordering only three sets, one for himself, one for Arthur B. Davies, and one for Walt Kuhn.[21] These were presumably bound into books as Sheeler had suggested, but it is not known whether a copy has survived.

When de Zayas opened the Modern Gallery in 1915, he proclaimed: "Photography has always been recognized by '291' as one of the important phases of modern expression. The sale of photographic prints will be one of our activities."[22] The first exhibition included photographs by Stieglitz, but no other photographs were shown until 1917, when de Zayas opened his landmark exhibition of "Photographs by Sheeler, Strand, and Schamberg," which ran from March 29 to April 9. These were America's three great young photographic talents, yet they were practically unknown except to Stieglitz, de Zayas, and a few others. Strand was the only one with any reputation at all as a photographer; Stieglitz, already viewing Strand as his successor, had shown his photographs at "291" in March 1916 to good critical response, and six prints had been reproduced in *Camera Work* in October 1916 along with Stieglitz's words of praise.[23] Sheeler and Schamberg had small reputations as painters but none at all as photographers, and their work in this medium had not been shown previously.

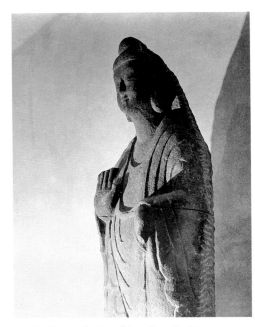

Fig. 11. Charles Sheeler, *Chinese Stone Bodhisattva*, c. 1916-18, gelatin-silver print, The Lane Collection.

Fig. 12. Morton Schamberg, *City Rooftops*, c. 1916, gelatin-silver print, The Lane Collection.

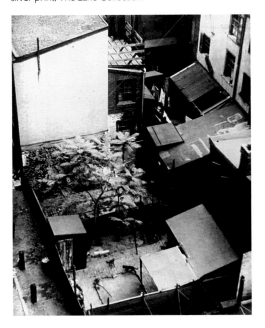

Remarkably, the small exhibition, consisting of just fourteen works, engendered several reviews in the press, and even more remarkably it was Sheeler's work that dominated each of the short articles.[24] Strand apparently contributed "architectural themes" and "a magnificent mountain bit," while Schamberg showed "a number of charming portraits" and a view of "a city backyard" (fig. 12). As for Sheeler, the works included "an obsidian mask, as executed in Mexico," (fig. 13) "a wood carving of a female figure from the French Congo," "Brancusi's 'Head of a Child,'" and a view of New York.[25] The *American Art News* judged Schamberg's work to be more conservative than the others, concluding that it made up "the most attractive part of the little display."[26] However, the astute Henry McBride in the *New York Sun* gave praise that must have thrilled Sheeler: "Of the three new photographers, Sheeler keeps himself most severely within the limits of true camera form, and a photograph of a New York building has the incision of a Meryon print and the inevitableness of Cézanne's 'Bouquet des Fleurs.'"[27] McBride was the first critic to recognize Sheeler as both a photographer and a painter. It became his practice to compare Sheeler's photographs with masterworks of the past in other media, seeking to give both Sheeler and photography itself credibility. Linking Sheeler to Meryon and Cézanne was extraordinarily insightful on the critic's part, for both these highly regarded artists had used photography as the basis for compositions in other media (Meryon for his prints of Paris, Cézanne for such compositions as *The Bather*). Sheeler was just beginning to make sophisticated use of photography and may well have been encouraged by McBride's review to continue his explorations. Moreover, the specific comparison to Cézanne's *Bouquet des Fleurs* (c. 1900-1903; National Gallery of Art, Washington, D.C.) was especially fortuitous. Sheeler regarded Cézanne more highly than any other master and on one occasion borrowed a small Cézanne still life from the Arensbergs for extensive study in his studio. *Bouquet des Fleurs* was actually shown at the Modern Gallery in 1916, where it was bought by Sheeler's friend Agnes Meyer. Its centrally focused composition, with white vase and flowers in the center

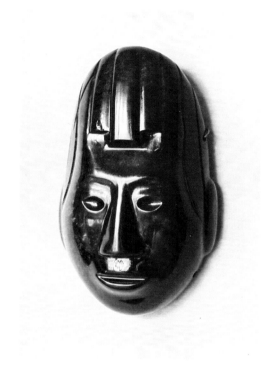

Fig. 13. Charles Sheeler, *Obsidian Mask*, 1917, gelatin-silver print, The Lane Collection.

Fig. 14. Charles Sheeler, *African Musical Instrument*, 1917, gelatin-silver print, The Lane Collection.

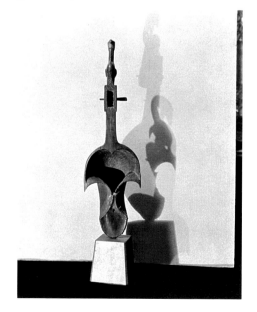

locked into place by a strongly rectilinear background and the sharp diagonals of the table below, may well have inspired Sheeler's own photographic compositions of 1916-17 and beyond.

In 1919 John Quinn commissioned Sheeler to photograph the Jacob Epstein sculptures that Quinn owned, for a book by Bernard Van Dieren. Quinn told Epstein he was deeply impressed by Sheeler's prints of African sculpture. His admiring remarks also reveal much about the struggle that photographers still faced in gaining recognition for their art: "The ordinary photographer could not do this work satisfactorily. The best photographer in the country is Charles Sheeler of Philadelphia who happens to be a very good artist also."[28]

Sheeler continued to be in demand as a photographer of artworks. He worked for de Zayas even after the Modern Gallery closed in 1921 (and continued to do so up to 1924, when de Zayas returned to Paris), making photographs of objects and assisting with clients and sales.[29] In the early twenties, Sheeler also worked regularly for the Whitney Studio Club, photographing exhibits of Greek art and American folk art, and for *The Arts*, where his photographs were regularly featured.[30] In addition, A. E. Gallatin commissioned him to provide sixteen collotypes for his monograph on Gaston Lachaise, which was published in a limited edition of four hundred in 1924.

In 1922 Sheeler participated in one of the few Dada works of his career,[31] collaborating with his friend Marcel Duchamp (who also photographed Sheeler about this time) on a book based on the writings of Henry McBride, the critic who so admired Sheeler. *Some French Moderns Says McBride* was published in an edition of two hundred by the Societé Anonyme. It consisted of reprints of several reviews of French art that McBride had written between 1915 and 1922, set on eighteen cardboard pages bound by three metal rings. Sheeler provided the seven photographs reproduced in the book, most printed from negatives he had previously made for de Zayas. They included photographs of Brancusi's *Danaide* of 1913 (later bought by Agnes Meyer), Francis Picabia's *A Little Solitude in the Midst of Suns* of 1915, Picasso's *Violin and Guitar* of 1913, and Braque's *Musical Forms* of

II

Bucks County, 1917

1913 (both of which went to the Arensbergs and appear in photographs Sheeler made of their apartment), as well as paintings by Matisse, Derain, and Rousseau.

In this notebook, 11¾ by 9¼ inches in size, McBride's articles begin in tiny type, which becomes increasingly enlarged until the letters are almost an inch high and only a few words appear on a page; then on the last page, the type suddenly reverts to its original small size. Signed with Duchamp's pseudonym "Rrose Sélavy" and with Sheeler's photographs credited with the stamp "PHOTO SWEELER," the book amounts to a whimsically assembled tribute to those Americans who responded to the call of French modernism, from the leading critical advocate, the important galleries McBride reported on, to the adventurous collectors and to Sheeler himself.

It was in 1917 that Sheeler reached artistic maturity. In that year he found his own spare, modern vision, and he developed the means of expressing it in various media, most notably in conté crayon and other means of drawing, and in photography. Moreover, from this year on, photography became central to his art. Sheeler seemed suddenly to realize that photography could be far more than a sidelight or a means of making his living: he recognized that he and the camera were meant for each other, and henceforth photography played a complex and integral role in his life and his work.

Sheeler must have been encouraged by the critical response to his photographs shown at the Modern Gallery in March 1917. Moreover, he had already won a partisan in the master photographer Alfred Stieglitz. Early in 1917 Sheeler had photographed Georgia O'Keeffe's paintings for her spring show at "291" (the last exhibition at that gallery).[1] Stieglitz admired Sheeler's photographs and apparently had planned to devote one last issue of *Camera Work*, to appear in the summer of 1917, to Sheeler and O'Keeffe together.[2] However, *Camera Work* died with the June issue, which featured the work of Paul Strand (the magazine had just thirty-seven subscribers at the end), and so Sheeler never had the pleasure of having his work exhibited in Stieglitz's gallery or reproduced in his publication. Nonetheless, Stieglitz found various ways to be supportive of the younger artist until their break in 1923.

Even more important for Sheeler was the support of Modern Gallery owner Marius de Zayas, his patron, friend, and sometime employer. In December 1917 de Zayas mounted an exhibition of a series of photographs Sheeler had made of his country home in Doylestown, Pennsylvania.[3] This exhibition — the thirty-four-year-old artist's first one-man show in photography — quickly and finally established Sheeler as a master of this medium.

The subject of the series was the small stone farmhouse in Bucks County that Sheeler and Schamberg had been renting since about 1910.[4] (The friends shared it until Schamberg's death in 1918; Sheeler continued to rent it until 1926.) The two artists used the house in summers and on weekends for painting and as a rural retreat where they could rest and be refreshed. The house itself had been built in 1768 by Jonathan Worthington, a Quaker settler. As Sheeler wrote to his friend Henry C. Mercer, the collector of the American vernacular artifacts who helped him lease it, "(The) chief reason for my enthusiasm for the little house is that it remains so nearly intact, even to such details as the ironwork."[5] Sheeler also surely appreciated the simple, rectilinear forms of the house and especially its interior. For just as he admired African tribal art for its simple, strong forms and would later find the same virtues in Chartres Cathedral and in Shaker architecture, here he saw a special opportunity to create modern form out of early vernacular design.

Sheeler's show at the Modern Gallery again was greeted by surprising critical attention and acclaim. One writer commented that "Negro art [i.e., African sculpture] has exerted considerable influence on the artist, who has sought to prove by photography the reality of modern forms and values."[6] Another found the exhibition "instructive" and commented on Sheeler's aims (which, given the common thread of the reviews, must have been outlined either by de Zayas or Sheeler himself in a press release): "Sheeler says his object has been to prove that the principal elements in modern art are sensorial and exist in nature; that the impersonal lens has furnished proof of the fundamental truths in modern art."[7]

The longest and most laudatory article reviewing the show was that of Henry McBride in the *New York Sun*, which was headlined, "New Light on Cubism." McBride — one of the most sophisticated critics of his time — reported that in these works "the camera has registered certain effects and qualities hitherto seen only in the works of Pablo Picasso and his ablest followers." He praised them for being excellent, "straight" photographs ("there is no blurring, no fog") with realistic subjects, and he compared the quality of the printing to that of the etchings of Charles Meryon.[8]

Scholars have generally dated this Doylestown series circa 1914 on the basis of tradition. However, there is no evidence that any of these photographs was made before 1917; if one or more had existed early in that year, why, one would ask, wouldn't the artist have included it in the important Modern Gallery

Fig. 15. Charles Sheeler, *Doylestown House: Old Kitchen (Vertical)*, 1917, gelatin-silver print, The Lane Collection.

Fig. 16. Charles Sheeler, *Doylestown House: Open Door*, 1917, gelatin-silver print, The Lane Collection.

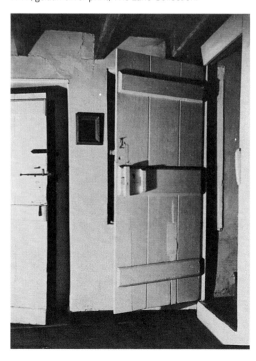

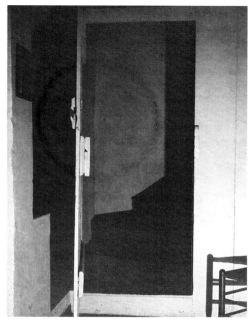

Fig. 17. Charles Sheeler, *Doylestown House: Stairway in Shadow with Chair*, 1917, gelatin-silver print, The Lane Collection.

exhibition in March? Moreover, there is a strong implication that these photographs had been recently made when Sheeler wrote to Stieglitz on November 22, 1917, saying: "About the photographs of my house, which I am glad to hear you liked — de Zayas was quite keen about them and proposes to make a show of the set (12) — following, according to schedule, the present (Derain) show."[9]

Sheeler's letter makes it clear that this series consisted of just twelve prints. However, it may never be known which twelve images Sheeler's original set included, as the artist preserved sixteen negatives that he labeled collectively "Doylestown House." In the group are negatives for each print in this exhibition (cat. nos. 9-20), along with four others: an exterior view showing the front door and two windows for which no print is known; a vertical depiction of the oven in the old kitchen (a more close-up view than cat. no. 10), which Sheeler printed at least once (fig. 15); *Open Door*, for which two prints are known (see fig. 16; a variant of cat. no. 15); and *Stairway in Shadow, with Chair* (fig. 17; a very close variant of cat. no. 16).[10]

Sheeler explained the series further in his November 22 letter to Stieglitz: "I decided that because of something personal which I was trying to work out in them, that they were probably more akin to drawings than to my photographs of paintings and sculptures and that it would be better to put them on a different basis — to make only three sets — one to be offered as a complete set (12) at $150, and the remaining two sets, singly at $15.00."

To deal first with the matter of sets: All of the Doylestown house prints in the artist's estate retain their original mounts, which are of three distinct types. The first is 20 by 14½ inches in size, with the photographs mounted high on the sheet and protected by an overmat; the second is similar but of smaller size (17½ by 14 inches). Several of each of these types were signed in pen, under the mat, "Pennsylvania House/photograph by/Charles Sheeler." A third group of prints was simply mounted on thin board, (about 16 by 13 inches in size) with no overmats, with the print surrounded by an incised line; none of these is signed. Thus the physical evidence suggests that three complete sets may well have been printed at the time, each on its own kind of mount.[11] No single complete set of twelve survives, suggesting that Sheeler must have broken up all three sets. It should be added that in some cases more than three prints of a given image exist. Apparently several of the images, such as *The Stove* (cat. no. 11) and *Open Window* (cat. no. 17), became somewhat popular and Sheeler made a few additional prints of them for friends and other buyers.[12] For example, shortly after the March exhibition at de Zayas's gallery, Sheeler nervously but excitedly suggested an exchange of work with Stieglitz. Stieglitz picked out *The Stove, Open Window, Stairwell,* and *Stairs from Below,* and Sheeler apparently received one Stieglitz print in return.[13] In this and a few other similar cases, Sheeler probably made additional prints beyond the three sets.

For Sheeler these photographs were "more akin to drawings" than to his commissioned photographs of works of art; they were, in other words, works of art themselves, and he priced them as such. Like drawings, they were experimental and handmade. But what was the "something personal" he was trying to

9

work out in them? Was he perhaps too self-effacing to tell Stieglitz that he was trying to discover whether a camera could truly substitute for the hand of the artist? And was he aiming to prove — as suggested by the critics — that modernism was, after all, compatible with American idiom and with the American vernacular? Whether Sheeler was looking at works of art from China, Africa, or the Shakers, or was making his own photographs or paintings, he always saw with the same catholic eye, and he always found the same universal qualities. He did not believe in the traditional value system that ranks painting above drawing, Renaissance art above African, and so on; instead, he employed his own values, seeking and finding universal form, structure, and order, as easily in Bucks County architecture as in the works by Picasso and Cézanne he so much admired.

Many years later, the photographer Paul Strand said: "Sheeler and I were aware that we were beginning to experiment with abstraction.... It had to do with understanding a painting like a Villon or a Braque — things in which there is an enormous amount of movement and no recognizable content as a whole."[14] Strand and Sheeler must have seemed to Stieglitz to be exactly what he had been hoping for, what he had worked so hard for — young Americans who could build on his foundation, who would carry photography to new levels. Strand himself had taken important initial steps beyond Stieglitz in 1915 and 1916. Sheeler would have known Strand's work from his March 1916 show at "291," and he probably learned from it. In June 1917, the final issue of *Camera Work* reproduced several of Strand's most adventurous prints, including *Abstraction, Bowls* and *Abstraction, Porch Shadows*, both dating from 1916.[15] In these works, the viewer first sees nonobjective, flat form and only upon further study realizes that the photographer has played a trick with scale, light, or camera angle, and that one is really looking at common coffee cups or sunlight streaming through a porch railing. Sheeler's Doylestown series of the following year, by contrast, was grounded in reality. In the case of these works, it is only after considerable look-

ing that fact and geometry merge and we realize the abstract, black-and-white strength of the compositions.

Moreover, Sheeler's photographs of his Doylestown house work together as a whole. Each individual print functions as a modernist examination of form, but the series taken together operates on another level, as an intense examination of a place and of form. With this series Sheeler established the pattern he would use in his photographs of the Ford plant at River Rouge, of Chartres, and in other major series, first introducing the subject at hand with an overall study (cat. no. 9), moving closer on the outside (cat. no. 10), then circling, probing, gathering details that together suggest the whole. *The Stove* gives as much information about the interior as we will get: we see a corner of the room, two closed doors, a window bisected by a stove pipe, and a black stove silhouetted directly in the lower center. This print was shot at night, like many in the series; the only source of illumination is the bright photo lamp placed inside the stove itself. The next image (cat. no. 12) shows the stove even more as a flat, black shape, in closer detail yet more abstractly. Next we move to the left of the hearth (cat. no. 13), then look down the wall toward the opposite door and window (cat. no. 14). As we turn right, the stairway door opens (cat. no. 15), and we step closer to the stairs (cat. no. 16). Having mounted the stairs, we arrive at the second-floor window with sliding screen and a gloxinia plant (cat. no. 17). There follow two views of the narrow attic stairs from the back, one a geometric study in white with black (cat. no. 18), the other a study in blacks with white verticals (cat. no. 19). The final image is slightly dizzying, looking up from below at stairs rising toward the unreachable (cat. no. 20). Thus, following both his training as an architectural photographer and his aspirations as a modern artist, Sheeler takes us on a tour of a humble place, examining it inside and out, moving up and down, peering into doorways and passages, going under the visible to find constructed reality while providing his own thesis on how abstraction could be adapted to American needs. De Zayas himself summed up the results of this show when he wrote: "It was Charles Sheeler who proved that cubism ex-

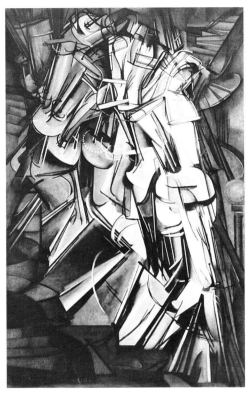

Fig. 18. Charles Sheeler, *Marcel Duchamp's Nude Descending a Staircase # 3*, c. 1920, gelatin-silver print, The Lane Collection.

ists in nature and that photography can record it."[16]

Sheeler made no secret of his debt to Cézanne and Picasso. He had made several beautiful photographs of Duchamp's *Nude Descending a Staircase* (fig. 18), which could have encouraged his interest in the stair theme;[17] and he certainly learned from the example of Stieglitz and Strand. He surely also knew the work of Alvin L. Coburn (1882-1966), an adventurous photographer whose work was featured in several editions of *Camera Work* before 1908. Coburn's flattened, somewhat abstracted views of New York dating from 1910-12 may have influenced both Sheeler and Strand. Interestingly, the year 1917 saw Coburn back in London producing his most advanced work, the so-called Vortographs, in which recognizable forms — faces, crystals — are blurred, repeated, and otherwise manipu-

lated to such an extent that they become almost totally nonobjective. If Sheeler saw these prints after they were shown in London in February 1917, they might have encouraged his own developing modernist vision, though their implication – that abstraction can be imposed simply by the intellect of the artist – stood in sharp contract to Sheeler's own point of view.

Sheeler may also have learned from the work of the British photographer Frederick H. Evans (1853-1943), whom Stieglitz regarded as "the greatest exponent of architectural photography."[18] Evans's purist photographs had been illustrated in *Camera Work*, shown at "291," and collected by Stieglitz.[19] Evans's specialty was the cathedrals of England and France: he photographed the English cathedrals at Lincoln, Wells, Ely, York, and London's Westminster Abbey, and in France the cathedrals at Bourges, Chartres, Rheims, and so on, normally making a few exterior views before moving to the interiors. His platinum prints show a superb range of tonal values, from darks (though never blacks) to silvery grays; his compositions are foursquare and symmetrical, and one often sees a light source in the center distance. Works such as *Lincoln Cathedral: Stairway in S.W. Turret* (fig. 19) anticipate Sheeler's work at Doylestown, especially a composition such as *Stairwell* (cat. no. 19), and while Evans is certainly not a modernist, there is an affinity between his work and Sheeler's.

At about the same time that he was working on his Doylestown series, Sheeler made several photographs of barns in Bucks County. These subjects seem never to have constituted a close-knit series and were probably made over at least two years' time, from 1916 through 1917 or so. Most are fairly conventional three-dimensional views of various large barns, often seen in the raking shadows of morning or evening light (fig. 20). But the group culminates in two of Sheeler's best-known photographs, one an abstract, flat study in whites, the other a rich, complex study in blacks. The first, *Side of White Barn* (cat. no: 21), has long been admired. Constance Rourke, in her 1938 biography of the artist, thought it preeminent, admiring its "strong sense of inherent design and a rendering of

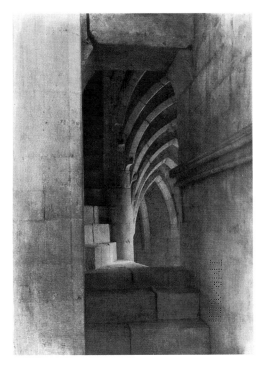

Fig. 19. Frederick H. Evans, *Lincoln Cathedral: Stairway in Southwest Turret*, 1895, gelatin-silver print, International Museum of Photography at George Eastman House, Rochester, N.Y., Gift of Gordon Conn.

textures which has been unsurpassed," and finding in it justification for Steichen's remark, "'Sheeler was objective before the rest of us were.'"[20]

In a letter written in later years, Sheeler referred to *Side of White Barn* as dating from "about 1915."[21] However, by the time he made this photograph, he was thinking in a rigorously formal way; its taut, abstract composition is more consistent with his work of 1917 both in photography and in his drawings. Sheeler worked through the same problems of abstraction and reality in his Bucks County drawings of 1916-18. In these drawings, many of which are dated, one can see the artist's progress as he struggles to find his own vocabulary and style and his images grow increasingly simple and abstract. The drawings of 1915 and 1916 are still in a Cézannesque mode, with curving tree forms contrasting with rectangu-

lar barns.[22] Those which one would place early in 1917 have obvious photographic roots and are clearer and more rectilinear,[23] while the fully realized works of later in 1917, such as *Barn Abstraction* (fig. 21) are spare and abstract, completely lacking in three-dimensionality or incidental detail. The 1918 drawings build on this foundation, becoming even fuller and richer.

Several prints of *Side of White Barn* survive in their original mounts, and in them one sees the artist experimenting with the subtlest nuances of tone and composition, adjusting each edge as he sought a perfect image. One print he marked "Best one": here he tightened the image, cropping the chicken on the left so that one sees only its head, cutting the roof down to two rows of shingles, and bringing in the right margin ever so slightly.

Sheeler's working method was firmly established by this time: he saw, sketched, and experimented through the lens of his camera (and occasionally through photographs by others). Because he was so clearly committed to this approach – first seeing through the camera and then translating his discoveries into other media – it is hard to imagine that the photograph *Side of White Barn* did not precede the drawing *Barn Abstraction*; but it is also difficult to see it coming much before, for example before the less accomplished drawings of 1916. Hence a date of early 1917 for the photograph seems reinforced by examination of Sheeler's drawings of that time.

The process Sheeler worked through in photography was similar to the one he applied to drawing but left behind less evidence of his struggles, for with the camera he could simply discard or not print unsatisfactory negatives. However, his earliest photograph of the Doylestown interior (fig. 22), dating perhaps to 1914-16, shows him beginning his attempt to make formal structure from his rural retreat. In this picture one sees a rough work table with matches, keys, a large portfolio, a mirror with a carved Italianate frame, a potted gloxinia, and, hanging on a wall, a geometric modernist collage, perhaps a lost work by Schamberg. The photograph conveys

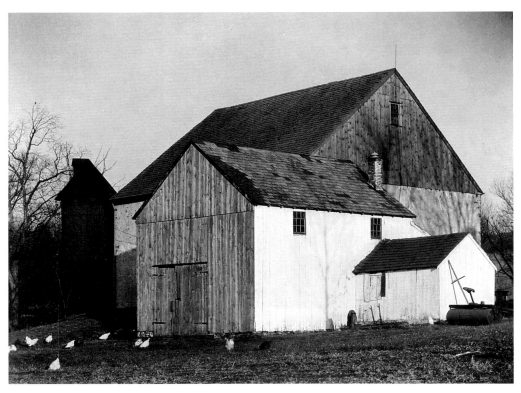

Fig. 20. Charles Sheeler, *Bucks County Barn*, c. 1917, gelatin-silver print, The Lane Collection.

a sense that Sheeler knew where he was headed but was not yet certain of the route.

Equally advanced and equally successful as *Side of White Barn* is the photograph that Sheeler simply called *Buggy* (cat. no. 22).[24] With its extraordinary range of blacks, sharp tonal contrasts, complex shapes, and deep spatial recession, it makes a perfect complement to the classically simple *Side of White Barn*. Here again, Sheeler experimented with various formats: one print is matted so that the wooden beam at the top center is parallel to the edge, while in others this beam seems slightly diagonal, adding tension to the image. The same process is at work on the right side, with one print almost masking out the tiny window of light at the right edge, and another leaving it in. For Sheeler, very precise matting was a crucial last step in the making of a photograph: with the mat he made his final aesthetic choices, and the importance of studying the original mats,

many of which have survived in Sheeler's estate, is great indeed for students of his work. As Sheeler himself pointed out, "Each print has an intrinsic life of its own, and there should be the same sort of discrimination between fine photographic prints as between different Rembrandt etchings."[25]

Just three months after his show at the Modern Gallery, Sheeler entered the thirteenth annual spring exhibition of photography sponsored by the John Wanamaker department store in Philadelphia. The exhibition, from March 4 to 16, 1918, was juried by Stieglitz, Arthur B. Carles, Hugh Breckenridge, F. Vaux Wilson, and Leopold Seyffert, the last four all leading painters and teachers in Philadelphia. The year before, a somewhat similar jury, also headed by Stieglitz, had given first prize to Paul Strand for his *Wall Street*; Sheeler had not been an entrant. In 1918 the jury recognized Sheeler's achievements by awarding

him first prize of $100 for a work called *Bucks County House*, and fourth prize for *Bucks County Barn*. The first-prize photograph was illustrated in the exhibition catalogue and can thus be identified as *Open Window*. And we can be reasonably certain that the photograph called *Bucks County Barn* was *Side of White Barn*, on the basis of the comment by a critical reviewer, W. G. Fitz, in *The Camera*: "The Barn (Fourth Prize) is texture and nothing more."[26] Second prize in the show was given to Strand for his *Wheel Organization* of 1917 (which Fitz preferred to the winning Sheeler; fig. 23) with third prize going to Schamberg for his portrait of a boy wearing a large bow tie (fig. 24). This division of the spoils caused Fitz caustically to report that "Sheeler, Strand and Schamberg are *the* Trinity of Photography – Mr. Stieglitz says so."[27] Like many jokes, of course, this one contained more than a little truth.

Sheeler made several outstanding still life photographs during this same rich period of discovery and growth. One, *Zinnia and Nasturtium Leaves* (cat. no. 7), has traditionally been dated to 1915,[28] but again, like *Side of White Barn*, it seems too formal and too crisp an image for Sheeler to have produced then, and a more likely date is circa 1916-17.

Shortly afterwards Sheeler received an important commission from Mrs. Eugene Meyer, Jr. Agnes Meyer (1887-1970) was a leading member of the American avant-garde, a close friend and long-time correspondent of Stieglitz, de Zayas, Steichen, and Brancusi, and – after her marriage to Eugene Meyer in 1910 – a major early collector both of European and American modern art and of Oriental art.[29] In 1915 she worked closely with Francis Picabia and Paul Haviland in helping de Zayas establish the Modern Gallery, which she funded. Though this project had begun with the blessing of Stieglitz, and the Modern Gallery was originally to be a branch of "291," it led shortly to an angry break between Stieglitz and the Modern Gallery group, especially Mrs. Meyer, as her tone in a letter to de Zayas suggests: "My advice to you is have nothing more to do with Stieglitz – never see him, never think of him."[30]

The growing schism between the two camps surely made life difficult for Sheeler, who was trying to establish himself equally as a

Fig. 21. Charles Sheeler, *Barn Abstraction*, 1917, Black conté crayon on paper, Philadelphia Museum of Art. Gift of Louise and Walter Arensberg.

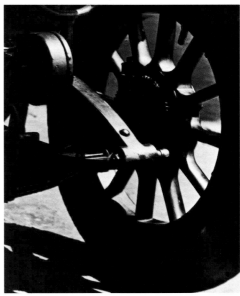

Fig. 23. Paul Strand, *Wheel Organization*, 1917, gelatin-silver print, Aperture Foundation, Paul Strand Archive, Millerton, N.Y.

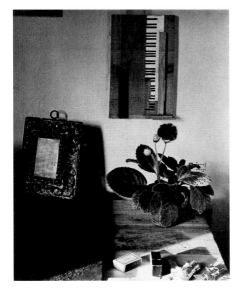

Fig. 22. Charles Sheeler, *Doylestown Interior*, c. 1916, gelatin-silver print, International Museum of Photography at George Eastman House, Rochester, N.Y., Museum Purchase.

painter and a photographer, and who badly needed the goodwill both of Stieglitz and of de Zayas. He must have tread lightly, for he was supported by both for several years to come. Moreover, Mrs. Meyer, whom he would have known well from the Modern Gallery, where he assisted de Zayas and acted for a time as gallery manager, became a lifelong friend and patron. Sheeler photographed "the greater part of her very fine collection of Chinese paintings, bronzes, and sculpture, which he very much admired," as well as their Brancusi sculpture and other modern works.[31] He also took a number of portrait photographs of her, as did Steichen. In about 1918 or 1919, Mrs. Meyer commissioned from Sheeler a book of photographs of her grand new country house in Mt. Kisco, New York, "Seven Spring Farm," designed by Charles A. Platt.[32] According to Sheeler, Mrs. Meyer "wanted to surprise her husband with a book of pictures," and for a period Sheeler "practically commuted up there."[33] The two were still discussing the matter in August 1923 when Mrs. Meyer asked

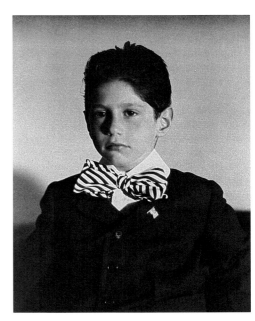

Fig. 24. Morton Schamberg, *Portrait S.*, 1917, gelatin-silver print, The Lane Collection.

him to redo the photograph of the hall. ("As you remember, this was not successful in the book you made for me.")[34]

The book Sheeler made contained twenty-nine of his photographs. It begins and ends with distant views of the house and the wooded hill on which it stands, and in between gives a thorough tour of the main floor and the grounds. We move with the artist through the dining room, living room, morning room, front hall, and so on. One senses that Sheeler may have felt constrained by the importance of the job, the great wealth and influence of his clients, and the need for a series of good "likenesses" of the house, for many of the photographs are very close in style to his architectural work of 1912-16 and show little of his new abilities as a modernist. However, certain views, such as the one of the front hall (fig. 26) are beautifully composed and printed. In the reflection of the stairs in the mirror and the slight asymmetry, there is evidence of Sheeler's mastery. A light-toned, Whistlerian picture of the attached indoor swimming pool (fig. 25) is astonishingly pictorial, while others, such as the symmetrical curtained window (fig. 27) are highly abstract. However, the most memorable images here are two pictures of the water lilies growing in a small square pool in the garden. The first (fig. 28), pale in tone, is somehow tender and poignant in its depiction of several small blossoms. The second, which Sheeler always called *The Lily – Mt. Kisco* (cat. no. 8) is more dramatic, with a large flower standing out in the center, surrounded by fantastically real yet abstract leaves. This became one of Sheeler's favorite prints, and he experimented with various printings and mat sizes as he tried to perfect the image.

The Modern Gallery closed in April 1918 after less than three full seasons, but it reopened at 549 Fifth Avenue in the fall of 1919 as the De Zayas Gallery. Sheeler moved to New York permanently at this time and worked regularly for de Zayas, managing the gallery when the proprietor was away. The gallery continued to show extraordinary works, including African and Chinese sculpture, the paintings of Gauguin, Cézanne, Seurat, and Matisse, and the work of John Covert, Arthur B. Davies, Walt Kuhn, and

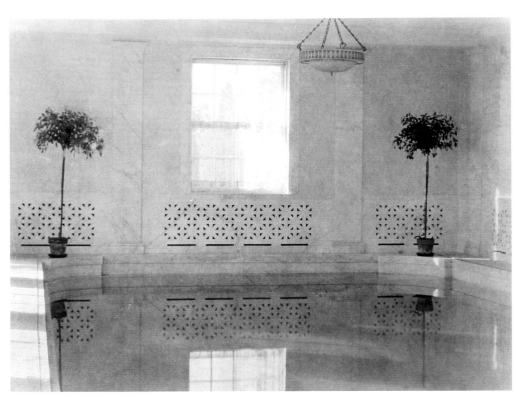

Fig. 25. Charles Sheeler, *Pool – Mount Kisco,* c. 1918-19, gelatin-silver print, Century Association, New York.

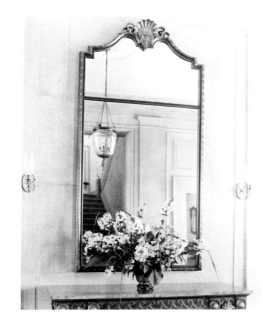

Fig. 26. Charles Sheeler, *Front Hall Mirror – Mount Kisco,* c. 1918-19, gelatin-silver print, Century Association, New York.

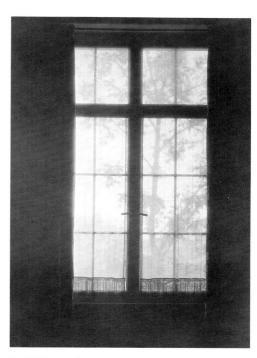

Fig. 27. Charles Sheeler, *Dining Room Window – Mount Kisco,* c. 1918-19, gelatin-silver print, Century Association, New York.

Fig. 28. Charles Sheeler, *Water Lilies – Mount Kisco,* c. 1918-19, gelatin-silver print, Century Association, New York.

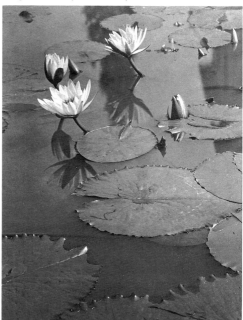

Sheeler. Yet its financial problems continued, and the gallery closed finally and permanently after the Davies show in April 1921.[35]

De Zayas, ever loyal to Sheeler, mounted a show of thirty-nine paintings, drawings, and photographs by the artist in February 1920. This was a restrospective, surveying Sheeler's growth as a modernist over nearly five crucial years, from 1916 to 1920. Included were such paintings as *Lhasa* (fig. 5) and *Flower Forms* (1919; Terra Museum of American Art, Chicago); a group of watercolors and drawings, including eight representations of Bucks County barns; and about ten or twelve photographs.[36] Among the latter were several prints that can be identified today, including *Buggy, The Lily – Mt. Kisco,* and *Zinnia and Nasturtium Leaves,* and several other pictures, of a North American Indian painting, Chinese sculpture, and at least three African sculpture subjects.

Once again Sheeler drew a good critical response. One writer reported simply that the "predominating subject … is 'Bucks County Barn,'" and, without remarking specifically on the photographs, summed up, "He can draw and he knows color."[37] Another reviewer was Henry McBride; his article was longer and his understanding greater. Noting that "Mr. Sheeler's subjects are Bucks County barns, flowers and still lifes, and these have been worked out both in photography and watercolor," he quickly and astutely suggested that "what will operate against a swift fame is a certain coolness in the work." McBride understood Sheeler, comparing his sense of composition to Picasso's, finding the work "as taut and tight as Van der Weyden's," and concluding, "In the photographs Mr. Sheeler is more dominating…. They rank among the most interesting productions of the kind that have been seen here."[38]

Charles Sheeler is seldom thought of as a film-maker, but he did make at least three films early in his career, and each one sheds light on his development and his photographic art. *Manhatta,* which he made with Paul Strand in 1920, is the only Sheeler film that survives today, but two earlier efforts in this medium are known from surviving stills. Regarding the first one, Constance Rourke noted that "a still from an early motion picture of Sheeler's shows Schamberg partially reclining with a parroquet [i.e., a parakeet] on his wrist, his narrow figure, the turned head and finely articulated hand against the dark."[1] Though subsequent scholars did not follow up on this lead, Sheeler did leave two such stills in his estate (figs. 29 and 30). Schamberg, dressed in a business suit, is reclining on a sofa in their Philadelphia studio, holding a large parakeet close to his face. By the time Rourke wrote her book in 1938, Sheeler had either forgotten what the film was about or simply didn't tell her, so she speculates that "Schamberg might have been talking theoretically about either parroquets or art." The two stills represent well-composed, well-lit interior scenes, indicating that Sheeler (and Schamberg, who was doubtless his partner in this project) had reached a high level of technical and visual competence. Rourke dates the film "half a dozen years" before Schamberg's death, or 1912, but a date of circa 1914-15 seems a better guess on stylistic grounds.

Sheeler's second film was more significant, and more of it is known. All his life he kept, in a wrapped package, a set of thirteen stills from a film made in about 1918-19; each depicts Katharine Baird Shaffer, whom Sheeler married in 1921. These stills are matted, as if ready for exhibition, though they seem never to have been shown publicly. Like the earlier film, this one was probably made with a hand-cranked 35-mm. camera, judging from the dimensions of the enlarged stills.

The Katharine stills break down into three groups, which may suggest the internal development of the film itself. First, there are two shots of Katharine, dressed in black, sitting on the edge of a table; these portraits are powerful, and she looks beautiful and vulnerable in them (see cat. no. 23). The main part of the film follows, represented by eleven stills of

Katharine completely in the nude (see cat. nos. 24-29).[2] The camera is close to her but never shows her face, and each carefully composed frame is filled with female form. One can feel her moving as she lies on her back with a leg out, pulls a leg up, leans back, leans over, turns over, and then rises to her knees. It is a slow, naked ballet, with great sensuality and, at the same time, a keen sense of the abstract and the formal. When one looks at these stills — just as with the later Rouge or Chartres photos — one first sees architectonic form, lights and darks, and then slowly recognizes the subject. As in all of his major series, the photographer introduces his subject with overall shots and then moves in for closer study. Then, two further stills constitute the third and last group: these are composite prints that fragment the body into planes and angles, coming close to abstraction (fig. 31). It is impossible to know whether the image-layering technique occurred in the film itself, or whether — as is more likely — Sheeler later combined two negatives in order to make these prints. In any case, Sheeler would not use this technique again until 1932, for his photographic triptych *Industry* (fig. 54).

The Katharine film must date from 1920 or before, as Sheeler made an elegant pencil drawing, dated 1920, after one of the stills.[3] The film also probably predates the painting dated 1919 that Sheeler called *Forms — Flowers*. The curvilinear forms in the painting surely have the human body as their source, and Sheeler may well have used stills from the film, or perhaps other photographs of Katharine in the nude, in preparing the painting.

Katharine Baird Shaffer was born in Loch Haven, Pennsylvania, and is said to have become a classical and jazz pianist after studying music in Philadelphia. She was briefly married to and then divorced from Archibald Moore, and apparently met Sheeler in Philadelphia in the mid-1910s. She moved to New York in about 1918 (shortly before Sheeler did) in order to keep house for her brother, and she is remembered as being "stout, vivacious, and an expert cook."[4]

Sheeler's extraordinary film about Katharine may owe something to Stieglitz's long series of portraits of Georgia O'Keeffe, which he began in 1918-19. Sheeler first saw these pic-

tures in May 1919, for on May 20, Stieglitz wrote Strand, "On Sunday morning Arensberg came up with Sheeler. The same result as with de Zayas.... Arensberg was literally taken off his feet by the photographs and said that no painter could ignore their existence."[5] It may have been the sight of this new work by Stieglitz that inspired Sheeler to make his own photographic portrait of a woman to whom he was already very close. Stieglitz's pictures of O'Keeffe are formally elegant, sensual, and direct, but there is a personal mood to them, a romantic quality, that Sheeler rejected in his own series. In *Georgia O'Keeffe #2* (1918), O'Keeffe places her open hand between her breasts, and her garment falls gently, like a veil, to either side; Stieglitz here was concerned with form and shape, of course, but the hand never ceases to be a hand, the breasts remain breasts, and the garment implies the full figure's presence. Sheeler, on the other hand, saw as a more developed modernist. Once his theme was established in the early part of the film, he broke from the romantic, Western tradition of the nude, eliminating extraneous details and the outside world and examining the shape and structure of the female body. Thus the concept of Sheeler's film may owe something to Stieglitz, but its style does not.[6]

A few years later, Sheeler photographed Katharine again (cat. no. 40). Here she appears older, heavier, sadder, perhaps — and one wonders whether at this time they knew of her illness. She is portrayed with an aura of tragic calm, even nobility, as she stands before a fireplace wearing pearls and a long dark dress. Directly behind her on the mantel is Sheeler's own photograph of a classic sculpture of Aphrodite, its curvilinear form outlined against a black background.[7] The photograph thus invites us to identify Katharine's form with that of classical sculpture, and perhaps also to see Sheeler as a modern artist in the classical tradition. He admired this sculpture particularly, and he thought it especially relevant to what he was trying to do. In a review for *The Arts*, he wrote: "It is beautifully demonstrated in the *Aphrodite* that as great purity of plastic expression may be achieved through the medium of objective forms as has been thought to be only obtainable by some of our present day artists, by means of a purely abstract pres-

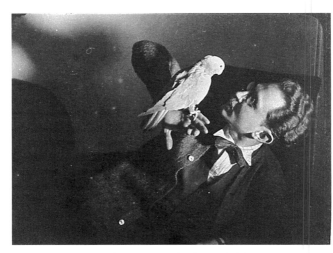

Fig. 29. Charles Sheeler, *Schamberg with Parakeet*, c. 1914-16, gelatin-silver print, The Lane Collection.

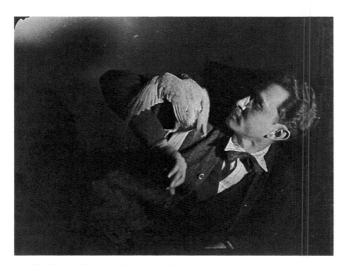

Fig. 30. Charles Sheeler, *Schamberg with Parakeet*, c. 1914-16, gelatin-silver print, The Lane Collection.

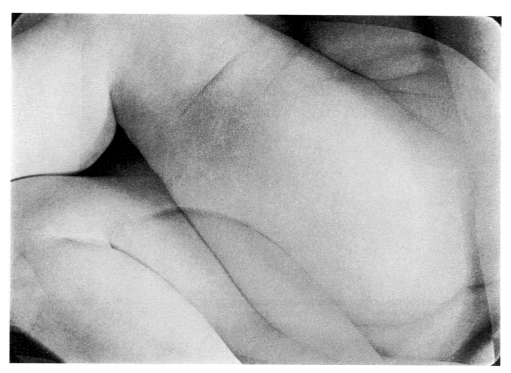

Fig. 31. Charles Sheeler, *Nude # 7*, c. 1918-19, gelatin-silver print, The Lane Collection.

entation of forms."[8] These comments reveal Sheeler's artistic strategy: to seek what he called "great purity of plastic expression," that is, innovative, eye-opening formal brilliance, through the use of "objective forms," or observed reality. He eschewed both the limitations of realism and what he saw as the artificiality of the nonobjective (or pure abstraction); his models were the Greeks, Piero della Francesca, and masters of the early Renaissance, as well as African sculpture and the works of Cézanne.

Sheeler moved to New York from Philadelphia during August of 1919;[9] at just the same time, Paul Strand returned to New York from his army service. The two photographers had known each other for several years, having exhibited together at Marius de Zayas's Modern Gallery in 1917. Both were regarded as protégés of Stieglitz, and Stieglitz kept Strand informed of Sheeler's doings while he was in the service. In November 1918, for example, he wrote: "Sheeler – he has done some wonderful new things, Pennsylvania Barns! Uses Bromide paper now – smooth. Has much quality."[10] Strand also greatly admired Sheeler's work. Just a few days after Strand returned, he received an invitation to exhibit his work in a "Pictorial Photographers of America" show; in declining, he outlined his own values: "Photography ... is either an expression of a cosmic vision, an embodiment of a life movement or it is nothing – to me. This quality I find only in the work of ... Charles Sheeler and Alfred Stieglitz."[11]

In late 1919 or early 1920, Strand and Sheeler joined forces to make their film *Manhatta*. Neither Rourke's biography nor Sheeler's unpublished autobiography sheds any light on the genesis of this project; however, Strand in later years recalled that "Mr. Sheeler had acquired a beautiful motion picture camera, Debrie, and proposed that we might make a kind of experimental film about New York together."[12] On another occasion Strand recalled Sheeler's telling him that he had "just bought a motion picture camera. It's a beauty. It's a Debrie camera, a French camera. It cost $1600." Strand visited Sheeler and admired the "very handsome instrument." He concluded, "I don't remember any of the details, but the upshot of it was the idea of making a little film about New York. Who developed it, whether it was he or both of us together, I don't recall."[13] There is no doubt that the fine, lightweight Debrie L'Interview Type "E" motion picture camera belonged to Sheeler, and that he already had had some experience with film-making, while this was Strand's first such venture. Sheeler would apparently discontinue all work in the medium after making *Manhatta*; it was Strand who went on to a distinguished career in film. Strand, for his part, brought to the partnership his own tough-minded, spare sense of composition and his considerable experience in photographing New York. Though Sheeler had made his own photos of New York by 1917, Strand was far more experienced with this subject. And as Strand pointed out, referring to this time, "I believe both of us were well along the road of abstract organization of reality."[14] Strand and Sheeler worked well together, and for this brief period following Schamberg's death in 1918, Strand took Schamberg's place as Sheeler's good friend and close collaborator.

Strand recalled that "*Manhatta* was based on a very close and fluid experimentation between us, a very fine film, 6 minutes ... with Walt Whitman titles, which has become an avant garde classic in spite of the fact that it had but one week's showing."[15] In a press release he prepared for the film, Strand stated the artists' aim: "to register directly the living forms ... through the most rigid selection, volumes, lines, and masses, to their intensest terms of expressiveness."[16] Their one-time collaboration resulted in a six-and-a-half-minute silent film, comprised largely of a cadenced sequence of frames.[17] Film historians have long judged it a landmark avant-garde American film, yet only recently has it been given serious study.[18]

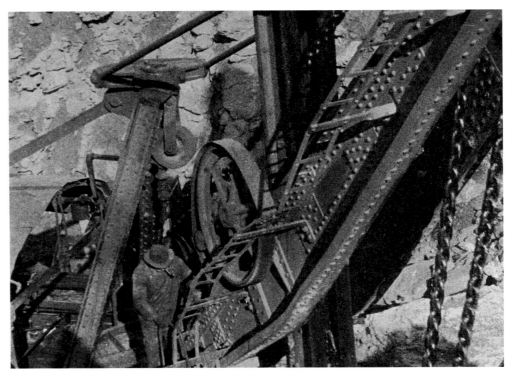

Fig. 32. Charles Sheeler, *Manhatta – Man Operating Equipment*, 1920, gelatin-silver print, The Lane Collection.

Sheeler and Strand worked on the film during the spring and summer of 1920. A series of frames featuring the Cunard liner *Aquitania* and tugs must have been shot either on July 24, 1920, when the ship arrived from Liverpool newly converted to oil fuel, or about August 21, when it arrived again.[19] The film was finished by the fall, for on October 27 Stieglitz wrote that it had been shown privately to Walter Arensberg and de Zayas in California.[20] Curiously, well into the project, Stieglitz seems to have thought that it was the work of Sheeler alone, for on August 10 he wrote Strand from Lake George, asking: "I wonder do you see much of Sheeler. Is he continuing his 'abstract' movie? and is he painting?"[21] In August Strand left with his friend the critic Herbert Seligmann for a few weeks in Nova Scotia, perhaps putting the film aside for a time.[22] On August 24, Stieglitz wrote Strand again from Lake George, welcoming him home and in-

quiring: "I suppose you have seen Sheeler – I wonder how he is. – wonder how the movie is progressing."[23] By this date Sheeler and Strand were back at work on the film, shooting a sequence outside Morgan & Company from the steps of the U.S. Subtreasury building; that sequence relates to Strand's Wall Street photograph of 1916.[24]

The two film-makers evidently had difficulty in getting their work shown at a movie palace, as it took nearly a year to obtain a booking. Its first public showing took place on July 24, 1921, at the Rialto Theatre on Broadway, where it was included in the program as a "scenic." Its title was listed as *New York the Magnificent*, and it was spliced with intertitles taken from Whitman's "Crossing Brooklyn Ferry" (1856) and "Mannahatta" (1860). It drew six favorable – though very brief – newspaper reviews.

There has been uncertainty regarding the

film's title. Strand preferred to call the film simply "the scenic" and in his press release described it as a "scenic of New York under the title of 'New York the Magnificent.'" Sheeler simply identified his package of stills as "New York movie." The most substantial review was that of Robert Allerton Parker, who did not cite the title but described enthusiastically how Whitman's "proud and passionate city" was revealed without plot and yet "most eloquently in the terms of line, mass, volume, movement."[25] Two years after the initial showing, when the film was taken to Paris through the aid of Marcel Duchamp (and possibly de Zayas), it was retitled *La Fumée de New York* (*The Smoke of New York*) for its showing at the Théâtre Michel as part of a Dada Festival.[26] It was not until 1926 that it was called *Manhatta*, when it showed again in New York, at the Cameo Theater. This was the title used by Symon Gould, a distributor representing the Film Arts Guild, when he requested a print from Sheeler in May the next year.[27] The film had one showing in London in November 1927 at the eighteenth London Film Society performance,[28] and then it disappeared from view. As Strand tells it, "At this point we very amateurishly turned over the negative and the print to a so-called distributor who promptly disappeared with both and we have no record whatsoever of *Manhatta* until the year 1950 when a miracle happened." The miracle was a letter to him and Sheeler from the British Film Archives saying they had a print of the film.[29]

The film is remarkable for its coherent assembly of contrasting impulses. It contains highly abstract passages – especially in the taut, geometric treatment of rooftop architecture – while others are pure pictorialism, with misty harbor scenes that recall Whistler's work. Its flattened perspectives, innovative framing from oblique angles, and rich patterning gained from a bird's-eye camera position are notable. The film has no plot, and the spectator is encouraged to read its progression in terms of a rhythmic sequence of urban images, which stand in contrast to frequent shots of sky, steam, and water. The most emphatic counterpoint is between the solid, manmade machinery and skyscrapers and the clouds of steam and smoke that they emit. Appearing throughout the film, the windswept smoke

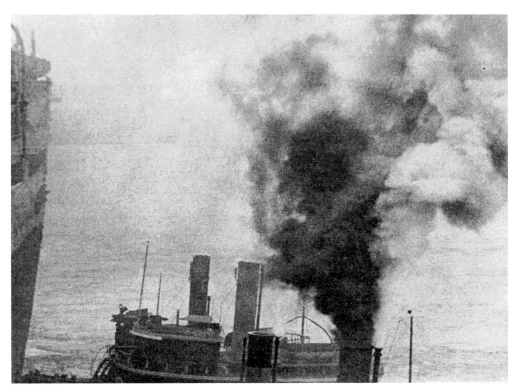

Fig. 33. Charles Sheeler, *Manhatta – Ferry Docking Aquitania*, 1920, gelatin-silver print, The Lane Collection.

suggests the simmering nervous energy of the city.

Despite the lack of plot, the film does have a narrative quality. The ferry's arrival in New York signals the day's beginning and the sunset marks its end, making the film, on one level, the story of a day in the metropolis. The intertitles from Whitman add a literary level, and also contribute to the film's glorification of urban power, that extraordinary combination of human and mechanical energy that the city exemplifies. The intertitles give rhythm and rationale to the whole. Throughout the film, the abstract treatment of space, form, and shape is pitted against a more old-fashioned aesthetic; in the same way, the film contains passages that contradict the uplifting Whitmanesque vision. For example, early in the film, the camera pans over an anxious crowd of commuters bustling into the city as one man struggles to make his way against the crowd.

As the film proceeds to what Strand's press release called "the towering geometry of New York," the camera pans downward over the Park Row Building, the left-most part of the frame encompassing a fragment of the Woolworth Building, and the right-most part coming just shy of Liberty Tower. This sequence, like many in the film, was shot either from a high window or the rooftop of the Equitable building. The Equitable Building becomes, in effect, the central axis around which the film develops. There follows a sequence of men operating heavy equipment (fig. 32), erecting yet another skyscraper; more views of rooftops; a sequence emphasizing mechanical movement, including shots of the locomotives of the New York Central yards and the *Aquitania* cruising in to be docked by attendant tugs (fig. 33). The final images echo early ones, suggesting closure. A frontal, iconic view of the Brooklyn Bridge, with pedestrians walking

across it, recalls an earlier view from the side; the camera returns to Trinity Church, viewing it through a balustrade from the Empire Building across Rector Street (cat. no. 31); a train passes downward along the Church Street elevated railway, a crowded street scene follows, which again corresponds closely to an early scene; and then the sunset ends the film on a romantic note.

Sheeler's art is generally remarkable for its stillness. *Manhatta*'s incisive use of movement, occurring with very little panning but with frequent activity within the frame, is unique in what survives of his oeuvre. Yet in some ways, the film is perfectly in tune with Sheeler's usual approach to photography. The serial strategy he worked out with the Doylestown house, in which the initial overall views lead into a more analytical rendering of its parts, is repeated in *Manhatta*. In the film, the opening skyline views provide context, followed by close analysis of the subject – the tall buildings of lower Manhattan – which they identify.[30]

A photographer who may have inspired the two filmmakers was A. L. Coburn, whose overhead view of Madison Square from the Metropolitan Tower in *The Octopus* (1912) was an important precedent for the extreme angles and downward views to rooftops that *Manhatta* exploits. Coburn's volume *New York* (1910) recorded many of the same structures and views, occasionally from high angles, though perhaps not with the forceful design and interrelatedness of imagery evident in *Manhatta*. Images reminiscent of Coburn's *New York* appear too frequently in the film to be ignored. His views of smoke-emitting freighters passing before the skyline, of workers silhouetted amid girders with the Williamsburg Bridge in the distance, of the Battery, and of the Park Row Building are all echoed in similar images in *Manhatta*, suggesting that Coburn's volume may have served as a springboard for Sheeler and Strand's experiment.

Coburn's shallow space, use of bird's-eye views, and delicate balance of shapes and angles emerged from a background in Japanese pictorial design. His interest was stimulated by his studies in 1903 with Arthur Wesley Dow,

an influential professor at Columbia University's Teacher's College who later taught Georgia O'Keeffe. Dow enthusiastically encouraged photography as art, as evidenced by his hiring Clarence White at Columbia and by his contributions to influential photographic journals. Interestingly, Strand's press release for *Manhatta* recalls Dow's language in his important book *Composition*, and one has a sense of Dow's influence — at either first- or second-hand — in the film. Dow was a great believer in Oriental design, equating Korin and Hiroshigè with Giotto and Rembrandt, and Sheeler also had great respect for Asian art.[31] He and Schamberg had a two-panel nineteenth-century Japanese screen and at least two Utamaro prints in their studio, and Sheeler later acknowledged the Asian influence on his painting *Church Street El* (1920; Cleveland Museum of Art), which itself was based on a still from *Manhatta*:

> *"I used an intentional reverse of perspective ... placing the point of greatest concern close to the position of the spectator, well down in front, rather than at some distant point on the horizon. In a way the picture includes the spectator.... This arrangement was not my invention of course. Some if not all of the Orientals have used it."*[32]

Sheeler employed this "intentional reverse of perspective" in two stills from *Manhatta*, *From the Empire Building*, and *Rooftops* (cat. nos. 32 and 33), using powerful diagonals that extend across the surface to prevent a deep spatial recession. The device enabled the filmmakers to fill the space with flat, geometric shapes that interlock like pieces of a puzzle into an overall design. Large flat masses of shadow contrast with textured sunlit ones; repeated rows of windows and the subtle textures of shingles create complex patterns against smooth passages. In each of these two stills, a plume of smoke offers visual relief, creating amorphous white shapes against slatelike masses of black.

The artists' intention in using the incantatory Whitman intertitles may never be known. Jan-Christopher Horak argues persuasively that the titles were very carefully and meaningfully wedded to the film.[33] Whitman's poetry had been put to the service of a nativist American

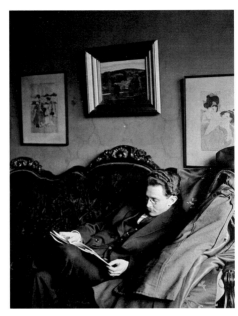

Fig. 34. Charles Sheeler, *Schamberg Seated with Utamaro Prints*, c. 1915-16, gelatin-silver print, The Lane Collection.

avant-garde impulse three years earlier in Robert Coady's short-lived publication *The Soil*, and it would have been natural for Sheeler and Strand to use it.[34] But it is also possible that they added the intertitles to make an avant-garde experiment comprehensible in popular terms, as a compromise in order to sell it to the Rialto. Sheeler himself has never been directly quoted on the matter, but there is some evidence that he might have felt misgivings about the Whitman intertitles. In an intriguing review of Victor O. Freeburg's book *Pictorial Beauty on the Screen*, for *The Arts* in 1924, Sheeler expressed disdain for the use of this kind of verbal text to carry the flow of the visual medium:

> *Almost invariably in the motion pictures which have been produced today, with which we are familiar, there has been little or no evidence of conscious effort in the directing mind to create a picture with a visual significance quite apart from the service of the story. ... Until ... a motion picture has been conceived and produced, detached from plot and captions, we cannot hope to see fully the realization of the motion picture as a new channel for the expression of visual forms.*[35]

Sheeler was responsive to certain aspects of Freeburg's book, particularly its argument against supporting verbal texts in silent films. Yet Sheeler wrote that Freeburg "seems to over-estimate the desirability of the continuous optical ease of the spectator." Sheeler concluded — perhaps tellingly for *Manhatta*'s audience — that Freeburg's ideas are "directly related to the present type of commercial film, which from the necessity of a wide distribution, must still be fettered to a plot."

Why or even when Sheeler stopped making films is unclear. After *Manhatta*'s premier, he apparently was excited enough about filmmaking to pursue a plan to make slow-motion pictures of athletics for an advertising agency with Strand, but the results are not known. *Half Nelson*, a singular drawing that Sheeler later destroyed, might well have resulted from such a venture. The closely cropped image of two wrestlers is framed much like Sheeler's nudes and appears on stylistic grounds to have been based on a film still.[36]

Shortly after completing *Manhatta*, Sheeler began working as a still photographer for *The Arts*, a position that would bolster his career and widen his increasing separation from Stieglitz and Strand. As early as September 16, 1920, just as *Manhatta* was being finished, Stieglitz responded to a letter from Strand, writing: "What you wrote about Sheeler is true as I see it too. It's really pathetic. New York is certainly a blood-sucker."[37] Obviously the partnership between the two film-makers was less than perfect at this point, but there is no way of telling exactly what Stieglitz was referring to. A year later, in another letter to Strand, Stieglitz said of de Zayas's plan to show the film in Paris: "All I fear is that Paris will know the film as Sheeler's work even if you are originally mentioned. It will be Sheeler and Strand. And then Sheeler." Stieglitz concluded this letter with this remarkable statement: "It's one of those ticklish questions when one of the 2 is 'artist' and the other only photographer!"[38]

The question of which photographer deserves credit for what parts of the film seems unanswerable at this time. There is an underlying sense, in much of the relevant correspondence and in other statements, that Sheeler was somehow both the initiator and the senior

partner in the project;[39] but on the other hand, much of the work in the film is stylistically closer to Strand's earlier work than to Sheeler's. In 1922, *Vanity Fair* featured five stills from the film, giving credit to both Sheeler and Strand. Yet as early as 1920, Sheeler felt free to use one of the stills for his painting *Church Street El*. And it was Sheeler who printed the fifteen others that remain in his estate. Apparently Strand never printed any stills from the film and none exist in his estate.[40]

Sheeler's experiences with *Manhatta* led him to further explorations of New York. One group of prints features the Park Row Building, which appears in the film. With his view camera he could improve considerably on the clarity and subtlety of the print, in comparison to the film, and he switched to the vertical format he always favored. In a remarkable series of seven images taken from the Equitable Building (see cat. nos. 34-37), Sheeler used the still camera slowly to pan across an area, seen in the film, extending from the Woolworth Building at Barclay Street and Broadway — eight blocks away, though it seems much closer in the photograph — and as far as the Liberty Tower (55 Liberty Street), just four blocks distant. The Park Row Building is included in every image, sometimes playing a major role in the composition and sometimes a minor one, and it acts as a fulcrum around which the series develops. Its superb abstract shape must have particularly appealed to Sheeler: seen in early morning light, it consists of three equal narrow vertical elements, the left one full of windows, the center a black void, the one on the right a blank gray stripe with one tiny window near the bottom (see cat. no. 35). In each print, the Park Row Building assumes a different relationship to the abstract whole. These photos are about the abstract effects of strong sunlight and deep shadows and the extraordinary urban richness of New York's buildings; they are a far cry both from the romantic evocations of Stieglitz's New York photos and the deliberately flattened, linear effects of Strand's.[41]

In 1922 Edward Weston visited New York and met Sheeler at the suggestion of Stieglitz. Weston was deeply impressed with Sheeler's "dignified, austere" photographs. He wrote in his daybooks, "The 'N.Y.' done by Charles Sheeler had a genuine grandeur, nobility." Weston called the series "a remarkable 'portrait' of New York, the finest architectural photographs I have seen." While he found Strand's work derivative of Stieglitz's, he perceived in Sheeler "no attempt to force attention by clever viewpoint. He didn't try to be different — he was."[42] Sheeler gave Weston one of the New York prints; their friendship began here and was to be lifelong.

Following the closing of the De Zayas Gallery in 1921, Sheeler accepted a long-standing offer to exhibit his work at the Charles Daniel Gallery, which had attracted such key painters as John Marin and Marsden Hartley after the demise of "291." Though photography did not interest Daniel particularly, Sheeler's exhibition there in 1922 included photographs as well as paintings and drawings, presumably at Sheeler's request. This show consisted of sixteen works, including the oil *Skyscrapers* (1922; Phillips Collection, Washington, D.C.), another view of New York, several still lifes, and "seven of his very remarkable photographs," according to the *American Art News*.[43] One of these prints, which was described as "extraordinarily like a fine pencil drawing," was a view of "an old barn," and another was probably *New York, Park Row Building* (cat. no. 35). The *New York Times* described Sheeler's photographs as the "last word in selective fact" and "quite at the top" but judged that Sheeler's drawings made the photographs "stiffen" and concluded that "no one who loves photographs … will bring them anywhere near these drawings by Charles Sheeler."[44]

While Sheeler had long thought his photographs were akin to his drawings, he quickly discovered he could become vulnerable to comparisons that actually pitted one medium against the other. McBride had found his photographs "more dominating" in the De Zayas show of 1920; now the *Times* critic, taking an opposite stance, used the exhibition to perpetuate a widespread prejudice against photography.

Sheeler was in a difficult position. On one side, critics drawn to paintings and drawings could use these to dismiss his photography, as the *Times* did; on the other side, there was little support amidst the Stieglitz group for his symbiotic investigations. Stieglitz advocated the divorce of photography from the other visual arts. As Strand maintained in 1921, early photographers "did not understand their material" and tried to imitate painting without realizing that "photography could negate ninety-nine percent of what was, and still is, called painting."[45] Sheeler, however, went on making direct and objective photographs that remained truly photographic, while also using them as a basis for further investigation in paintings and drawings.

Surprisingly, perhaps, it was Georgia O'Keeffe, the painter most closely identified with Stieglitz (and also married to him), who grasped the subtlety of Sheeler's dual pursuit and voiced a thoughtful and eloquent defense on his behalf. This came in response to the December 1922 issue of the short-lived publication *MSS.*, in which Stieglitz and Strand engaged the better part of the New York intellectual community in debating the question "Can a Photograph Have the Significance of Art?" In defense of Sheeler, O'Keeffe wrote:

No one considering his work questions [Sheeler's] paintings and drawings as ranking among the most interesting of their type in America today. To me his photographs are of equal importance. He is always an artist. He has done things with photography that he could not do with painting and vice versa.[46]

Sheeler himself was asked to enter an opinion on the status of photography but wrote that his photographs "best express my opinions." De Zayas also contributed, defending his old friends and claiming that "outside of what [Stieglitz] and Sheeler have done in photography I find the rest quite stupid."

Perhaps it was the *MSS.* debate that generated the piece by Thomas Craven in *Shadowland* three months later, for Craven made Sheeler the paramount test case for the status of the camera. Sheeler, he said, "advances the theory that photography, while different from painting in many of its aspects, is equally important and beautiful. An expert in both departments, he speaks with authority." But

Craven came down on the side of Sheeler's paintings, finding his photography "not emotionally exciting." Comparing his oil *Skyscrapers* with the related photograph, Craven said the painting conveys "a certain linear precision, and remarkable range of tonal contrast which suggest the photograph; but the beauty of the painting lies in the design, in the imaginative reconstruction of the basic planes to produce a new form stronger than the literal object of the negative."[47]

There were very few critics like McBride, who, judging painting and photography equally as art, saw no reason to divorce them and also understood the special qualities of each medium. In his review of the spring exhibition of the Salons of America at the galleries of the American Art Association, McBride praised Sheeler's New York photographs and said it was "a pity" that they were not grouped with paintings of like themes by George Ault, Bertram Hartman, and Wood Gaynor. Sheeler's photograph of a Pennsylvania barn (probably *Side of White Barn)* was to him "one of the most noteworthy productions in the history of photography" and McBride felt no reluctance in comparing its "passionate insistence on composition" with Cézanne once again.[48]

In the May 1923 issue of *The Arts*, Sheeler reviewed a show of Stieglitz's photographs that had opened April 2 at the Anderson Galleries.[49] This was the first of several pieces Sheeler would write for the magazine, and it was given prime placement. It had been announced in the previous issue, in April, with a notice on the title page: "Mr. Sheeler will discuss the art of Stieglitz with the sympathy of a friend and with the knowledge of a skilled photographer of the first order." Yet when the review appeared, it triggered a final break between them. The gallery exhibited 116 works by Stieglitz, ranging from portraits of friends and artists, including O'Keeffe, to landscapes and his famous cloud series.[50] Sheeler's review was full of praise, but Stieglitz was angered by its suggestion that his platinum prints possessed a "material preciousness," comparable to gold leaf in Italian painting. Stieglitz objected both to having his work called "precious" and to having his photography compared to painting. In the piece, Sheeler also compared Stieglitz's cloud photographs to "the landscapes of

Mantegna" and suggested that in *The Hay Wagon* (1922) "now and again there reappears a trace of the Munich tradition of painting." For Stieglitz, photography had to be an independent medium; as he saw it, any connection between painting and photography smacked of the pictorialists, and thus Sheeler's remark was insulting and destructive. As he declared, "ART OR NOT ART THAT IS IMMATERIAL THERE IS PHOTOGRAPHY."[51]

The Stieglitz camp reacted to the review angrily and publicly. Arthur Boughton attacked Sheeler in a letter to the *New York Sun and The Globe* of June 20, 1923 ("Mr. Sheeler … gives photography's case away by comparing it with Mantegna").[52] Paul Strand wrote a similar letter, which appeared in the same paper on June 27, speaking of the "irrelevance of the ever present comparison of photography to a totally different medium," and of "Mr. Sheeler's errors and omissions" regarding platinum paper."[53] Stieglitz himself wrote to Strand: "Sheeler has something wrong about me in his make-up and has had for some time," and he called Sheeler's attitude "small and ugly."[54] Stieglitz must have been keenly aware of Sheeler's growing reputation and his critical successes in these years. The very issue of *The Arts* that carried Sheeler's review of Stieglitz also featured a long, laudatory article by the editor, Forbes Watson, on Sheeler and his paintings, and all this must have added fuel to the fire.

Sheeler had first worked for *The Arts* in 1921, when his photograph of an early Gothic Madonna, made for de Zayas, provided the frontispiece (and was specifically mentioned in Watson's editorial). Sheeler and Watson became close friends and Sheeler's photographs and paintings appeared frequently thereafter, reaching a high point in 1923. In January of that year, the Arts Publishing Corporation advertised the sale at a 20 percent discount of "Photographs of Modern Painting and Sculpture and of the Masterpieces of African Art by Charles Sheeler." Sheeler was credited for nine photographs of modern works in the Albert Barnes Collection in January and February; in March, eight of Sheeler's photographs of African sculpture, including three Dan masks (cat. nos. 3, 4, and 5) were reproduced for the article "Negro Art," by Marius de

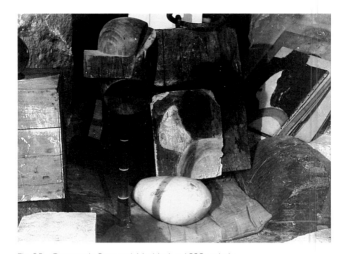

Fig. 35. Constantin Brancusi, Untitled, c. 1923, gelatin-silver print, The Lane Collection.

Fig. 36. Charles Sheeler, *Ritz Tower, New York,* c. 1925, gelatin-silver print, Courtesy Robert Miller Gallery, New York.

Zayas. Four photographs by Sheeler of Brancusi's sculpture appeared with an article on the Rumanian artist in July along with Brancusi's own photographs of his work and Paris studio. Nine of Sheeler's photographs illustrated the article "New Architecture in New York," by Charles Downing Lay, in August; leading them off were two important works from the New York series, including *New York. Temple Court* (cat. no. 37). There were also views of the New York Public Library, the Singer Building, and the Hotel Ambassador, among others. These articles and accompanying illustrations were used to promote the sale of back issues the next year; Watson's piece on Sheeler was identified on a September 1924 list of those articles "in which our readers have indicated more than usual interest."

Sheeler's activities as photographer, artist, and exhibition organizer on behalf of the Whitney Studio Club were also duly reflected in *The Arts*. He provided photographs for the catalogue of an exhibition of early American art that was organized by Henry Schnackenberg in February 1924; several of his photographs of the works appeared with *The Arts* review the next month. *The Arts* provided coverage for the exhibition of works by Picasso and Duchamp that he organized at the Whitney Studio Club, which followed his own show of paintings and drawings. His photographs of works in de Zayas's exhibition of Greek art at the Whitney Studio Club were reproduced with Sheeler's own review of the show in March 1925.[55]

When Brancusi came to New York for an exhibition of his work at Wildenstein Galleries (January-March 1926), he visited the Sheelers on 8th Street and "we mounted and framed his drawings at my place," according to Sheeler.[56] Sheeler also photographed Brancusi several times and Brancusi gave him a print depicting the sculptor's studio, inscribing it "C. Brancusi à Sheeler" (fig. 35).

His break with the Stieglitz circle led Sheeler into closer association with other prominent photographers who had also fallen out with Stieglitz. Among them were Edward Steichen, who would hire him at Condé Nast, and Clarence White, a follower of Arthur Wesley Dow and Max Weber. White invited Sheeler to exhibit his photographs in Paris in 1924[57]

and gave him a one-man show of photography at the Art Center in New York in 1926. The Art Center provided the showcase for the Pictorial Photographers of America, an organization that White had founded and hoped to expand nationally and internationally, with regular exhibitions in an ever-growing number of cities. Although its soft-focus tendency differed significantly from Sheeler's style, the group was not doctrinaire in its stance, and it embraced commercial photography as a creative art, a pursuit that engaged Sheeler himself. Sheeler became fairly active within the Pictorial Photographers of America group, sitting on exhibition juries in 1926 and 1929. A non-elitist, open-ended organization that met monthly at the National Arts Club, it maintained cordial relations with some of Sheeler's strongest partisans, such as Steichen and Frank Crowninshield, who as art editor of *Vanity Fair* wrote favorably of Sheeler's work.

The mid-twenties marked something of a dry spell for Sheeler, though he did produce a handful of his most beautiful drawings (mostly still life subjects in conté crayon) and the first major painting of the inside of his house (*Interior*, 1926; Whitney Museum of American Art, New York) in these years. De Zayas and the Arensbergs had left New York, John Quinn's collection was sold after his death in 1924, and the Daniel Gallery apparently offered Sheeler no further exhibitions after 1922. Now married to Katharine, Sheeler supported himself during this period with freelance commercial work, much of it done through N. W. Ayer and Son, the major Philadelphia advertising firm. Stieglitz, of course, objected to anything that might put the purity of photography at risk, but in the inflationary economy of the twenties even the best artists took up commercial work. Thus, Paul Strand turned to portraiture and advertising, he and Sheeler frequently looking for jobs together,[1] and Edward Steichen went to work as chief photographer for Condé Nast Publications in New York in 1923. Sheeler from the very beginning of his career had used his camera to support himself; he knew how to use commissioned work for the ends intended, and how to learn from it and from the contacts it brought, all without letting it interfere with what he called "my pictorial work."

Sheeler made photos advertising a variety of products during the twenties, including Firestone tires, Champion spark plugs, and L. C. Smith typewriters, and he also did work for the Kodak Company.[2] His photograph of a gleaming black typewriter (fig. 37) is particularly strong, and his work for Kodak — with whose products he was most familiar — was unusual and effective. In one example, (cat. no. 41), he illustrated one of the new Kodascope Model C 16-mm. movie projectors,[3] introduced in 1924, with a pair of graceful female hands — perhaps, as his audience then would have understood it, to suggest the projector's simplicity and ease of use. The delicate hands recall Stieglitz's photographs of Georgia O'Keeffe, and the complex shadows on the background wall are typical of Sheeler's own use of strong lighting and shadows in such prints as *African Musical Instrument* (fig. 14) or *Chinese Bodhisattva* (fig. 11).

Fig. 37. Charles Sheeler, *L. C. Smith Typewriter*, 1924-28, gelatin-silver print, The Lane Collection.

sionally opera stars, athletes, and authors. Sheeler photographed Norma Shearer (fig. 39), Theodore Dreiser, the boxer Georges Carpentier, Brancusi, Lunt and Fontaine, and Aldous Huxley; he also did some truly vulgar features, such as "Ann Pennington Struts a New Step – A Dance Up From the Levee – 'The Black Bottom.'"

Sheeler's *Aldous Huxley* (cat. no. 42) is perhaps the strongest of the Condé Nast photos: here the photographer apparently enjoyed being with the sitter, and the composition, with its strong value contrasts and the abstract vertical element to the right, is highly effective. At his best, Sheeler successfully emulated the standard Condé Nast style, developed by the firm's first photographer, Baron Adolph de Meyer, and brought to its height by de Meyer's successor, Edward Steichen. This mode called for theatrical lighting, high contrasts, and a polished and glamorous look. Steichen's subjects look beautiful and completely confident; there is no hint of vulnerability or mortality. The shy, intelligent Sheeler, an artist and a perfectionist, must have been ill at ease with all this constant dealing with the superficiality of appearances, and many of his sitters in turn look wooden and somehow uncomfortable.

In January 1927, after less than a year at it, Sheeler wrote his friend Walter Arensberg, "I know little or nothing but my job which by this time has come to be like a daily trip to jail. It continues just as strenuous as ever, and more irksome." He went on to point out that the advertising work was not nearly so bad in comparison: "Besides I have been doing quite a bit of work for advertising, architectural subjects, which comes nearer being of interest than whether they are wearing the bow on the right or left side this season."[8] Nonetheless, he remained on the Condé Nast staff until about May 1929, when he left to prepare for his trip to Europe.

On October 25, 1927, Sheeler wrote Arensberg from Detroit about a new photographic commission he was just undertaking: "A few weeks ago N. W. Ayer & Son, who have recently taken on the Ford account, told me that they had proposed that Edsel Ford engage me to come out to Detroit

Early in 1926, Sheeler was asked by his friend Edward Steichen to join him on the staff at Condé Nast.[4] This appointment was doubtless approved by the publisher, for Sheeler had long been a favorite of Nast's. As early as August 1917, *Vanity Fair*, one of Nast's magazines, had reproduced a Sheeler photograph of a Brancusi sculpture; the May 1920 issue illustrated *Zinnia and Nasturtium Leaves* (cat. no. 7), along with a laudatory caption: "Mr. Sheeler has repeatedly verified, with the wholly impersonal lens of the camera, the existence in nature of rhythmic and emotional forms which the public has all along thought of as being mere inventions of the painter."[5] One of Sheeler's 1920 photographs of the Park Row Building was captioned "Cubist Architecture in New York" in the same magazine in 1921; the painting *Church Street El* was illustrated later that year, five stills from *Manhatta* in 1922, and a Doylestown house print in

1923.[6] Also in 1923, in the March *Vanity Fair*, Sheeler was included with Hartley, Marin, and others in an article entitled "Among the Best of American Painters." The piece was illustrated with Duchamp's photograph of a thoughtful-looking Sheeler, the caption identifying him as "a distinguished modern, whose art has early American roots."[7]

Once on the staff, Sheeler devoted much of his time to Condé Nast: between April 1926 and June 1929, when his regular employment there came to an end, he contributed about sixty photographs to the pages of *Vanity Fair* and more than ninety to *Vogue*. The *Vogue* pictures are nearly all of fashionable, well-dressed women; some of the best ones portray Margaret Kahn (the daughter of Otto Kahn), Marilyn Miller, and Mrs. Oliver Iselin with her two children. The subjects he photographed for *Vanity Fair* were celebrities of all kinds, with an emphasis on actors and actresses and occa-

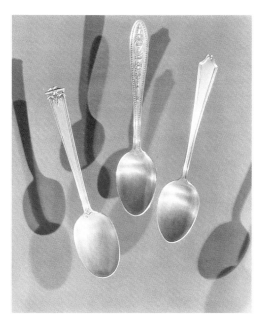

Fig. 38. Charles Sheeler, *Spoons*, 1924-28, gelatin-silver print, The Lane Collection.

Fig. 39. Charles Sheeler, *Norma Shearer*, 1926, gelatin-silver print, The Lane Collection.

and make an extensive collection of pictorial photographs of the plant."[9] The "plant" was the Ford Company's mammoth manufacturing facility southwest of Dearborn, Michigan, about ten miles from Detroit. It lay near the Rouge River, which gave it access by water to the Great Lakes ports and to the Atlantic via the St. Lawrence seaway, and thus the factory was often called "River Rouge," or simply "the Rouge." Sheeler found the Rouge to be an "unbelievable establishment" and reported to Arensberg that "it defies description," concluding, "The subject matter is incomparably the most thrilling I have had to work with."[10]

Sheeler's subject was at the time "the largest industrial complex in the world, as well as the most advanced, architecturally and technically."[11] But other companies had plants nearly as large; the revolutionary quality of the Rouge lay in Ford's conception of it as complete and self-sufficient in terms of automobile manufacture. Ford "saw the larger relationship of iron, lumber, water power, coals; rivers and railroads; power plants, foundries, assembly units."[12] The company owned ore mines, sources for lumber and limestone, and coal mines; "raw materials were carried on Ford-owned railroad lines, delivered by Ford freighters, and processed at the Rouge steel mills for use in factory construction and automobile manufacturing."[13] Moreover, the plant, most of it designed by Albert Kahn, was unique in its form, its cleanliness, and its airy, well-lit quality. Begun in 1917, the Rouge plant was complete by the time of Sheeler's visit in 1927. Occupying over eleven hundred acres, with twenty-three main buildings and dozens of subsidiary structure, ninety-three miles of railroad track, and twenty-seven miles of conveyors moving raw materials, the Rouge employed about seventy-five thousand people.

Sheeler visited the Rouge at a time of great tension and expectation within the Ford Company. After years of dominating the automobile industry, sales of the Model T had been declining since the banner year of 1923, when 2,120,898 Fords had been sold, or 57 percent of all the cars purchased in America.[14] The noisy, boxy Model T had become outdated; in 1926 its share of the market was down to 34 percent and falling. After considerable internal struggle within the company, with Henry Ford

resisting and his son Edsel Ford, now president of the company, pushing for change, on May 26, 1927, as the fifteen millionth Model T came off the assembly line at Highland Park, it was announced that production of the car would cease. Closing production put sixty thousand people out of work in Detroit alone. Over the summer, the assembly line was moved to the River Rouge plant, where the new Model A would be produced. The new car was made up of six thousand parts, almost all of them new, and the assembly line itself had to be rebuilt and its sixteen thousand machines retooled. For the Ford Company, this was a calculated gamble; losses during 1927 amounted to $30 million, and the company's future rested on public acceptance of the Model A.

During the summer and fall of 1927, the company mounted a large-scale, shrewdly timed promotional campaign designed by the Ayer advertising firm and led by Henry Ford himself, designed to create widespread public interest in the new car. Its appearance and specifications were kept secret, and "in the last few days prior to the unveiling, a $1.3 million advertising campaign had whipped up excitement still further."[15] In the end, the Model A proved a great success. When it was unveiled on December 2, "100,000 sightseers mobbed Ford's exhibits in Detroit"; for its showing in New York, Ford had to hire Madison Square Garden to accommodate the crowds, and by Christmas 1927 the company had received nearly a million firm orders (with cash deposits) for the new car.[16]

Most of Sheeler's advertising work was commissioned by Vaughn Flannery, the talented, dashing advertising man who at the age of twenty-five had become art director of N. W. Ayer & Son, a position he held from 1923 to 1930. The Ayer firm was Philadelphia's oldest and largest advertising agency, with offices around the world. Its specialty was low-key, generic ads and it frequently employed fine artists (N. C. Wyeth and Rockwell Kent were among many who made Steinway ads for them at this time).[17] Flannery was a painter himself and later showed his work at the Kraushaar Gallery in New York. He admired Sheeler's photography, and after his firm won the Ford account in 1927, it was Flannery who

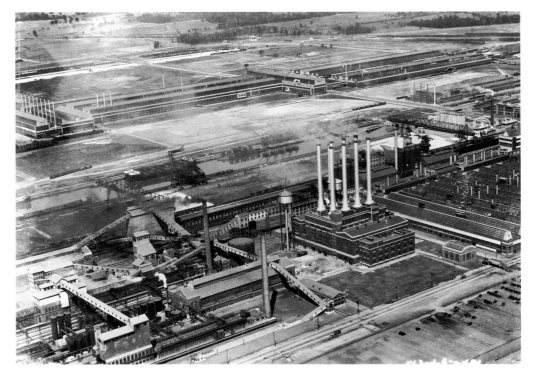

Fig. 40. Unknown photographer, aerial view, Ford Motor Company's River Rouge Plant, 1931, from Collections of Henry Ford Museum, Greenfield Village, Mich.

Fig. 41. Charles Sheeler, *Coke Oven Area – Ford Plant*, 1927, gelatin-silver print, The Lane Collection.

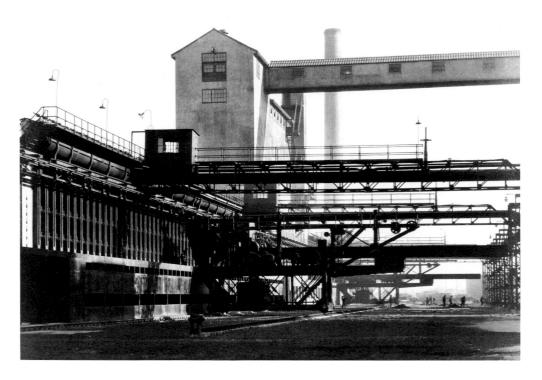

conceived the idea of commissioning a series of photographs of the River Rouge plant from Sheeler. According to Susan Fillen-Yeh, the two men were friends and together often visited the great art collection of Dr. Albert C. Barnes (some of which Sheeler had photographed) in Merion, Pennsylvania.[18] The Rouge project was a small part of the huge promotional and advertising campaign that Flannery and his firm organized during 1927. Sheeler wrote to Walter Arensberg on October 25, "My program as mapped out now will consist of photographs of details of the plants and portraits of machinery as well as the new Ford (take my word for it and order one now) and also the Lincoln."[19] Flannery must have known that Sheeler was perfect for the job. He was a great photographer, especially gifted when it came to architecture, his speciality, and he also loved automobiles. A year later, while still working for Flannery on the Ford account, Sheeler photographed the new Lincolns and then bought one. As he wrote Arensberg, "To sit at the wheel is a revelation. It is to begin over again. The feel and sound of the engine is something to wake up on the middle of the night and think about." He concluded, "My pleasure in it is akin to my pleasure in Bach or Greco and for the same reason – the parts work together so beautifully."[20]

Sheeler shared with his pre-Depression generation a love of machinery, faith in the efficiency and leadership of American industry, and a belief that the efficient and the practical would be naturally beautiful. He had been a pioneer in the previous decade in evolving a style for one art (his photographs) out of another art (African masks); in developing a home-grown modernist style from his Doylestown house; in making the first American films of their kind in the ones devoted to Katharine and New York. Now, at the Rouge, he gave profound expression to the values of the machine age, and in so doing he affected the way photographers and painters would see American industry for two subsequent generations. He did so thoughtfully and openly, writing:

Every age manifests itself by some external evidence. In a period such as ours when only a comparatively few individuals seem to be given to religion, some form other than the Gothic cathedral must be found. Industry con-

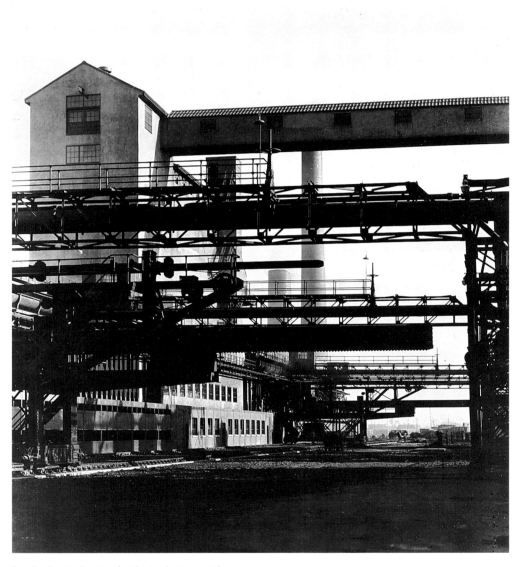

Fig. 42. Charles Sheeler, *Coal Bunker Building and Coke Ovens – Ford Plant*, 1927, gelatin-silver print. Museum of Modern Art, New York, Gift of Samuel M. Kootz, 400.42

cerns the greatest numbers — it may be true, as has been said, that our factories are our substitute for religious expression.[21]

Sheeler's mandate was to photograph "details of the plants and portraits of machinery," and this is exactly what he did. Flannery must have already discovered that overall views of the huge plant, even aerial ones, were ineffective (see fig. 40). Nor did he want pictures of the workers and the assembly line itself, perhaps because they would be too individualistic, too revealing about the long, endlessly repetitive labor involved in producing the car. In the weeks before the Model A was introduced, when the plant was operating at a chaotic fever pitch in an effort to produce the first models on time, Flannery needed photographs of calm industrial grandeur that would express the nature of the enterprise as Ford wanted people to see it — as "one huge, perfectly timed, smoothly operating machine."[22] The photos were not to be used in advertising for the car as such, but rather were for internal and external use in promoting a generic image of Ford as a quiet colossus, as *the* great American machine. Flannery seems to have kept Sheeler away from both the car itself and the production line, encouraging the idea of a kind of virgin birth, the notion that the Model A had suddenly and miraculously appeared out of this majestic place, perfectly formed, without pain or labor. This was in keeping with Ford's overall marketing strategy for the new model, which was kept shrouded by the dealers until it could be dramatically unveiled on December 2.

After being at River Rouge for just a few days, Sheeler took several photographs. He reported to Arensberg, "Today as an appetizer I showed them several proofs of the photographs I have made so far and they went over very big. It's really a job made to order."[23] His aim — to find unsuspected form and abstraction in architecture (which, though manmade, he treated as natural form) — coincided with Flannery's purposes. As with other series, he apparently began on the outside with larger views of buildings such as the Production Foundry (cat. no. 43), the world's largest foundry at that

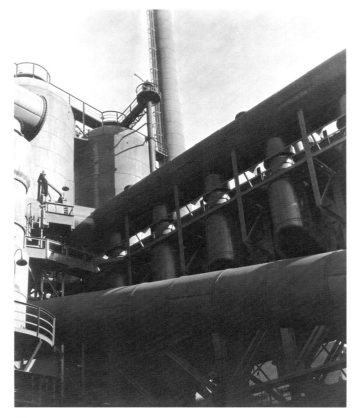

43

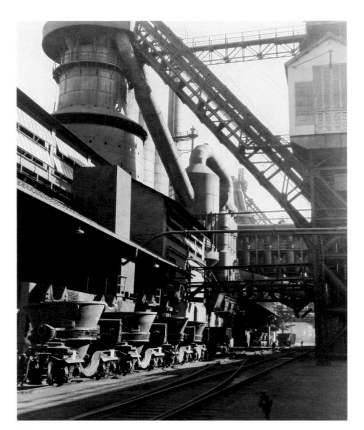

45

44

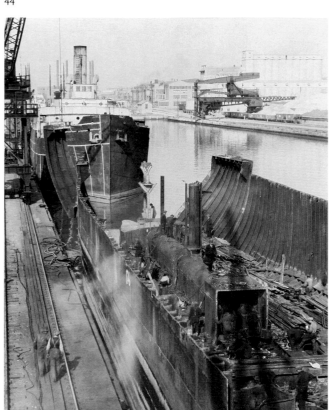

46

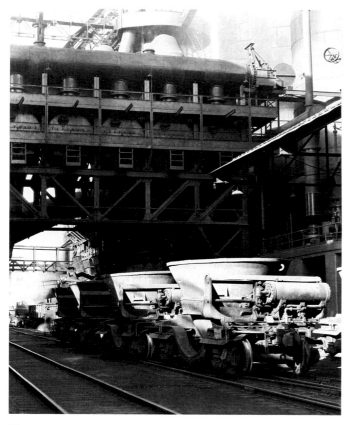

47

48

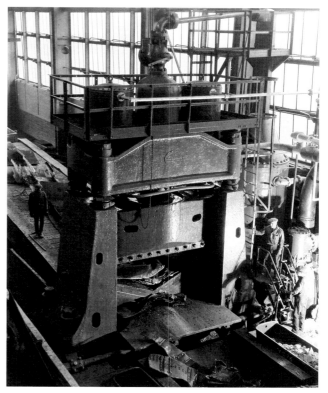

49

Fig. 43. Charles Sheeler, *Gas Mains – Ford Plant*, 1927, gelatin-silver print, The Lane Collection.

Fig. 44. Charles Sheeler, *Salvage Ship – Ford Plant*, 1927, gelatin-silver print, The Lane Collection.

Fig. 45. Charles Sheeler, *Slag Buggies and Blast Furnace – Ford Plant*, 1927, gelatin-silver print, The Lane Collection.

Fig. 46. Charles Sheeler, *Canal with Salvage Ship – Ford Plant*, 1927, gelatin-silver print, The Lane Collection.

Fig. 47. Charles Sheeler, *Row of Slag Buggies Under the Blast Furnace – Ford Plant*, 1927, gelatin-silver print, The Lane Collection.

Fig. 48. Charles Sheeler, *Boiler with Electrical Control Panel – Ford Plant*, 1927, gelatin-silver print, The Lane Collection.

Fig. 49. Charles Sheeler, *Metal Shear – Ford Plant*, 1927, gelatin-silver print, The Lane Collection.

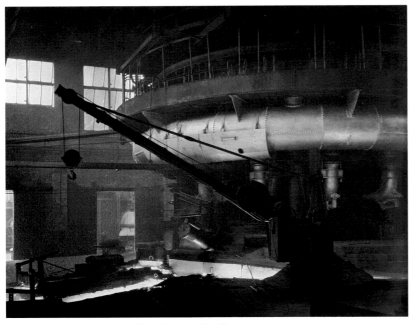

Fig. 50. Charles Sheeler, *Base of Blast Furnace – Ford Plant*, 1927, gelatin-silver print, The Lane Collection.

Fig. 52. Charles Sheeler, *Bar and Billet Mill Motor Room – Ford Plant*, 1927, gelatin-silver print, The Lane Collection.

Fig. 51. Charles Sheeler, *Drive Reducer, Bar and Billet Mill – Ford Plant*, 1927, gelatin-silver print, The Lane Collection.

Fig. 53. Charles Sheeler, *Drive Shaft, Bar and Billet Mill Motor Room – Ford Plant*, 1927, gelatin-silver print, The Lane Collection.

time. A close look at the foundry photograph reveals the word "Ford" on the railroad car at the left, practically the only corporate identification in any of these pictures. Having introduced the subject just as he did with the Doylestown house, and as he would do at Chartres, with a horizontal panoramic view,[24] Sheeler moved in closer and changed to the vertical format that he used for the vast majority of his best work.

The photograph known as *Criss-Crossed Conveyors* (cat. no. 45)[25] has become the best-known of this series, and Sheeler apparently reproduced it in a relatively large edition of four or five prints. Just three months after it was made, this photograph was illustrated in *Vanity Fair* with the caption "By Their Works Ye Shall Know Them." Sheeler of course was still on the Condé Nast staff and must have approved this religious reference, a paraphrase of "By their fruits ye shall know them" from Matthew 7:16. The caption goes on to consider Henry Ford himself "an almost divine Master-Mind," then widens the religious reference by calling the Rouge plant "America's Mecca."[26] Depicting crisscrossing conveyors of coke and coal, with other conveyors receding to the left and the eight tall stacks of Power House No. 1 in the far distance providing a strong vertical element, this print functions – like so many of Sheeler's best compositions – as a strong yet seemingly natural abstraction. The central X-form dominates the image, which seems affirmative, bold, and exciting, and the only uneasy grounding for the viewer lies in the rows of train wheels just barely visible across the bottom of the composition.

The Rouge series includes a number of Sheeler's most dynamic compositions. In *Criss-Crossed Conveyors* the diagonals dominate but are balanced by the more distant verticals. In *Power House No. 1* (cat. no. 44) the same stacks are seen closer up, and they dominate the image while being held in place by the diagonals of the roof below. Even in this simple-looking composition there is a push and pull of elements, as the clouds of steam obscure parts of each stack; below, the dark roof with light banding rises toward the center, falls away sharply, then rises again, while a strong shadow creates another diagonal from the center to lower right. *Blast Furnace and Dust Catcher*

(cat. no. 48) uses the same formula even more powerfully, as a huge vertical thrust is balanced by strong black diagonals in the lower left corner and the upper left, and by the series of diagonals rising vertically through the center of the composition. These three images were in the group of six Rouge photographs that Eugene Jolas published in *Transition* in 1929, where he commented, "The almost puritanical rigidity of his studies should not blind us to the inner force and beauty inherent in them."[27]

Other exterior shots, depicting further "details of the plant," illustrate the huge cranes near the boat slips or the salvage ships lying in the water before being broken up for their steel. Sheeler then turned from the plants themselves to his other mandated subject, "portraits of machinery," with several studies of slag buggies. These first appear in *Slag Buggies and Blast Furnace* (fig. 45), in which a row of buggies on rails anchors the bottom of a vertical composition; a second photograph gives a closer view; then *Slag Buggy* (cat. no. 52) shows just one buggy, providing an evocative portrait of this graceful machine. Sheeler followed his usual compositional practice here, but it is so subtle that one hardly notices the anchoring diagonals of the ties and tracks at the lower right, or the straight black vertical of the lamppost rising in the center. As with many of Sheeler's photographs, the viewer is put off balance here, for it is hard to tell what you are looking at – it might be a real object or a stage set – and equally difficult to determine the time of day, or whether you are indoors or out. The strong shadows read "day," but the soft, murky atmosphere seems to read "dream" or "night." As always, Sheeler begins with reality, leads the eye through several stages of recognition, and ends with a pure and abstract formal beauty.

After shooting about half of the series outdoors, Sheeler moved inside. Here he repeated the process, beginning with large-scale overall views and ending with close-up details. *Ladle Hooks, Open Hearth Building* (cat. no. 51) depicts much of the interior of Albert Kahn's soaring Open Hearth Building of 1925, where two great suspended hooks picked up and poured molten iron from giant ladles into ingot molds. This was a dangerous, hot place, "normally an area of great confusion and clutter,"

crowded with men and machines.[28] But Sheeler chose a moment of inactivity, with only two workmen visible – one in the middle ground, one in the distance – and his view is a serene one. He uses the tracks inventively: one serves as a diagonal coming from the left corner, while the other becomes a perfect vertical element that plays a dual role, leading the viewer into space while also guiding the eye straight up through the left-center of the composition. Parallel to it, to the right, is the main vertical axis, formed by the figure of the man, the giant hook above his head, and its supporting cables. The distant beam completes the cross, its horizontality echoed by the distant windows parallel to it and by a heavy crosswalk at the very top of the picture.

This photograph had immediate appeal. It appeared as the cover illustration for the February 15, 1929, cover of *Ford News*, the company magazine, with the caption "a cathedral of industry." It was published in *Arts et Métiers Graphiques* in Paris in 1930, and again in the United States in 1931.[29] The image seems pure and simple, yet awe-inspiring, and it conveys Sheeler's own sense of industry as something capable of evoking religious feeling. This photograph functions on several levels: as a work of art with strong formal qualities, as an evocation of grandeur and calm, and also as an illustration of how the Ford plant actually looked. It always seems surprising to open a Ford journal and find one of Sheeler's photographs used for its commissioned purpose: today we are likely to assume that an artist cannot please both himself and his patron, especially a patron with its own commerce at heart. Yet Sheeler succeeded on both levels, just as a Renaissance portraitist might have created both a satisfying likeness and a great work of art when painting one of the Medici. These photographs worked for Sheeler, but they also worked well for Ford, and they seem entirely apt when one sees them in Ford publications.

Sheeler closed his Rouge series with several "portraits of machines." *Ladle on a Hot Metal Car* (cat. no. 53) represents another scene in the Open Hearth Building. Here, the hook is seen in use, lifting a massive ladle in order to pour molten iron into the

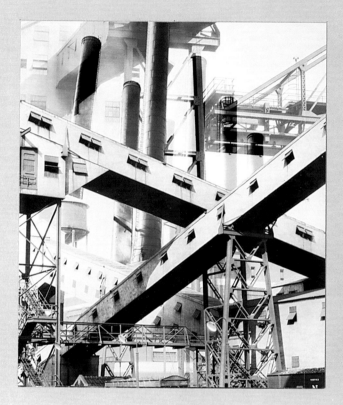

Fig. 54. Charles Sheeler, *Industry*, 1932, gelatin-silver prints, (triptych), courtesy of the Art Institute of Chicago, Julien Levy Collection, 1975.1146.

open hearth furnace. This print is visually extraordinary, for while there is some light visible from the angled row of windows above, in the fire on the left, and on the suspended hook to the right, there is practically none at all on Sheeler's subject at the center of his composition, the ladle itself. Yet out of this darkness comes fact and emotion; as one's eye begins to distinguish one black from another, it makes out a form that seems living and not mechanical, animalistic rather than engineered. Sheeler's reference was inescapable, and when the

photograph appeared in *Ford News* in 1931, one of the magazine writers, E. P. Norwood, labeled it with the caption, "Huge ladles, suggesting prehistoric monsters, disgorge their loads of hot metal."[30] Viewing machinery this way was not foreign to Sheeler, for a few years later he wrote to Walter Arensberg describing "a monster shovel which strips the earth off the coal" that he had seen in Pennsylvania. "It gives one a good idea of what those tall prehistoric monsters were like which could feed on the leaves from the tops of

trees. With the difference that this monster has a Diesel engine for a heart and prefers crude oil for its diet."[31]

Equally suggestive is *Stamping Press* (cat. no. 56), a little-known image that again presents an amazing, sensuous array of blacks. Here a complex machine, a huge pile of gears, wheels, and shafts, towers over a single human being, who seems to peer dangerously into its mouth. Actually the workman is probably repairing or cleaning the die that stamped out fenders — barely visible at lower right — for the

new Model A. This photograph represents practically the only instance in Sheeler's series in which one sees a recognizable automobile part in production, and one of the few showing someone at work. Sheeler was to use this image again in an important way in 1932, when he made a mural design entitled *Industry* (fig. 54) for an exhibition of mural proposals by American artists at the Museum of Modern Art. The design incorporated four of the Rouge photos. The narrow left and right panels are the left and right halves of *Stamping Press*, in both cases cropped at the bottom and along the left edge, while the center panel makes use of *Criss-Crossed Conveyors*, cropped a little on the left and with the background stacks removed, then overlaid with the blurred stacks from *Power House No. 1* and, faintest of all, with a reverse image of *Pulverizer Building* (cat. no. 46). The large panels produced for the 1932 show were destroyed, but the small study, originally owned by Julien E. Levy, survives.[32]

Sheeler's Rouge series is almost equally divided between exterior and interior views, and between details of the plants and portraits of the machines. Whether by personal inclination or by mandate from his employers, he stayed away from the two largest and in a sense most important structures at the plant, the Motor Assembly Building and the "B" Building, housing the famed assembly line, 340 feet in length, which could produce over a million cars a year. In his exterior views, Sheeler concentrated instead on the early stages in the auto-making process – the salvage ships, cranes, coke ovens, conveyors, slag buggies, and especially the blast furnaces – all of which had to do with steel-making rather than with automobiles as such. And he followed the same pattern inside the plant, paying most attention to the heavy machinery in the Open Hearth Building, the Blast Furnace, and the Bar and Billet Mill. Henry Ford was particularly proud of the company's self-sufficiency, as represented by its steel-manufacturing capacity, and one goal of the promotional project undertaken by Sheeler may well have been to emphasize this fact. Equally likely, however, is that the dense, crowded, always busy assembly line simply wouldn't show the sublime industrial might that the company wanted to

Fig. 55. Charles Sheeler, *Ford Trimotor Airplane*, 1928, gelatin-silver print, The Lane Collection.

demonstrate, no matter who the photographer was.

Sheeler's thirty-two Rouge photographs are known today from twenty-eight original prints (many are found in only one surviving vintage print, while for a few images there are two or more prints); two images are known through copy negatives at Ford, and two from contemporary publications.[33] Ford's original set, apparently the only complete group Sheeler made, has been lost, and, altering his normal practice, he did not retain either a master set of prints or the negatives themselves.

On January 11, 1928, Sheeler wrote Arensberg again, saying: "I have my collection of Ford photographs about finished and will probably proceed to Detroit the latter part of next week. To deliver the photographs to Edsel in person and to increase the collection.[34] It thus appears that he spent about six weeks at the Rouge, finishing around December 1,

1927, then returned home for another six weeks of printing and darkroom work before returning to Dearborn late in January. In the same letter, Sheeler added: "In addition to the group of pictorial photographs I photographed the new car both in Detroit and in New York since my return. These have been appearing in the rotogravure of the Sunday papers." Thus Sheeler clearly distinguished between his "pictorial work" – his art – and his purely commercial or illustrated work. Moreover, on this second trip to the Rouge he may well have taken more photographs, as suggested by his letter. This may well have been when he photographed the new Ford Tri-Motor plane, which was then in production in the Stout Engineering Building at Dearborn. His photos of this plane with a large "7" on its tail, are in the Lane Collection (see fig. 55).

On one of his two trips to Dearborn, Sheeler made a number of other photographs,

which do not survive today in their original form but which are known because Sheeler subsequently employed them in developing compositions for paintings and drawings. Thus, Sheeler surely used two different photographs of the cement plant silos for two major paintings of 1930, one for *American Landscape* (Museum of Modern Art, New York) and another for *Classic Landscape* (Coll. Mr. and Mrs. Barney A. Ebsworth, St. Louis). One photo would have viewed the silos from the west shore of the boat slip, while the photograph for *Classic Landscape* presented a closer view of the railway tracks. In both cases, the images are more panoramic and wider in scope than any of the Rouge series prints; it seems doubtful that the two original photographs were ever considered by Sheeler to be part of that series, and he may well have made them, perhaps on this second trip, with the possibility of paintings in mind. Similarly, he would have used a photograph for the picturesque Rouge scene called *River Rouge Plant* (1932; Whitney Museum of American Art, New York),[35] and which depicts the northeast corner of the boat slip where coal was processed. As with the two 1930 paintings, in this case the scene most likely made a better painting than it did a photograph, and Sheeler doubtless recognized this. A fourth missing photograph would have been Sheeler's source for the painting *City Interior* (1936; Worcester Art Museum), and other photographs were used for two closely related conté crayon drawings of 1931, *Smokestacks* (The Lane Collection) and *Ballet Mechanique* (Memorial Art Gallery, University of Rochester, New York).[36] These last three images, unlike the ones discussed above, are perfectly consistent in terms of composition with the Rouge series as we know it, and the original photographs could have been part of that group. Thus in the end (as with earlier series) it seems impossible to reconstruct with complete certainty the original group of images as planned by Sheeler, in this case because it is likely that some important prints are now lost.

Sheeler's photographs of the River Rouge plant might make him seem very much the realist, but of course he was not: the structure of each composition was based on observed reality, just as it was for almost every painter or photographer of the period, but Sheeler always went on to dissect form, to discover and then elucidate what others had carved or built. Henry Ford built one plant, but Sheeler photographed another. In Ford's plant thousands and thousands of workers built automobiles in a crowded, tense, dangerous atmosphere, in what even friendly historians called "a place of fear," where the steel operation never functioned efficiently, and where the Model A provided only temporary respite against the competition from General Motors.[37] The Ford plant – like Sheeler's Doylestown house, like Chartres – existed only to become grist for his mill, form for his unparalleled eye; his plant is idea, abstraction, serenity, the exquisite balance of palpable structure, of lights and darks, the exploration of every tonal nuance. Using building blocks left by others, he discovered new architectonic forms. All of Sheeler's photographs function on several levels, just as the Rouge photos do, because he invested each work with three or four layers of meaning, beginning with the elemental reality – the place or machine – going on to the composition that he "found," the tonal range he determined, and finally to the mood or spirit of the individual work of art. Sheeler can be called a realist or a cubist, a romantic or a classicist, and each term is as helpful, or as unhelpful, as the last.

Sheeler's Rouge photographs were apparently never exhibited as a group, but nonetheless they had a profound impact. Though industrial sites had long been photographed, these images provided a new standard, a new way of seeing this subject, and they were widely emulated. Singly or in small groups, they were published and republished in America and Europe. And certain scholars and critics responded very strongly. For example, Samuel Kootz, then a young art critic and historian and later a distinguished dealer of abstract expressionism, wrote an article on the "Ford Plant Photos of Charles Sheeler" in 1931, noting the personal, anthropomorphic quality of Sheeler's interpretation: "The steel is pure, unornamental, faithful to its utilitarian purposes. Its ductile forms, at times slender, straight, virginal, change with rapid tempo into brutal, clutching, crashing symbols of power." In conclusion, Kootz said: "The language of art is always dominant in these Ford photographs.

The fine drawing, the athletic tenseness of line, the plastic sequences, the exquisite textures, the intricate rhythms, are as sure, as conscious, as the best modern painting."[38]

V

Chartres

Charles and Katharine Sheeler sailed for Europe at the end of April 1929. After landing in England, they traveled immediately to France, where they spent about six weeks before touring Germany. Sheeler enjoyed the Louvre and other sights of Paris, but, as he wrote in a letter to Walter Arensberg, "The outstanding experience in France was the realization of a wish of long-standing to see Chartres."[1] He went on to say, "I never expect to get over that, at least I am hoping I won't." Using his portable view camera and two boxes of French glass 3¼-by-4¼ inch plates, he made twenty-one negatives, from which he later printed a series of fourteen images of the cathedral.[2]

Chartres in many ways would seem to be a surprising subject for a modernist at this time. Admiration for the Gothic style, after all, was typical of nineteenth-century taste, and its continuing use as architectural ornament was frequently attacked by avant-garde critics in the 1920s. Herbert Lippmann, reviewing the "Machine Age" exhibition of 1927 (Sheeler had sat on the artists' organizing committee), commented that older forms of previous civilizations "have been insidiously carried over into the present," and he advocated instead "the abstract simplicity and innate decorative unity of mechanist design."[3] Harold Sterner found promise in the way the architect Cass Gilbert had learned to downplay Gothic design over the course of his career, emerging from the "irrelevant gothic gingerbread on the Woolworth Tower" of 1913 to the relatively plainer New York Life Building of 1928.[4]

However, at the same time that pseudo-Gothic decoration was being rejected, there occurred a growing appreciation of the relevance of the true Gothic of twelfth- and thirteenth-century France. Modernists found precedents for their high ambitions in the grandeur of the great cathedrals of Europe. As Albert Gleizes put it, "The skyscrapers ... are creations in stone and iron which equal the most admired old world creations. And the great bridges there — they are as admirable as the most celebrated cathedrals."[5] Joseph Stella and John Marin painted the Brooklyn Bridge as a modern-day monument whose pointed arches refer to the Gothic. Sheeler himself in *Manhatta* used Richard Upjohn's Trinity

Church (1841-46), perhaps the finest Gothic church in America, as a foil to his main theme of urban growth and energy, and as a symbol of mortality and of historic ages past.

But Sheeler had an ambition to go beyond superficial use of the Gothic, to seek out the roots of the style itself. Sheeler's lifetime program was nothing less than to discover and to portray the archetypal elements of architectonic form. Early on, he had discovered a continuity of form that had nothing to do with nationality, race, or time. He found the truth he sought in Piero della Francesca and in Cézanne, in Africa and in Picasso, at Doylestown and at River Rouge. His art makes us see that modernity is only true and universal form stripped of irrelevant details, and that the structure of modernism can be found in everything that man has touched with genius.

Given his program, it would have been surprising had Sheeler not dreamed of going to Chartres to make a final test of his thesis. By the early years of the twentieth century, Chartres was no longer regarded merely as one of the major cathedrals of France; it was increasingly understood to represent Western civilization itself, in the same way the Parthenon stood for the glory of ancient Greece. Already the subject of many books, Chartres had taken new meaning for Americans with the writings of Henry Adams. In his *Education* (privately printed in 1907, then published posthumously in 1918), Adams might have been speaking directly to and for Sheeler when he compared the "moral force" of a room of machinery to the power of the Cross for Christians. Explicating this comparison, he wrote: "On one side, at the Louvre and at Chartres ... was the highest energy ever known to man, the creator of four-fifths of his noblest art, exercising vastly more attraction over the human mind than all the steam engines and dynamos ever dreamed of; and yet this energy was unknown to the American mind."[6] Adams here laid down a challenge to his fellow Americans: it was one that only Sheeler, among modern American artists, took up.

In his *Mont St. Michel and Chartres* (privately printed in 1904, published in 1913), Adams eulogized Chartres at length, writing of its history, discussing the cult of the Virgin, and describing its major features: "the great tri-

umph of its fenestration" especially the Western rose window, the famous early sculpture on the west portal, the superb, soaring interior, and the south tower, which he called "the most perfect piece of architecture in the world."[7] For Adams, the thirteenth century marked "the point of history when man held the highest idea of himself as a unit in a unified universe," while the twentieth century he saw as a very different time, one of multiplicity. Sheeler would have praised everything about Adams's remarks except their pessimistic view of the present; indeed, Sheeler spent his life trying to prove the unity of past and present, of painting and photography, of Gothic form and Picasso's cubism or his own Rouge series. And during the twenties, the reputation of Chartres continued to grow. Henri Focillon, already influential in America, declared its artistic primacy in his lectures at the Sorbonne in Paris. *The Arts*, edited by Sheeler's friend Forbes Watson, published several articles extolling the Gothic in its context (while continuing to oppose Gothic frills in contemporary architecture.)[8]

Sheeler said that his goal at Chartres was to create a series that would yield "a more comprehensive presentation than would be possible in any one photograph showing the cathedral in its entirety."[9] He began, as in his earlier series, by providing a context for succeeding images through an introductory photograph of the whole church and its environs. In *Chartres — View from Near Porte-Guillaume* (cat. no. 60),[10] he shows the cathedral from the southeast, rising over the old town of Chartres on the banks of the Eure River. His vantage point was a conventional one, very close to the view that appears on the introductory page of René Merlet's English-language guide of 1926.[11] The rest of the series, however, is far from conventional: each succeeding print records a detail of the south side of the cathedral's exterior, and each one is in a sense a close-up of Sheeler's introductory image. Sheeler shunned the obvious and never recorded the most familiar and most historic aspects of the place, just as he omitted the Ford automobiles and the workers from the Rouge series. Avoiding the expected and the

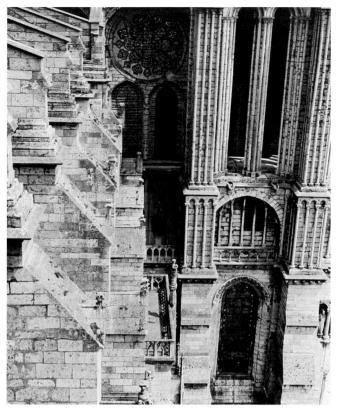

Fig. 56. Charles Sheeler, *Chartres – View of South Porch and Buttresses*, 1929, gelatin-silver print, The Lane Collection.

Fig. 57. Charles Sheeler, *Chartres – East End with Tree*, 1929, gelatin-silver print, The Lane Collection.

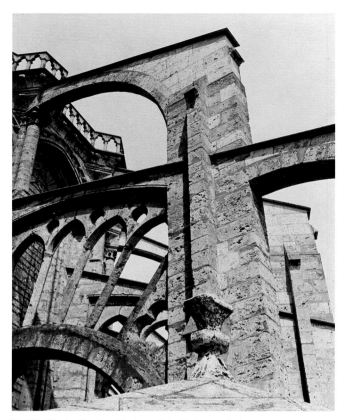

Fig. 58. Charles Sheeler, *Chartres – Flying Buttresses, East End*, 1929, gelatin-silver print, The Lane Collection.

Fig. 59. Charles Sheeler, *Entrance Gate, Nuremburg, Germany*, 1929, gelatin-silver print, The Lane Collection.

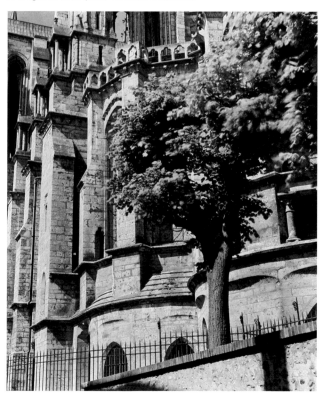

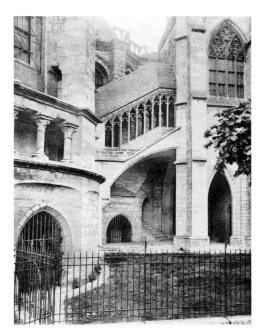

Fig. 60. Etienne Houvet, *St. Piat Chapel*, collotype, from *Cathédrale de Chartres*, Chelles, 1919.

identifiable, the artist completely neglected the famous interior of Chartres; and on the exterior, he concentrated entirely on details of the south side. Sheeler avoided the art historical and followed instead his own definite agenda. Once again his effort was to seek out abstract form in the essence of the structure itself.

In *Chartres – South Side from Street* (cat. no. 63), Sheeler photographed straight on the buttresses emanating from the nave, the shadows of early morning simplifying the image into dark and light masses. Two buggies are visible, tucked into shadowed corners, while electric wiring above hints at a contrast between the ancient and contemporary forms. For *Chartres – South Porch with Carriages* (cat. no. 62), Sheeler moved closer to the subject, one carriage having now moved behind the other, both still veiled in the long shadows. In *Chartres – Vendôme Chapel Exterior* (cat. no. 61), the carriages are gone, and the photographer stands on the ground before the crux of the nave and transept crossing, the Vendôme Chapel exterior at left, a section of the south porch at right. The light

is now brighter, later in the morning. His succeeding images come ever nearer to the church, compressing and isolating it in a search for its intrinsic harmonies and for the special beauty linked to its function.[12]

Inevitably, Sheeler's photographs reveal an intensely formal concern, while his emotional reactions are underplayed. Most emphatic are the strong massings of light and shadow, assertive line and powerful rhythm, as in *Buttresses on South Side* (cat. no. 66). Yet his photographs never obscure or subvert his subject. Further, with the exception of the initial view, the compositions undermine all sense of foreground, middle ground, and background. The sky is largely cropped out, except where architectural forms lock it in as an abstract shape, as with *Flying Buttresses at the Crossing* (cat. no. 67). Sheeler eliminated ground by flattening it within the general shape of shadowed mass, as in the views with carriages.

In its formal aspects, Sheeler's work again follows Arthur Dow, who began his influential book *Composition* (1899) with an illustration of flying buttresses from Chartres. Dow saw that massings of light and dark (for which he used the Japanese word *notan*, referring to the harmonies resulting from the combination of light and dark spaces) were central to the cathedral's character. For Sheeler, the formal challenge was how to convey the idea of Chartres without succumbing to the conventional. To render it in a modern way, Sheeler chose to isolate its parts, revealing what was intrinsically important in terms akin to those of Dow (and of modernism), insisting upon the crucial place of line, rhythm, mass, and surface tension.

Five of Sheeler's fourteen photographs were taken from ground level along the south side (cat. nos. 61, 62, 63, 66, and 69); three were shot from bays within the south porch (including cat. nos. 65, 68, and 70); one is from in the south tower (fig. 56); one is from at the transept crossing (cat. no 67); and three are from along the exterior of the apse (cat. no. 64 and figs. 57 and 58). His prints were "the results of climbing all over the exterior of the Cathedral with a camera," he said.[13] While the locations from which Sheeler shot his photographs were neither tricky nor obscure, his closely cropped compositions are so ordered and self-contained that they seem isolated from

their actual locations on the cathedral, and each has its own independent abstract unity.

Concentrating on the south side and the southeastern end of the apse with its adjoining St. Piat Chapel, Sheeler ignored the famed stained glass windows of Chartres, the severe Romanesque south spire, the late Gothic north spire with all its picturesque gargoyles, the awe-inspiring interior, and the celebrated sculpture on the great western facade and about the north and south portals. Sculpture unavoidably appears, but only incidentally within the niches of the buttresses.

Buttresses and flying buttresses become Sheeler's main subject. He rightly understood them as the key to Chartres, as the engineering device that made its size, drama, and interior lighting possible. Henry Adams had spoken of "the astonishing feat of building up a skeleton of stone ribs and vertebrae, on which every pound of weight is adjusted, divided, and carried down from level to level till it touches ground." He summed up: "Chartres was the final triumph of the experiment on a very large scale, for Chartres has never been altered and never needed to be strengthened."[14]

Recent scholars support Adams's view of the significance of the buttresses. Buttressing high walls was the major development that made this architecture possible at the end of the twelfth century, according to Jean Bony: "The use of the flying buttresses seems to have given a new start to all the basic Gothic desires for reduced bulk, for spaciousness, for linear expression." Chartres's flying buttresses survive as masterpieces of utilitarian beauty, elegantly engineered to support the walls' great weight. Bony sums up his discussion of Chartres's "overwhelming dimensions" in this way: "Power is the key word at Chartres: power in constructional engineering, power in the carving of space, power too in the whole vocabulary of forms."[15]

Succeeding photographs in Sheeler's series illustrate the repeating parallel shapes of lower buttresses that anchor the walls to the earth, then the middle levels with their guardhouse-like niches holding single sculpted figures, and then finally — high in the air, hardly visible to most viewers — the complex columns and arches of the flying buttresses themselves. *Fly-*

ing Buttresses, East End, with Chapel Roof (cat. no. 64) is typical of Sheeler: the composition leads the viewer in from the lower left, rises through the stabilizing vertical element to the right-center, then leaves us trying to make sense of the overlapping forms in the middle. There is no recognition of ground or sky here, and little depth; forms are recognizable yet flattened and abstracted. *Flying Buttresses at the Crossing* (cat. no. 67) presents the most dramatic, soaring image of the group. Its vertical, backward thrust recalls Rouge photos such as *Criss-Crossed Conveyors* (cat. no. 45), and it also echoes that print's strong, X-shaped composition.

Sheeler's photographs of Chartres at times are quite similar to those of Etienne Houvet, keeper of the cathedral, who made over nine hundred views of it. Houvet's photographs illustrate many of the popular guides to Chartres of the time, including the English-language version of 1924. His monographic series of ninety photographs won him a medal from the Académie des Beaux-Arts in 1919.[16] Houvet's monograph gives a full visual survey of the church, beginning with the west front with its two towers, going to every side, to the sculpture, the porches, the chapels, and the interior; and Houvet goes high onto the exterior, as Sheeler would, to study the buttresses. The prints are beautifully composed and printed, and Sheeler comes very close to duplicating some of his compositions, as one sees, for example, in comparing Sheeler's *St. Piat Chapel* (cat. no. 69) with Houvet's print of the same subject (fig. 60). Yet, though the scene portrayed is almost the same, there is no similarity between the two as works of art. Houvet's view is picturesque and local; he gives us a winding path by which to enter, a grassy foreground, stairs, a way of entering the doors, and sky above. Sheeler, taking his photograph from almost the same spot, lowered his camera so that the granite wall and iron fence become barriers and function as flat horizontal elements at the base of his composition. In his view, there is no path, no grass, and no easy entry, for the arched doors become dark holes. Strong sunlight and shadows create vertical elements;

other shadows make short black diagonals coming from the left side. Houvet photographs accessible, real form; Sheeler at the same place photographs flat, unreachable blacks and whites.

Sheeler's letters and remarks make it clear that the artist understood the greatness of Chartres; in comparison, other subjects paled. As Henry Adams had put it, "All the steam in the world could not, like the Virgin, build Chartres."[17] Sheeler was a lifelong student of the sympathetic relationship of faith to form; here at Chartres he studied this relationship in a supreme manifestation. Yet when he returned with his Chartres photographs, there was little acclaim. Within two months the stock market crashed, and the outlook for both creative and commercial photography dimmed. Only a decade later, when he was working with Rourke on her book, Sheeler looked back on Chartres with mixed feelings. Speaking of the cathedral, he said, "I revere this supreme expression," but he went on to say that he realized that "it belongs to a culture, a tradition, and a people of which I am not a part," and that he preferred American subjects.[18] By the time Rourke's biography appeared, America was deep in the Depression, and American art much involved with nativism and regionalism. By 1938 Sheeler had long since given up photography as his major occupation and he seems to have looked back on his love for Chartres and his great accomplishment there with ambivalence. Moreover, despite the quality of his Chartres photographs, he rarely utilized them in the way he did his other great series, of Doylestown and River Rouge, to make later drawings and paintings.

Sheeler timed his European trip to coincide with the huge international exhibition of photography "Film und Foto," organized by the Deutsche Werkbund and held in Stuttgart from May 18 to July 7, 1929. In early January of that year, Edward Weston was asked to organize the American section of this exhibition and was given "complete charge of it"; but interestingly, Steichen and Sheeler must have already been contacted, as they were the two Americans praised as photographic "pioneers" in the 1928 press release announcing the show.[19] Apparently, Weston selected the photographers from the west and asked Steichen

to choose the easterners, and Weston wrote a brief essay on the state of American photography for the catalogue.[20] They invited ten Americans to participate, including Berenice Abbott, Imogen Cunningham, Paul Outerbridge, and Sheeler, and also included themselves.[21] Sheeler is listed in the catalogue as having contributed ten photographs; one was *Side of White Barn*,[22] but the others have not been identified. However, as Beaumont Newhall points out, Sheeler's work was already known in Europe, a series of New York prints having been reproduced in *Cahiers d'Art* in 1927,[23] and it seems likely that some of them and some of the Rouge series were shown at Stuttgart.

Sheeler would have seen at Stuttgart a large selection of work by the Bauhaus, as well as works by Kurt Schwitters, El Lissitzky, and others of the international avant-garde. One German artist who might have been of interest to him was Albert Renger Patzsch, who had begun making industrial photographs in the mid-twenties; his prints of factories and rail lines near Essen done about 1930 have intriguing parallels with Sheeler's Rouge series. The opportunity to see Sheeler's work must have been important for the Germans, as it would have encouraged them in the direction they were taking. Sheeler was indeed an international pioneer, and American photography was preeminent in the years from about 1917 to 1929, during the height of Sheeler's photographic career. As Katherine Grant Sterne observed in 1932 at the "International Photography Exhibition" at the Brooklyn Museum, "If the Germans have been the prophets of the 'new objectivity' in art, and the Russians its economic and social components, it is the Americans who, without bothering much with aesthetic theories or manifestoes, have developed the notion until it could be safely transplanted to an alien soil."[24]

Sheeler was much impressed with Germany. After his return, he wrote Arensberg, "Germany is the land of our adoption. It feels good to be there — and the galleries were a revelation to me. The big International Film and Photo exhibition was also very interesting."[25] Thus the exhibition itself seems to have been less important to him than the "galleries" (presumably meaning the major museums)

VI
The Thirties

and the country itself. After Stuttgart, Sheeler and Katharine followed a large circular route to Munich, Nuremburg, Berlin, Hamburg, and finally to Bremen, from which they probably sailed for England and home. They apparently traveled by train, taking two side trips along the way, one to the Bavarian city of Rothenberg, the other "a glorious motor trip from Munich to Innsbruck through the Bavarian Alps."[26] A few prints resulted from this trip, depicting the Bavarian landscape, sometimes with high peaks in the distance, and the Nuremberg Gate (fig. 59). However, much as he liked Germany, it provided no photographic subjects that matched the level of Chartres.

In 1931 Sheeler was forty-eight years old, and was regarded (in the small circle that cared) as one of America's chief photographers. His photographic career had begun as a sideline he thought would not interfere with his primary ambition to be a painter; but for fifteen years, from 1916 on, photography had become his dominant interest. During this period, he had to support himself through his commercial work at Condé Nast and elsewhere because of the narrow market for both his photography and his paintings and drawings. The Ford commission of 1927 proved a unique occasion, paying handsomely yet providing enough freedom and the right kind of subject to inspire some of his best work; most of his commercial work was far more conventional. On his return from Europe in August 1929, Sheeler apparently planned to return to Condé Nast, despite his distaste for that work, but owing to the Depression and perhaps other factors, there was no work available there. According to Sheeler, his painting sales ceased altogether, and "even the photography just vanished into thin air. By then it had built into a substantial source of income, but within a matter of weeks, it just stopped."[1]

During the fall of 1929, Sheeler turned back to painting with renewed energy. During these months he painted *Upper Deck* (fig. 61), which he saw as a breakthrough, marking "the dividing line between my previous work and that which has followed."[2] He had used photographs as a source for painting compositions before, in paintings such as *Church Street El* and *Skyscrapers*, among others, but now for the first time he did nothing to disguise or alter his photographic source. *Upper Deck* was based on a photograph (fig. 62) Sheeler had made in 1928 as part of a commissioned series of prints depicting an ocean liner, the SS *Majestic*;[3] significantly, the photograph itself was not one of Sheeler's best, but the painting was. From this time on, Sheeler studied the relationship of photography to painting and drawing with great care and insight. He found the equation between works in different media was rarely one to one. Thus his greatest photographs, with their subtle tonal ranges, were seldom transferable into paintings, while a major painting could result from a lesser photograph that contained the kind of composition

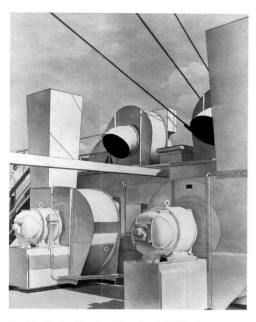

Fig. 61. Charles Sheeler, *Upper Deck*, 1929, oil on canvas, Fogg Art Museum, Harvard University. Purchase, Louise E. Bettens Fund.

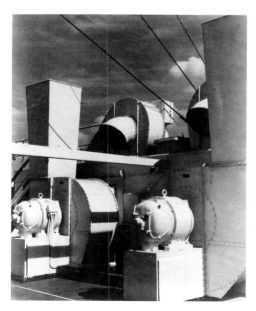

Fig. 62. Charles Sheeler, *Upper Deck*, c. 1928, gelatin-silver print, Gilman Paper Company.

Fig. 63. Charles Sheeler, *View of New York*, 1931, oil on canvas, Museum of Fine Arts, Boston, The Hayden Collection.

– or "blueprint" – that he sought.

As Sheeler said of this discovery, "This is what I have been getting ready for."[4] He went on in 1930 and 1931 to make some of his finest paintings, all with compositions based on photographs, including *American Landscape*, *Classic Landscape*, *View of New York* (fig. 63) – a final look at his shrouded view camera and the New York studio he was giving up – and *Home, Sweet Home* (Detroit Institute of Arts). During this creative period, Sheeler used up his savings "from those prosperous years of photography"; then, as he put it, "I had to get out of the New York studio and retreat to South Salem."[5] He was ready to take on any job, "just to exist." At this time, the energetic Edith Halpert offered to take on his paintings at her Downtown Gallery. Sheeler recalled her saying, "'I think I could sell enough of your pictures so you could paint all the time.'" Her gallery did not deal in photography, and she was simply not interested in the medium. Moreover, Halpert urged Sheeler to do nothing but paint, and to keep his photographs out of gallery exhibitions (though she is not known

to have discouraged their inclusion in museum retrospectives). Her feeling apparently was that paintings were difficult enough to sell at this time without the added handicap of having critics and collectors see them as "merely photographic." Moreover, Sheeler himself was evidently ready for the change: now in mid-life, he had had a notable career as a photographer, and with the making of *Upper Deck* and Halpert's backing he was ready to take up a new career in which painting would be primary and photography secondary.

Sheeler made this change at a time when his reputation as a photographer was at a high point. Late in 1931, after his first show of paintings at the Downtown Gallery, several of his photographs were included in the inaugural exhibition of the Julien Levy Gallery at 15 East 57th Street, New York. The Harvard-educated Levy would go on to become a distinguished dealer in surrealist and other modern paintings, handling Marcel Duchamp, Max Ernst, Salvador Dali, and Arshile Gorky, among others, but at the beginning his goal was to show that a gallery specializing in photography could survive; he soon learned that it could not, and so widened his offerings. For his first show he enlisted the aid of Stieglitz[6] and presented a "Retrospective of American Photography," which included prints by Stieglitz, Steichen, Strand, Weston, and Clarence White, among others, as well as Sheeler.[7] Even in this distinguished company, Sheeler was again singled out by the critics. *Creative Art* reported, "It is not until the prints of Sheeler that one comes to photography firmly conceived as a new plastic art."[8]

During 1932 – a difficult year for Sheeler, with his wife Katharine increasingly ill, and with their move to Ridgefield, Connecticut, from South Salem, New York – his work continued to be selected for the major photography shows. The medium was gaining a somewhat wider public, and a number of museums were recognizing it for the first time. Thus, Sheeler was included in the "First Annual Philadelphia International Salon of Photography" (at the Philadelphia Museum) in March, at the Brooklyn Museum's "First International Photographers" exhibition in the same month, at an important international show at the Albright Gallery, and the Museum of Modern Art's

"Murals by American Painters and Photographers" in May.[9] But just at this moment, as he was poised to join Weston and Adams and the others whose reputations were built during the years and decades that followed – at the time when critics and the public gradually came to accept photography – Sheeler withdrew. He virtually stopped accepting invitations to group shows, and his photographic output decreased. In 1933, for example, Ansel Adams implored him to have a one-man show at his gallery in San Francisco; Sheeler declined on the basis of having lost his New York studio and having no photographic facilities at his new house, and because he thought that any exhibition without current work would be too much of a "memorial show."[10] A year later he turned down a request from Edsel Ford for a photo mural for the Ford Pavillion at the "Century of Progress Exposition." In this case, Edith Halpert wrote declining the offer: "While Mr. Sheeler has – as you know – a large series of photographs made at your order showing various aspects of the Ford Plant, he is so completely engrossed in painting these days he does not wish to continue his photographic work."[11] As Sheeler wrote in a letter to Walter Arensberg, "I must keep in mind the making of a living and of eventually overtaking my debts," and painting – with Halpert's guidance and support – now seemed to offer the best chance for this.[12]

Sheeler was devastated by his wife Katharine's long struggle against illness (thought to be stomach cancer) and by her death in June 1933. During the next few years, he began to travel increasingly, perhaps seeking emotional escape and also searching for new subjects to paint and to photograph. About 1934 he visited Mt. Lebanon Shaker Village at New Lebanon, New York, and made four photographs of the interior of the Second Meeting House (see cat. nos. 71-73). Although this was not an exhaustive series in the sense of Chartres or River Rouge, Sheeler's prints are sensitive and beautiful. He had long been interested in the Shakers and owned a number of Shaker objects by this time. His photographs are spare, refined studies in gray; they are modern recollections of his work at the Doylestown house, and their plain, abstract qualities suggest Sheeler's depth of feeling for the Shakers.

In 1935 Sheeler became a member of the New York Camera Club, where he exhibited on occasion and made use of the darkroom and other photographic facilities he was otherwise lacking. Late in the same year, he traveled to Virginia at the invitation of Colonial Williamsburg for a stay of several months. Details of the commission are unclear, but apparently Abby Aldrich Rockefeller, founder of Colonial Williamsburg and since 1929 the major collector of Sheeler's paintings, suggested that he do a photographic essay on the restoration, which had opened just the year before.[13] Sheeler struggled with the subject, in the end making about forty photographs, which mark a low point in his career. One surmises that he felt alone and out of place yet under pressure to produce for the Rockefellers. He loved history and its artifacts, but the artificiality he found at Williamsburg must have bothered him. He made a special effort to portray the brick Governor's Palace, the masterpiece of the Williamsburg reconstruction effort: in eleven different views, he took it from every angle, closeup and at a distance, but never managed to charge his image with any of the energy, or with the tension between the real and the abstract, that marks his best photographs. He also made several prints of Bassett Hall, the Rockefellers' handsome clapboard dwelling, and photographed a number of the small houses and outbuildings. Moving inside, he shot several room interiors showing furniture, paintings, and other objects in the collection. A favorite subject was the Virginia Kitchen, and the two photographs of it became well known. The one that shows a corner of the room with pots and other utensils hanging on the walls (fig. 64) was used in 1937 as the subject for a small painting commissioned by the Rockefellers; the other depicts a black servant, "Aunt Mary," dressed in period costume and seated at the kitchen table. Both kitchen pictures were printed in several sizes.[14]

The one truly distinguished print that came out of this project was *Stairwell, Williamsburg* (cat. no. 74). Stairways of every kind had interested Sheeler since his earliest architectural work. They were a central theme in his Doylestown house series and served as the subject of paintings and drawings throughout

his career, from *Lhasa* (fig. 5) of 1916 to *New England Irrelevancies* (The Lane Collection) of 1953. Stairs, doorways, and windows provided Sheeler with naturally abstract forms; and the fact that he went back to them again and again suggests that they also played an important symbolic role for him. In his earlier work, such as the painting *Stairway to the Studio* (1925; Philadelphia Museum of Art), the views up steep, narrow stairways convey a sense of aspiration, of Sheeler's desire for success in the face of great difficulties. Then, during this troubled period in the thirties, he took his views downward from the tops of stairs, creating a feeling of imbalance, perhaps of falling — as in his painting *Newhaven* (1932; The Lane Collection) and in *Stairwell, Williamsburg.* The latter, a study in cool grays, has strong geometry along with marvelous spatial ambiguity: it seems to rise and fall at the same time, and the only real clue as to place or scale lies in the tiny black light switches on the far wall.

Sheeler did not stop making photographs during the thirties or forties; in fact, he made many. But truly fine images became rare. Sheeler's experience at Williamsburg, where he worked hard for several months and ended up with just one outstanding print, was an extreme one, but it does suggest the problem. Lacking opportunities to exhibit and sell new photographs, and thinking now as a painter — seeking composition and inspiration — he looked to photography as a means rather than an end.[15] Thus, for example, when Sheeler went to New Bedford, Massachusetts, in 1939 to photograph a power plant there, he made several prints of industrial buildings with tall smokestacks (see fig. 65), which can easily be confused with the Rouge series. But because the final product he had in mind was a painting based on one of the prints, his concern in these photographs was for form and composition, and not for the subtle tonal ranges and exactness of image that he had attained in earlier work. And much the same is true of a small related series of prints that Sheeler made the following year, depicting the interior of the Baldwin Locomotive Plant (see fig. 66). In composition and lighting these are reminiscent of his interior views at the Rouge, but one no longer feels him engaged with his subject in the same way.

During the mid-thirties, Sheeler experimented for the first time with a 35-mm. camera. He purchased a Contax camera shortly after its introduction in 1932 by a German manufacturer, Zeiss Ikon. He made the two Williamsburg kitchen prints with it, as well as a portrait of the exterior of his Ridgefield house and a view of the Blue Ridge Mountains (fig. 67), among others. When Sheeler exhibited the Blue Ridge print at the Zeiss Company's New York showroom in 1937, he noted also that he had used a Zeiss Sonnar F/2 50-mm. lens on that occasion. And though he had some good results, he shortly went back to using larger cameras.

In 1938 Sheeler was commissioned by *Fortune* magazine to make six paintings on the subject of American industrial power. He wrote to Edward Weston describing the project: "In a series which I have just begun, which *Fortune* will reproduce, I hope to do my bit in calling attention to some phases of my America which I greatly admire. The pictures have to do with generators, producing 210,000 KW, Boulder Dam, Diesel Shovels, giant steam engines...." In his letter he also told Weston, "I have done very little photography in the past year but hope to make amends in the near future."[16] In preparation for his commission, Sheeler made several trips around the country, driving south through Tennessee to Alabama early in the year, then traveling west to Nevada and Arizona in October and November. Each site was searched out and then studied with great care. After deciding on a subject, such as the Tennessee Valley Authority's hydroelectric plant at Guntersville, Alabama (portrayed in the painting *Suspended Power* [1939; Dallas Museum of Art]), Sheeler then took two dozen or more negatives of the subject from various positions and directions; once home he would then choose one negative to use in the painting. The prints that resulted are effective — they served as studies for a painting that ranks among Sheeler's best — but they simply weren't taken or printed with the care and skill the artist used when making a great photograph was his primary aim.

Sheeler's long trip west led him to Boulder Dam (or Hoover Dam as it has been called since 1947) on the Arizona-Nevada border.

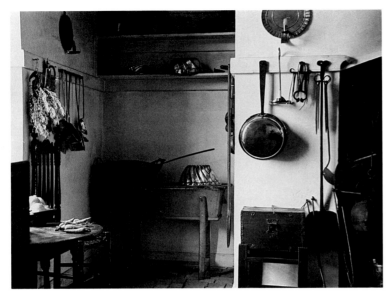

Fig. 64. Charles Sheeler, *Williamsburg Kitchen*, 1935-6, gelatin-silver print, The Lane Collection.

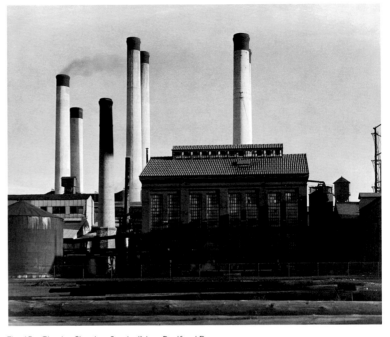

Fig. 65. Charles Sheeler, *Stacks* (New Bedford Power Plant), 1939, gelatin-silver print, The Lane Collection.

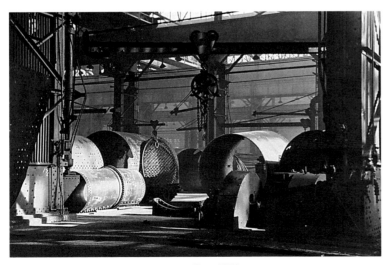

Fig. 66. Charles Sheeler, *Baldwin Locomotive Plant*, 1937, gelatin-silver print, The Lane Collection.

Fig. 67. Charles Sheeler, *Blue Ridge*, 1937, gelatin-silver print, The Lane Collection.

Finished in 1936, the dam was the greatest single source of power in the world and thus an obvious choice for the *Fortune* series. This grand subject inspired Sheeler to do a truly fine group of about twenty images (selected from his ninety-six 3⅜-by-4⅞-inch negatives), his first extensive series since Chartres a decade earlier (see cat. nos. 75-77). He shot it from below with the huge dam looming overhead, from the hills behind it, and from every angle. Most are horizontal compositions, a rarity in his work. The results were very different from the tender, gray prints of the mid-1930s, for the Boulder Dam prints study sharp contrasts of brilliant, sunlit lights and rich, solid blacks. Sheeler thought highly of these pictures; sending one print to Walter Arensberg, he commented with uncharacteristic pride, "That is the best I know how to do in photography."[17]

Another of the photographs done in preparation for *Fortune*'s "Power" series has become perhaps his most famous single image: This is *Wheels* (1939; cat. no. 78), which relates closely to his painting *Rolling Power* (Smith College Museum of Art) of the same year.[18] It depicts a detail of a New York Central locomotive. Here the heaviest of machinery is transformed into weightless abstraction lit by the noonday sun. As in the best of Sheeler's work, the viewer first sees abstraction, a complex layering of horizontals, circles, and subtle diagonals, lights and darks, then recognizes its "reality" as locomotive, then is torn between the seen and the known. This portrait of a machine is unique in Sheeler's photographic oeuvre: though related to some of the Rouge "portraits" such as *Ladle on a Hot Metal Car* (cat. no. 53), here Sheeler has zeroed in on his subject even more closely and effectively. Despite its uniqueness, the image became widely known when Edward Weston illustrated it in his important article on photography in the *Encyclopaedia Britannica* of 1942, and since then it has come to represent Sheeler's photography for many people.[19]

Sheeler planned everything in his art, leaving nothing to chance. He probably researched and then determined each subject for the "Power" series before setting off to make his final on-site photographic investigation. Thus the engine he used for *Wheels*, like his other

Fig. 68. Alfred Eisenstaedt, *Sheeler with his old Century camera*, (*Life* magazine © 1938 Time Inc.)

Fig. 69. Musya Sokolova Sheeler, *Sheeler with his Linhoff camera at Boulder Dam*, 1939, The Lane Collection.

such subjects, was exactly suited to his aims. The coal-powered Hudson engine was the most powerful, most efficient, and most beautiful one of its time. The first Hudson engine, produced by the American Locomotive Company in 1927, was distinctive in its "4-6-4" configuration — meaning that a four-wheeled truck under the cab was behind six large drive wheels (three on each track), with another four-wheeled "bogie" at the front. Advancing through several improved models, all with the same layout, ALCO finally produced fifty "J3"s in 1937; half of these had Scullin-type disc drive wheels with circular openings, and just ten "were clothed in a streamlined casing designed by Henry Dreyfus."[20] These were the engines that pulled the celebrated *Twentieth Century Limited* from New York to Chicago in sixteen hours, and "many observers considered these to be the most handsome of all streamlined locomotives."[21] Sheeler's photograph shows just a detail of the great locomotive: the two small wheels of the "bogie," which supported the front of the engine, and just one of its three big drive wheels. One sees only a concentrated, abstracted portion of the machine; as he did elsewhere, Sheeler here presented a lesson in selective seeing, for one feels more energy and beauty in the detail than when viewing the whole engine.

As Carol Troyen points out, Edith Halpert did a superb job promoting Sheeler's work, and his paintings were included in a number of important exhibitions in these years.[22] At the same time, his photography was also being increasingly recognized in its own right, without her efforts. Weston's *Encyclopaedia Britannica* article would have reaffirmed Sheeler's importance in the eyes of his peers, the professionals. A *Life* magazine article in August 1938 entitled "Charles Sheeler Finds Beauty in the Commonplace" illustrated three of his photographs along with five paintings, and thus introduced his work to a wide audience.[23] And the following year, he was given a large exhibition at the Museum of Modern Art. Organized by Dorothy Miller and opening on October 4, 1939, this was his first museum retrospective. Included were forty-four paintings, sixty-one drawings and

watercolors, and seventy-four photographs. The selection of photography gave a full survey of his career to that point, while also emphasizing his most recent work. Included were only two Doylestown house prints, but there were six advertising photos from the twenties and five for fabric designs dated 1933; the whole Chartres series was exhibited, along with eight of the River Rouge prints, and there were seven prints from 1939.

Sheeler, now fifty-six, received widespread critical notice with the Modern's exhibition. But just one reviewer considered the photographs as works of art, on their own: this was Edwin Alden Jewell of the *New York Times*, who wrote, "The photographs are simply magnificent. I do not think I have ever seen finer ones from any hand."[24] But he went on to ask the question that Edith Halpert in particular had feared: why should the creator of such works "attempt to approximate such statement[s] with the brush or pencil?" Jewell then judged Sheeler's paintings only by their color, failing to consider their scale or handling, or — most important — their visual impact, and he found the color at times unconvincing. Royal Cortissoz was less critical, noting only that "many of his paintings are photographic in character" but finding this no drawback.[25] But others were even harsher than Jewell: Sheeler was attacked for his patronage by the Rockefellers and Ford, attacked for lacking realism in failing to show the imperfection of industry and the worker's plight, attacked for his failure to "reveal himself," and attacked because so many other American artists deserved to be shown at the Modern.[26] Whatever Sheeler felt about this criticism, he stayed his course. Less than two weeks after his show had opened at the Modern, he left for Nevada and Boulder Dam in search of a final painting subject for the "Power" series.

If the critics failed to understand his work, Sheeler could take comfort in the friendships and mutual admiration that he built with many of his major contemporaries in the photographic world. He remained on good terms with Edward Steichen, and served at his invitation on the selection committee for the *U.S. Photography Annual*. Ansel Adams in 1940 invited Sheeler to participate in the "Pageant of Photography" show at the Golden Gate Inter-

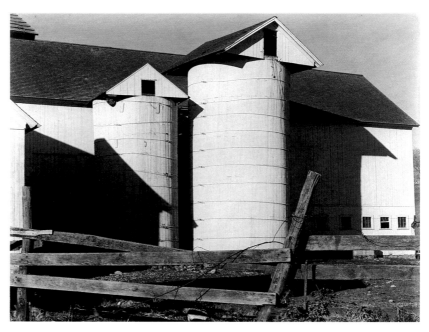

Fig. 70. Edward Weston, *Connecticut*, 1941, gelatin-silver print, Museum of Fine Arts, Boston.

Fig. 71. Charles Sheeler, *White Barn with Silos*, 1941, gelatin-silver print, The Lane Collection.

44

national Exhibition in San Francisco; this was his first substantial showing on the West Coast.[27] He was now in close touch with Beaumont Newhall and David McAlpin, two pioneers in the understanding of this field, and he continued to correspond with Edward Weston, whom he had met in 1922. Sheeler was not a flatterer, and his admiring remarks to Weston make clear his profound admiration for the Californian's work. Though their personalities were very different, Sheeler and Weston formed a deep and lasting friendship based on their art and their way of seeing. Sheeler wrote to him on one occasion, "It's gratifying to have a letter from one whose opinions I value so highly and whose works I so much admire."[28] Later, shortly before Weston's death, Sheeler wrote to say, "We are constantly reminded of you by the portrait that Ansel sent us some time ago."[29]

Sheeler had hoped to get to California to see Weston on his Boulder Dam trip of 1939, but was too short of time.[30] However, in 1942 Weston received a commission from the Limited Editions Club to do a set of photographs illustrating Walt Whitman's *Leaves of Grass*. He and his wife, Charis Wilson, traveled for ten months across the country, from Texas to Maine, and toward the end of the trip they visited Sheeler and his new wife. In April 1939, Sheeler had married Musya Sokolova, a Russian emigrée and former dancer who is remembered by friends as being a warm and ebullient woman. By the 1950s she had also become an accomplished photographer.[31] Weston told his sister Mary of the visit in simple terms: "We are in Ridgefield, Conn. with the Sheelers.... Charles Sheeler is a great painter and photographer."[32] Sheeler and Weston worked together for two or three weeks, an experience that was evidently pleasurable for both. Apparently Sheeler acted as guide, this being his territory, and he took Weston to a number of old barns and mills that he thought might make good subjects for their cameras. Weston's prints from this sojourn show him making use of Sheeler's architectural subjects, and also following his compositional style and his employment of raking late-afternoon light. On occasion their results were very close indeed, as one sees in comparing Weston's *Connecticut* (fig. 70) with

Fig. 72. Charles Sheeler, *Silo*, 1936-37, gelatin-silver print, The Lane Collection.

Fig. 73. Edward Weston, *Connecticut Barn*, 1941, gelatin-silver print, Museum of Modern Art, New York. Gift of Edward Steichen.

Sheeler's *White Barn with Silos* (fig. 71). Judging from the shadows, we can guess that Weston made his shot first, and Sheeler followed minutes later. In Weston's print, the broken board fence and leaning post serve as strong foreground elements, with the barn quite symmetrical across the background. Sheeler characteristically moves in and compresses the subject: omitting the fence, he took his shot from the right, so that the gables on top of the silos become flat, formal elements rather than three-dimensional ones. Similarly, the barn's roof line appears as a strong horizontal parallel to the picture's edge, anchoring it and contributing to the abstract, flat quality of the image.

On another occasion, Sheeler and Weston photographed a stark clapboard powerhouse elsewhere in Connecticut. Weston's untitled print (*Powerhouse, Connecticut*) reflects Sheeler's aesthetic: the building looks angular and flat, with the peak of its gable just touching the top edge.[33] Sheeler's photograph is now lost, but he used it as the basis for a painting he made in 1943, *Connecticut Powerhouse* (Edmund J. Kahn Estate):[34] here he has moved closer to the building than Weston, and it fills the whole of his frame, so that it seems both massive and menacing. On yet another occasion, Sheeler took Weston to the Connecticut silo he had photographed in about 1936 or 1937 (fig. 72) and which he had painted in 1938 (*Silo;* Coll. Steve Martin). Weston photographed the same structure, again making a somewhat more picturesque image than Sheeler's close-up, formal view (fig. 73).

Sheeler frequently discussed photographic technique and equipment with Weston, as he had with Stieglitz in the early years. In 1939, before embarking on the "Power" series, Sheeler told Weston that he had bought a 9-by-12-cm. Linhoff, an excellent drop-bed folding camera, which he used at Boulder Dam and elsewhere.[35] In 1942, while thanking Weston for some prints ("they are distinguished mementoes of our good days in Connecticut"), he reported "that at last I have a darkroom in this house, the chief joy of which is the Omega enlarger."[36] In the same letter, he noted the purchase of a new 8-by-10-inch AGFA, a German view camera, which replaced the "twenty-five-year-old Century," the Kodak camera he had been using for so

long. And finally, in 1954, he wrote, "I use nothing but 35. mm. and 2¼ x 3¼. I've given up that 20 x 24 that I used to tow around for candid shots."[37] This joking reference to a large view camera suggests that Sheeler used a 20-by-24-inch camera at some point, perhaps during his years at Condé Nast.

There was continuity and pattern to everything Sheeler did. His was the same eye from beginning to end. Both his aesthetic and his personal loyalties were lifelong; people he had known in the early days, such as Agnes Meyer and Paul Strand, came back into his life in the late years. When he married in 1939 for the second time, it was to a charming, earthy, sexual woman who seems to have been quite like his first wife. When he did a series of New York photographs in the 1950s, returning to a subject of the early twenties, the result was a creative variation on a favorite theme, not a repetition.

Thus, the fact that Sheeler went to work full time in the Publications Department at the Metropolitan Museum of Art during World War II is completely consistent with the course of his career. He had been a regular visitor to the Met since the Chase years, and he had photographed paintings there as early as 1920.[1] More important, he had been a photographer of art from the first years that he worked with a camera. There was nothing demeaning for him in photographing works of art; on the contrary, it was through such work that he had learned to see. And probably more than any American artist of his time, Sheeler both loved and understood the art of the past.

Sheeler was appointed Senior Research Fellow in Photography, reporting to the Department of Publications, about July 15, 1942. Edith Halpert likely played some role in persuading Francis Henry Taylor, the director, to take him on during a difficult time, when paintings were not selling and Sheeler, once again, was feeling doubts about his abilities.[2] In her excellent study of Sheeler's work at the Met, Wendy W. Belser quotes Marshall Davidson, then associate curator of the American Wing, recalling that "Francis Taylor brought him in, turned him loose, and said 'just get the best damned pictures you can.'"[3] Sheeler wrote Weston at this time, describing his new job as "ambassador at large with a camera" and noting that the choice of objects to shoot was left up to him.[4] The Met's *Annual Report* for 1942 put it this way: "Charles Sheeler, the well-known painter and photographer, was added to the staff of the Department of Publications, with a roving commission to photograph activities as well as

objects in the Museum."[5] This report included several of Sheeler's photographs, including his dramatic detail of the head and shoulder of a cast of Michelangelo's *Guiliano de Medici* (cat. no. 79) on exhibit in the Great Hall; a view of the Fifth Avenue entrance; another of students in the new Junior Museum; and one of a fragment of a newly purchased Egyptian statue of Rameses II.[6]

In his three years at the Met, Sheeler worked mainly in the Met's photo studio, but, as Belser says, "his relationship to the Department seems to have been independent of its regular business" and he was not involved in their routine photographic work.[7] During the three years Sheeler was there, the museum's photographer, Edward J. Milla, and his staff produced about twelve thousand negatives, while Sheeler made some three hundred. He was paid a regular salary (at the same level as an associate curator) plus ten dollars for every negative accepted by the Met for its use, and under his contract he was to receive photographic credit whenever one of his images was reproduced. Colleagues recall that he used the darkroom himself and was very much concerned with the quality of printing and reproduction.

More than 130 of Sheeler's photographs were published in the *Annual Report*, the monthly *Bulletin*, and in the other Met publications. Objects ranged over the entire museum, from Chinese, classical, and Egyptian objects to well-known paintings by Pieter Brueghel, Jan Vermeer, and Winslow Homer. Interestingly, he frequently wrote the captions for the photos himself. Thus, regarding Vermeer's *Lady with a Lute*, he commented that "the miracle resulting from the envelopment of forms by light was of lasting interest to Vermeer" (as it was of course to Sheeler).[8] Explaining his preference for presenting details of paintings, he wrote, "It has been our intention to create a fresh approach to these pictures in their entirety by presenting them in their parts" – an explanation that fits equally well with his approach at Doylestown, at River Rouge, and at Chartres. Sheeler's comments on the works of art are generally assured, modest, and graceful. His captions reflect his own interests and his own style; thus, describing a detail of Mantegna's *Adoration of the Shepherds*, he wrote –

again as if speaking of his own work – "Architectural detail was a consuming interest to Mantegna from first to last. It was applied not only to the buildings which frequent his pictures but to all the elements which play a part in his designs."[9] At the Met, Sheeler found yet another laboratory where he could test his basic thesis that "all great art comes from 'the main trunk' and shares with all other fine art a discernible abstract structure."[10]

Sheeler undertook several major projects at the Met, three of which resulted in books illustrated with his photographs. Just after arriving at his new post, he began to photograph the massive Assyrian reliefs that had come from the inner courtyard of the palace of King Ashurnasirpal II in the ninth century B.C. Sheeler photographed the whole of several friezes, then a series of ever-closer details. In one (cat. no. 82) one sees three graceful hands and arms, curvilinear and flat against their rough stone background; as with the Chartres pictures, one has a sense of the interplay of abstract forms, and the viewer must look hard in order to distinguish the king on the left, holding his bowl, and the arms of a servant (on the right) reaching toward him. These photographs, with their sensitivity and linear grace, have often been thought the finest Sheeler made at the Metropolitan. At Sheeler's urging, a handsome book entitled *The Great King*, including twenty-eight of his photographs, was published by the museum in 1945.[11]

Sheeler also made the photographs for two books on the Met's collection of Egyptian art. On both projects, *Egyptian Statues* and *Egyptian Statuettes*, he worked with Nora Scott of the Egyptian Department. She reported that Sheeler worked very slowly ("like molasses in winter"), studying the object at length, then preparing the shot, deciding on the exact lighting and composition he wanted before shooting.[12] He is also said to have frequently cropped his images in order to strengthen them (just as he used overmats with great care in the early days). He also made a large group of prints of the Cloisters, the Met's Medieval branch in Fort Tryon Park, New York (see fig. 74); a book on the subject was contemplated but was never published. Some of the most beautiful photographs he made during his time at the Met depict details of medieval and Re-

naissance sculpture, often shown in dramatic, shadowy light.

Sheeler first began to make color photographs while at the Met. His color transparencies, unlike the black-and-white negatives, have not survived, but his own list of published photographs includes eleven Winslow Homer Kodachromes, and others of an Eakins painting, a Chinese painting, and so on.[13] Sheeler would go on to experiment with color during the last active decade of his professional life, making a variety of images, from 8-by-10-inch color transparencies taken with his view camera to many 35-mm. slides of friends, travels, and possible subjects for paintings. While he continued to do his best photography in black and white, his new color work helped him create a more colorful, abstract painting style in the following years.

Sheeler left the Metropolitan on July 15, 1945, exactly three years after beginning. His contract was terminated by the Met on the grounds of economy; Sheeler's letter of response was businesslike while expressing regret that the museum had not "published more fine editions making use of my photographs" during his period of employment.[14] Apparently he was interested in staying on, but both his wife and Edith Halpert thought he should have more time for painting.

During the remainder of the forties, Sheeler gradually regained his energies as a painter, while producing little of note in photography. His photographs were included with paintings and drawings in small exhibitions held in 1946 at the Addison Gallery in Andover, Massachusetts, and in 1948 at the Currier Gallery in Manchester, New Hampshire – on both occasions in connection with commissions. Then in 1951, both the painting *Rolling Power* and the closely related photograph *Wheels* (cat. no. 78) were shown in an exhibition at Wesleyan University. So it appears that Halpert's strictures were directed primarily against Sheeler's showing any new photography on a commercial basis; in terms of museum exhibits, he could do what he wanted, and judging from these and other exhibitions, he continued to like having his works in various media exhibited together de-

Fig. 74. Charles Sheeler, *The Cloisters*, 1945, gelatin-silver print, The Lane Collection.

Fig. 75. Charles Sheeler, *William Carlos Williams*, c. 1945, gelatin-silver print, The Lane Collection.

spite the risks of critical or popular misinterpretation.

Sheeler's paintings of the late forties and early fifties show his renewed energy. They are complex abstractions, dealing with industrial and urban scenes as well as barns and rural views. Frequently, he traveled through New England in search of subjects, making working photos of various possibilities. These have interest as preliminary studies for paintings, showing his working methods as they do, but Sheeler never intended them to stand on their own.

At the same time, however, his interest in photography as art, as an end in itself, slowly revived. His friendships with both Weston and Adams deepened, and he and Strand were

reconciled after being out of touch for many years. Strand wrote him in 1950 to tell of the rediscovery of the *Manhatta* print, also sending him a copy of *Time in New England*, the beautiful new book he and Nancy Newhall had done, and Sheeler responded with gratitude and warmth.[15] He and Strand remained close until Sheeler's death in 1965, and Strand later summed up his opinion of Sheeler's work: "Using photography as a separate medium with complete understanding of its special character and value, Charles brought to it a vision of American reality which reflected the sensitivity of a clear and very honest artist."[16]

Between 1950 and 1954, Sheeler made a new series of about twenty prints of New York, returning to a favorite subject from the

early twenties. He went back to lower Manhattan and the Wall Street area, where he had worked before; but – quite in keeping with his ongoing search for the newest and the best – he concentrated now on the burgeoning uptown East Side above 40th Street. In 1950 Sheeler began a series of pictures of Rockefeller Center and some neighboring structures; in 1951 he took several shots of the new United Nations Secretariat Building on the East River, and in 1953 went to Park Avenue to photograph another new building, Skidmore, Owings and Merrill's Lever House, which had been finished just the year before, and had been quickly hailed as the ultimate in modern architecture. The Rockefeller Center photographs are especially successful (see cat. nos.

86-90): they are strongly composed, and in their blocky, simple black-and-white format they refer directly back to Sheeler's Doylestown house series of 1917. In these prints New York is flattened, simplified, and taken out of context, just as Sheeler had done with the Doylestown interior. These are very different from his New York views of around 1920 (see cat. nos. 34-38).[17] The earlier prints explore dense, complex mysteries, in their interwoven forms reminding us of musical quartets; the pictures of the 1950s are flatter and more one-dimensional — more like solos on a single instrument. *Buildings in Shadows* of 1920 (cat. no. 36), for example, makes important use of black shadows created by raking light, and his 1950 print of the RCA Building (cat. no. 90) does the same. But in the earlier picture, the blacks create voids and volume and the reflections of smokestacks and smoke on the left side impart a sense of mystery, while in *RCA Building*, blacks are employed in an opposite way, to flatten the surface rather than to suggest depth and texture. In this photo, the triangular upper left corner reads as pure abstraction, as the creation of an artist; the massive building itself seems floating, rootless, an energetic gesture recalling the paintings of Franz Kline rather than urban reality.

These late New York photographs were never conceived as a series, with each print a single detail, each a unit of a larger whole, in the manner of the Chartres series. Although there are eight or nine prints that explore the architectural power of Rockefeller Center (even going across the street to St. Patrick's Cathedral), each one stands on its own, independently.

Another group of Sheeler prints comes closer in concept to the series of the twenties: these are his photographs of the huge copper beech tree that stood behind "Birds Nest," the stone house in Irvington-on-Hudson, New York, where the Sheelers had lived since 1942. Sheeler made about fifteen photographs of the tree around 1951, examining it as a whole and then in close detail, under varying light conditions. At times he was most concerned with the shape of its branches and the blackness of the shadows that cast; in other photographs he recorded every nuance, every wrinkle, of the tree's bark, paying hom-

Fig. 76. Charles Sheeler, *Musya in Bed*, c. 1948-50, gelatin-silver print, The Lane Collection.

Fig. 77. Charles Sheeler, *Edward Steichen and John Marin*, 1951, gelatin-silver print, The Lane Collection.

age to it as a living thing. And in *Beech Tree – Roots*, 1951 (cat. no. 83), Sheeler imparted to the tree an exotic, animalistic quality, recalling this quality in his photograph *Ladle on a Hot Metal Car* from the Rouge.

Sheeler had frequently made casual "candid" photos of his friends, in earlier days photographing William Carlos Williams (fig. 75), Edith Halpert, Sam Kootz, Matthew Josephson, and others. During the late forties and fifties, he did the same, taking pictures of people he was close to. He took many of Musya, shooting her in the nude in both a black-and-white (3-by-4-inch) series and in 35-mm. color slides; other black-and-white prints show her laughing, or leaning out of a window, or – on one occasion – sick in bed (fig. 76). He took several pictures of his good friend the violinist Sascha Jacobsen, smoking and drinking. In 1951 John Marin celebrated his eightieth birthday at Sheeler's house, and Edward Steichen came to join the celebration; Sheeler photographed Marin and Steichen with his 35-mm. Contaflex, and later made 8-by-10-inch prints of four of the negatives (see fig. 77). On another occasion, Sheeler drove to Marin's home in Cape Split, Maine, this time taking a small group of shots of the rocks and sea near Marin's house.

In 1954 Sheeler was honored with his second major retrospective exhibition of paintings, drawings, and photographs. This exhibition, organized by the University of California at Los Angeles and traveling to five other museums across the country, was far more successful critically than the 1939 exhibition at the Museum of Modern Art. The reviews were largely appreciative; in general they concluded that the seventy-one-year-old Sheeler was a major American painter who had an interest in photography. Once again William Carlos Williams wrote a foreword to the catalogue; it was followed by a brief essay by Bartlett Hayes, who had become a close friend during Sheeler's residency at Andover in 1946, and a fuller account of Sheeler's career by Frederick Wight.

Forty-eight paintings, five conté drawings, and twenty-eight photographs made up the show. The photography selection included

some of his best work, such as *Side of White Barn*, *Open Window*, and *The Lily – Mt. Kisco*, but many great works were left out. While three of Sheeler's Rockefeller Center prints of 1950 were shown, the seminal Doylestown works were for the most part excluded; and just one of the early architectural series of New York and only one of the Rouge prints was included. Hence, the selection was hardly intended to represent his full achievement in photography. It paid virtually no attention to Sheeler's photographic thinking, that is, how he explored a subject through serial investigation, and the early work was underrepresented. Sheeler may have been thinking both of nineteenth-century photography and of his own early work when he wrote in the catalogue, "When one goes back to our early photography whose mechanics was extremely simple and from our modern point of view often crude, it is easy to see that the present immense elaboration of means isn't very important.... Some of this early work has never been surpassed."[18]

The apparent intent of the show was to survey Sheeler's development and vision as a painter; photography was placed in a supporting role. As Wight put it in his essay, "The important thing ... is not that the River Rouge photographs were made, but that four or more years later – after a trip to Europe – the related paintings were to follow." Williams wrote in his foreword, "Sheeler is a painter first and last with a painter's mind alert to the significance of the age which surrounds him."[19]

One of the few critics to mention the distinction of Sheeler's photography was Alfred Frankenstein of the *San Francisco Chronicle*. "One gathers that for Sheeler, photography is in many ways a subtler art than painting," Frankenstein wrote, adding, "He is ... an artist of the monumental, the dynamic, the powerful and the objective, and in this he is surely a major master."[20]

The UCLA show afforded Sheeler an opportunity to travel to Los Angeles. He spent several weeks at Ansel Adams's home in San Francisco and saw Edward Weston at Wildcat Hill in Carmel; he traveled to Santa Barbara, visiting the home of collector Wright Ludington, and toured Yosemite National Park, where he photographed. He also made pho-

tographs in the San Francisco area, including a street scene taken from the base of Telegraph Hill, Coit Tower, a view to the bay, and several shots of the Pacific Gas and Electric power plant at Morro Bay. Sheeler's photograph of eucalyptus trees at Weston's recalls the earlier series portraying the beech tree in Irvington-on-Hudson. But photography was not his main interest by this time, for as he wrote to Weston shortly before the UCLA opening, "While I mostly paint, I enjoy an occasional vacation by making photographs."[21] This comment underscores the complete reversal in Sheeler's practice that had occurred, and stands in contrast to his statement of 1928 in which he said, "I continue in my dual role of photographing much and painting now and then."[22] A year after the UCLA show, he wrote to Ansel Adams that he had read about the new Tri-X film on the market, but he concluded wistfully, "That wouldn't be news to you who makes the headlines instead of reading them."[23] Adams knew Sheeler only from his late work, and thus naturally concluded: "I admire his photography but I believe he was even more impressive as a painter."[24]

In 1956 General Motors commissioned Sheeler to make a painting based on the theme "The Spirit of Research." At the company's corporate headquarters in Warren, Mi., Sheeler's interest was piqued by the Eero Saarinen staircase, with its complex network of steel extension cables. Sheeler made five photographs of the staircase, which he later used as studies for paintings. In June 1956, the artist returned to San Francisco with Musya, staying again with Adams, and then traveled to Sequoia National Park, Fresno, Kings Canyon, and Yosemite. On his return to New York, he made a series of stereo slides of the Colorado Rockies.

In 1959 Sheeler suffered a stroke, which effectively ended his career. The results of his later efforts to photograph are not known, but apparently he wanted to continue his work. In 1961 he wrote to Adams, "I manage to shuffle around. I expect to try using the Polaroid in the near future. What film do you advise for my Pathfinder? A nearby friend has generously offered to drive me around an area I do not know."[25]

When Sheeler died of a second stroke on

Fig. 78. Charles Sheeler, *Tanks at Cedarburg*, 1952,
gelatin-silver print, The Lane Collection.

May 7, 1965, the *New York Times* obituary was headlined, "Charles Sheeler, painter, 81, dead," followed by the subhead, "noted photographer."[26] The Museum of Modern Art shortly thereafter moved to acquire and exhibit a large selection of Sheeler's photography from the Sheeler estate. Sheeler's dealer, Edith Halpert, ever wary of the comparative criticism that resulted from Sheeler's paintings hanging with his photographs, decided instead to entrust the photographs to Sheeler's friend, the Massachusetts collector William H. Lane, who had begun his extensive collection of Sheeler's work in the early 1950s. As Halpert explained to Sheeler's widow, "It took me years and years to change the public attitude which was built up many years ago, indicating that he merely transferred one medium to another and I hate to see it revived."[27]

Sheeler had successfully turned his main attention from photography to painting in about 1930, with the result that his best photography — and the full range of his vision — remained little known. Critics were naturally inclined to believe that his photographs had always been a subsidiary interest, and it was not until after his death that his full achievements began to be studied.

In 1967 a full issue of *Contemporary Photographer* was devoted to Charles Millard's fine study "Charles Sheeler, American Photographer." Millard noted that at the end of Sheeler's career, his photography, which in its first decades "had been among the most advanced in the country … by 1959 was certainly among the most undeservedly unrecognized."[28] The next year, Millard contributed a shorter version of his study to the first Sheeler retrospective following the artist's death. Organized by the National Collection of Fine Arts, Washington, D.C., this show of some 170 works included 35 photographs. This relatively small sampling was enough for critics to begin a reappraisal of Sheeler and his photography. Abraham Davidson, writing in *Arts Magazine*, said, "The terrible neglect of Sheeler's photography (and in large part this was Sheeler's own fault) can be demonstrated in exhibition after exhibition."[29]

In one of the most perceptive pieces that

resulted from this exhibition, Hilton Kramer noted, "It is a paradox of Sheeler's career that photographs freed him from the excesses of illustration."[30] Modern appreciation of Sheeler's photography thus dates from the 1968 exhibition and from Millard's writings. However, the critics of that time continued in the effort to weigh his achievements in one medium against his accomplishments in others, just as Jewell had in 1939, feeling compelled to reach a conclusion that he was best as either photographer, painter, or draftsman, and failing to grasp his multilayered achievement as a whole.

Sheeler's art is about wholeness and continuity, present and past, shadow and substance, painting and photography; to attempt to judge one medium against another — a problem that led Sheeler himself to downgrade his photography — is to miss the unique aspects of each, and to disassemble the whole they comprise. As Millard pointed out, Sheeler was the same artist in each medium: "the photography-painting relationship is not one of cause and effect, but rather one of community of vision."[31] Moreover, Sheeler's approach was established very early with his first commissioned photographs of art and architecture, and nearly everything that followed can be seen as an outgrowth from this background. He worked analytically, almost always in series; his superb eye, his ability to find a similar abstract structure across the widest range of man's history and art, and the tender feelings with which his work is imbued become apparent only when his works in all media are studied together.

The fact is that Sheeler painted, drew, and made photographs throughout his life as an artist. Establishing himself first as a painter, as a rebellious Chase student who exhibited at the Armory Show in 1913, he went on between 1916 and 1930 to become a major leader in modern American photography. During the next twenty-five years, he explored with equal perspicuity the role photography could have in the making of paintings. His work as a straight photographer had won him the admiration and friendship of Stieglitz, Steichen, and Strand; his later, pioneering work in the uses of photographic imagery made him a forerunner of many divergent artists of the 1960s and 1970s, from the photorealists to a wide variety of others who have continued to experiment with the ways that painting can make use of photographic techniques and images. It is probably only today — at a time when photography is at long last accepted both as an art in its own right and as an acceptable "sketching" medium for painters — that the full range of Charles Sheeler's accomplishments can be finally understood.

NOTES

I

Photographer of Art and Architecture

1. Sheeler, in Constance Rourke, *Charles Sheeler, Artist in the American Tradition* (New York, 1938), p. 24.

2. See William C. Agee, *Morton Livingston Schamberg* (Salander-O'Reilly Galleries, Inc., New York, 1982).

3. Sheeler, in Rourke, *Sheeler*, pp. 25, 27-28.

4. See Thomas Craven, "Charles Sheeler," *Shadowland* 8 (March 1923): 70.

5. Sheeler's letter to Stieglitz of September 18, 1911 (now missing, its contents unknown) was acknowledged in a letter of the same date from Stieglitz's assistant at "291" (Stieglitz Archive, Beinecke Library, Yale University, New Haven, Conn.).

6. Schamberg to Walter Pach, 1912, in Ben Wolf, *Morton Livingston Schamberg* (Philadelphia, 1963), p. 24.

7. See Sheeler to Stieglitz, May 25, 1915, Stieglitz Archive.

8. Ben Wolf, *Schamberg*, p. 56. Schamberg also painted her on numerous occasions (see Wolf, fig. 26), in a Fauve, Matisse-influenced style.

9. Sheeler, in ibid., pp. 23-24.

10. *Lhasa* (fig. 5) must have been painted in January or February of 1916, as the exhibition was held March 13-25 that year. It was based on a photograph by John Claude White (fig. 6) from his book *Tibet and Lhasa* (Calcutta, 1907-8).

11. Sheeler to Stieglitz, October 28, 1916, Stieglitz Archive.

12. Stieglitz to Sheeler, November 1, 1916, Stieglitz Archive. By permission of the Alfred Stieglitz/Georgia O'Keeffe Archive, Collection of American Literature, Beinecke Rare Book and Manuscript Library, Yale University.

13. See Marius de Zayas, "How, When, and Why Modern Art Came to New York," intro. and notes by Francis M. Naumann, *The Arts* 54, no. 8 (April 1980): 96-126. For an excellent study of the development of American modernism and the New York gallery scene in the half-decade following the Armory Show, see Judith K. Zilczer, *The Aesthetic Struggle in America, 1913-1918: Abstract Art and Theory in the Stieglitz Circle* (Ph.D. diss., University of Michigan, Ann Arbor, 1975).

14. See Sheeler to Stieglitz, November 23, 1916, Stieglitz Archive. Here Sheeler writes, "Enclosed is a receipt for the $50.00 cheque you gave me and on an account of the prints delivered, so far."

15. See Wolf, *Schamberg*, p. 39.

16. Sheeler, in A. L. Chanin, "Charles Sheeler: Purist Brush and Camera Eye," *Art News* 54, no. 4 (Summer 1955): 71.

17. See the *Christian Science Monitor*, February 4, 1918.

18. Sheeler to Stieglitz, January 25, 1918, Stieglitz Archive.

19. See de Zayas to Quinn, October 23, 1918, Butler Library, Columbia University, New York. For a treatment of Quinn's role as collector and supporter of the avant garde, see Judith K. Zilczer, "The Noble Buyer," *John Quinn,*

Patron of the Avant Garde (Hirshhorn Museum and Sculpture Garden, Smithsonian Institution, Washington, D.C., 1978).

20. Sheeler to Quinn, received June 7, 1919, John Quinn Collection, New York Public Library.

21. Quinn to Sheeler, June 9, 1919, Quinn Collection.

22. De Zayas, Modern Gallery press release, 1915, Butler Library, Columbia University. In earlier years, de Zayas had been skeptical about whether a photograph could be a work of art.

23. See the review of Strand's show by Charles Caffin, *New York American*, Monday, March 20, 1916, p. 57.

24. See *New York Evening World*, April 7, 1917, quoted by de Zayas, "How, When, and Why Modern Art," p. 121. A search of the *Evening World* and the *World* reveals no such article as the one de Zayas quotes at length; however, his records on the whole are accurate, and it seems possible that the article appeared in the early edition of the *Evening World* on April 7, only to be bumped in favor of late-breaking war news that filled later editions.

25. See de Zayas, "How, When, and Why Modern Art," p. 121. If it is true that there were only fourteen prints in the show, as seems likely, then two of the photographers were probably represented by five works and one by four. The *American Art News* review (n. 26, below) refers to Sheeler's African work in the plural, so our hypothesis is that Sheeler exhibited two African pieces, one "obsidian" (black volcanic stone) piece from Mexico, the Brancusi, and one New York picture, five altogether. The print of the "obsidian mask" is in the Lane Collection; the one of the Brancusi may be the Sheeler photo of Brancusi's *Sleeping Muse* reproduced in *Vanity Fair*, August 1917, p. 47.

26. *American Art News* 15, no. 25 (March 31, 1917).

27. McBride, *New York Sun*, April 8, 1917.

28. Quinn to Epstein, June 27, 1919, Quinn Collection. No photographer was credited for the fifty reproductions in collotype in Van Dieren's *Epstein* (New York and London, 1920), but at least six and possibly as many as fourteen images depicting objects in the Quinn collection are by Sheeler.

29. Sheeler and de Zayas continued to correspond after de Zayas moved abroad, and Sheeler apparently continued to handle some of his New York affairs for him.

30. See below, chapter 3.

31. See also the cover Sheeler designed for the February 1925 *Aesthete*, which he based on a New York photograph from 1920, probably *Buildings in Shadows*, cat. no. 36).

II

Bucks County, 1917

1. See Naomi Rosenblum, *Paul Strand: The Early Years, 1910-1932* (Ph.D. diss., City University of New York, 1978), p. 66.

2. Stieglitz's letter to Sheeler dated March 1, 1917, asks for prints but does not specify their subjects: Weston Naef, in *The Collection of Alfred Stieglitz* (New York, 1978), p. 218, speculates that he was asking for the Doylestown house

series but gives no evidence for this; moreover, the full-grown corn seen in the background of cat. no. 9 gives further evidence for mid-summer.

3. See Marius de Zayas, "How, When, and Why Modern Art Came to New York," intro. and notes by Francis M. Naumann, *The Arts* 58, no. 8 (April 1980): 125. The de Zayas records indicate that the exhibition was called "Paintings and Photographs by Charles Sheeler," but there is no evidence from any of the reviews that any paintings were actually included.

4. For this and following information about the house, we are indebted to Karen Davies's very useful study "Charles Sheeler in Doylestown and the Image of Rural Architecture," *Arts Magazine* 59, no. 7 (March 1985): 135-39.

5. Sheeler to Henry Mercer, March 26, 1924, quoted in Davies, "Sheeler in Doylestown," p. 136.

6. *American Art News* 16, no. 10 (December 15, 1917): 3.

7. Frederick W. Eddy, *New York World*, December 9, 1917, p. 5.

8. Henry McBride, *New York Sun*, December 10, 1917, p. 7.

9. Sheeler (1822 Chestnut St., Philadelphia) to Stieglitz, November 22, 1917, Stieglitz Archive, Beinecke Library, Yale University, New Haven, Conn.

10. In addition, there might once have been a seventeenth negative in this series, for the conté crayon drawing of 1933 *Of Domestic Utility* (Museum of Modern Art, New York) represents the Doylestown house and must surely have been based on a photograph, and very likely one made in this summer of 1917. No such print or negative now exists, but Sheeler would occasionally destroy negatives that he had used as the basis for later works.

11. Among the prints we have included herein, cat. nos. 9, 12, 14, and 15 were on the largest mount; cat. nos. 11, 13, 15, 17, and 18 were on the second mount; and cat. nos. 10, 19, and 20 were on the third type.

12. On occasion in later years, Sheeler printed favorite early negatives in a small format for use as personal Christmas cards; he used *The Stove* and in 1928 *Buggy* in this way. Sheeler also made a few additional prints of several images, including *The Stove* and *Open Window*, during the 1930s; these are on a white paper that lacks the warm tone of the 1917 printings.

13. Sheeler to Stieglitz, December 1, 1917, Stieglitz Archive. Sheeler wrote: "That you should express so much interest in the photographs I have been making is a tremendous satisfaction. ... I am glad that your interest focuses in the photographs of my house – and with full realization of my presumption may I inquire whether you would care to exchange a print with me for several of my series of the house?"

14. Strand, in Rosenblum, *Strand*, p. 67 (citing an interview of July 6, 1975).

15. Both the works date from 1916, according to Naomi Rosenblum's persuasive analysis in *Strand*, p. 56.

16. De Zayas, "How, When, and Why Modern Art," p. 104.

17. This comparison is suggested by Susan Fillin-Yeh in *Charles Sheeler: American Interiors* (Yale University Art Gallery, New Haven, Conn., 1987), p. 9. Fillin-Yeh also suggests that Sheeler and Schamberg "whitewashed" and

otherwise modernized the interior of the Doylestown house (p. 12). Certainly they must well have stripped it of old furnishings, curtains, and the like, but the first-floor room (see cat. nos. 11-16) shows no signs of having been whitewashed. However, the upstairs room (see cat. nos. 17-19) has a different look, with the beams, the baseboard, and the inside of the closet and back of the stair risers all painted or whitewashed.

18. Stieglitz, in the International Center of Photography's *Encyclopedia of Photography* (New York, 1984), p. 127.

19. See Naef, *The Collection of Alfred Stieglitz*, p. 359ff. Stieglitz also selected seven Evans prints for inclusion in the important "International Exhibit of Pictorial Photography" at Buffalo in 1910. See also Beaumont Newhall, *Frederick H. Evans* (Millerton, New York, 1973): in his preface, Newhall wrote of "...one view of an attic of an old English house with hand-hewn beams that reminded me of Charles Sheeler."

20. Constance Rourke, *Charles Sheeler: Artist in the American Tradition* (New York, 1938), p. 67.

21. Sheeler to Newhall (undated), in Beaumont Newhall, "Photo Eye of the 1920s: The Deutsche Werkbund Exhibition of 1929," in *Germany: The New Photography, 1927-33*, ed. David Mellor (London, 1978).

22. E.g., *Landscape No. 1* (1915; Fogg Art Museum, Harvard University, Cambridge, Mass.).

23. E.g., *Barns (Fence in Foreground)* (1917; Albright-Knox Gallery, Buffalo, N.Y.).

24. With the exception of this work, Sheeler called all of the barn pictures simply *Pennsylvania Barn* or *Bucks County Barn*, just as all of the photographs of the house were titled by him *Pennsylvania House*. Our practice in this catalogue has been to honor Sheeler's own title where it exists; if none exists, we have used titles that have been accepted over many years (such as *Side of White Barn*, *Stairwell*, etc.) and assigned simple new descriptive titles in other cases.

25. Sheeler, in Rourke, *Sheeler*, p. 121.

26. W. G. Fitz, "A Few Thoughts on the Wanamaker Exhibition," *The Camera* 22 (April 1918): 205. Fitz was a pictorial photographer whose work was included in the same exhibition; he was awarded four $5 prizes by the jury.

27. Ibid., p. 202. After the exhibition, Sheeler wrote Stieglitz to thank him, saying: "Someone on the Wanamaker jury must have been prejudiced in my favor, I am convinced. For that which happened would not have happened otherwise" (March 18, 1918, Stieglitz Archive).

28. This dating seems to have begun with the catalogue for Sheeler's Museum of Modern Art retrospective exhibition of 1939; as Sheeler doubtless was consulted, the dates assigned therein have some weight. On the other hand, stylistic evidence seems to contradict some of this traditional dating and it seems likely that Sheeler could simply have been a year or two off in his dating of the early photographs.

29. See Douglas K. S. Hyland, "Agnes Ernst Meyer, Patron of American Modernism," *American Art Journal* 12, no. 1 (Winter 1980): 64-81. Many of the Meyers' major modern works were given to the National Gallery of Art, while the bulk of their Chinese art went to the Freer Gallery, Washington, D.C.

30. Agnes Meyer to de Zayas, undated (1915?), Marius de Zayas Papers, Rare Book and Manuscript Library, Columbia University. De Zayas apparently did not take this advice completely to heart, and as late as April, 1923 he wrote the Preface for Stieglitz's exhibition of 116 photographs at the Anderson Gallery in New York.

31. Sheeler, taped conversation with William H. Lane, October 24, 1958 (The Lane Collection).

32. See Keith N. Morgan, *Charles A. Platt: The Artist as Architect* (New York, 1985), p. 124. Charles Lang Freer had already commissioned Platt to do both a country house and the Freer Gallery in Washington, and he suggested Platt to his friends the Meyers. According to Morgan and to the Meyer family, the house was completed in 1919. Sheeler must have photographed it shortly after it had been completed, furnished, and landscaped.

33. Sheeler, conversation with Lane, October 24, 1958. The book now belongs to the Century Association, New York, and is on loan to the Museum of Modern Art. We are most grateful to John Szarkowski for bringing the book to our attention.

34. Sheeler, August 10, 1923 (Agnes Meyer Correspondence, Library of Congress, Washington, D.C.). Mrs. Meyer was again in close touch with Sheeler in the last years of his life, and after he became ill in 1959 she made regular annual gifts of $3,000 to Sheeler and $3,000 to his wife.

35. See Hyland, "Agnes Ernst Meyer," p. 81.

36. A handwritten catalogue list survives (private collection), listing the thirty-nine works by title but not by medium. The dates of the above were February 16-28, 1920. Photographs of African sculpture were simply called *Still Life — Congo* and the like.

37. *American Art News* 18, no. 18 (February 21, 1920): 3.

38. McBride, *New York Sun* and *New York Herald*, February 22, 1920, sec. 3, p. 7.

III

Film-making

1. Constance Rourke, *Charles Sheeler, Artist in the American Tradition* (New York, 1938), p. 37. We are grateful to Thurman Naylor for confirming our identification of these and the Katharine prints as being stills from 35-mm. films.

2. Later in life, Sheeler made photographs of his second wife, Musya, in the nude; she is shown in bed and seated outdoors on a blanket.

3. *Nude*, Museum of Fine Arts, Boston. A second drawing, made from another of the Katharine stills, is undated (*Nude Torso*, c. 1920, Art Institute of Chicago). *Flower Forms* is in the Daniel J. Terra Collection, Terra Museum of American Art; it was purchased from de Zayas by John Quinn in February 1920. The original title of this painting was *Forms — Flowers*, which was more suggestive of the possible anatomical reference.

4. Karen Lucic, conversation with the authors reporting on her October 9, 1984, interview with Richard Kyle, nephew of Katharine Shaffer, May 29, 1987.

5. Stieglitz to Strand, May 20, 1919, Stieglitz Archive, Beinecke Library, Yale University, New Haven, Conn.

6. In terms of composition, Sheeler's nudes are also worth comparing to those of Edward Steichen, especially those published in *Camera Work* in April 1903, which, like Sheeler's, also exclude the model's face.

7. De Zayas gave this piece to the Prado in 1944. Contemporary scholars doubt its authenticity.

8. Sheeler, "Notes on an Exhibition of Greek Art," *The Arts* 7 (March 1925): 153.

9. By August 7, 1919, Sheeler was staying at the Continental Hotel, New York, and was installed at 160 East 25th Street by September. See Sheeler to Quinn, August 7, 1919, and September 12, 1919, John Quinn Collection, New York Public Library.

10. Stieglitz to Strand, November 17, 1918, Stieglitz Archive.

11. Strand to Mrs. Shreve, August 9, 1919, Stieglitz Archive.

12. Strand to Richard Shales, March 31, 1975, Strand Archive, Center for Creative Photography, University of Arizona, Tucson. Courtesy of Aperture Foundation, Inc., Paul Strand Archive, Millerton, N.Y.

13. Strand, interview by Milton Brown and Walter Rosenblum, November 1971, quoted in Jan-Christopher Horak, "*Manhatta*'s Mannahatta; or, The Romantic Impulse in American Film Modernism" (unpublished).

14. Strand to Millard, October 13, 1965, Strand Archive.

15. Ibid.

16. Strand, press release, Strand Archive.

17. "The film was shot at silent speed of 16 frames, not the 24 frame speed that came with the advent of sound, hence with the latter, the projector should be accordingly slowed." Strand to Miller, January 24, 1969, Strand Archive.

18. Recent scholars have viewed the film in various ways. Scott Hammen, in "Sheeler and Strand's 'Manhatta': A Neglected Masterpiece," *Afterimage* 6 (January 1979), sees it as the first independent, noncommercial and nonnarrative film masterpiece, despite its use of obtrusive intertitles taken from Whitman. Hammen writes that "Strand and Sheeler's impulse was a radical one....That the visual power that painting and photography aimed for should become a goal for the movie camera as well, with story telling and theatrical artifice ignored, was a brave step in the history of cinema" (p. 6). Dickran Tashjian, in *Skyscraper Primitives* (Middletown, Conn., 1975) considers it a quasi-modernist film abstraction in which Sheeler and Strand "occasionally employ a Cubist vocabulary," where rooftops "take on the guise of cubist *passage*, with ambiguously interlocking forms" (pp. 221-22). The most recent view is in Jan-Christopher Horak, "*Manhatta*'s Mannahatta." This excellent forthcoming article, which works out a detailed geography for the film within a five-block radius, is the first serious attempt at an in-depth stylistic analysis. Horak argues that the film has a narrative closely identified with the Whitman intertitles, so that it is as much based on Whitman's romantic impulses as it is a modernist, avant-garde work conceived strictly in terms of abstraction and machine age culture.

19. See *New York Times*, July 25, 1920, p. 16, and August 22, 1920, p. 13.

20. Stieglitz to Strand, October 27, 1920, Stieglitz Archive.

21. Stieglitz to Strand, August 10, 1920, Stiegtlitz Archive.

22. See Stieglitz to Strand, August 24, 1920, Stieglitz Archive.

23. Stieglitz to Strand, September 12, 1920, Stieglitz Archive.

24. See Naomi Rosenblum, *Paul Strand: The Early Years, 1910-1932*, (Ph.D. diss., City University of New York, 1978), p. 97.

25. Robert Allerton Parker, "The Art of the Camera: An Experimental Movie," *Arts and Decoration* 15, no. 6 (October 1921): 369.

26. See Duchamp to Strand, August 8, 1922, Strand Archive. Also, de Zayas evidently was attempting to arrange a Paris showing as of September 1921: see Stieglitz to Strand, September 13, 1921, Stieglitz Archive.

27. Gould's correspondence with Sheeler and Strand reveals that Sheeler sent him the titles and Strand separately provided the print of the film: see Strand Archive. In 1975, Strand told Richard Shales, "You can check how Mannahatta is spelled by referring to the Whitman poem," i.e., "Mannahatta." However, he added, "I could be wrong" (Strand to Shales, March 31, 1975, Strand Archive).

28. Horak, "*Manhatta*'s Mannahatta."

29. Strand to Shales, March 31, 1975, Strand Archive.

30. The opening shot is a broad view of the city, showing, from the left, Battery Place, the American Bureau of Shipping, the Equitable Building, the Banker's Trust Building, and other towers seen from the New Jersey shoreline. It is followed shortly by a denser view of the Manhattan skyline, which recalls photographs by Stieglitz from 1910 such as "City of Ambition" and "City Across the River." The early shots fully establish the locale the film will investigate. Like the initial pictures in each of Sheeler's major photographic series, which have a somewhat documentary look, these scenes establish a framework for the artist's abstracting vision. We are indebted to Jan-Christopher Horak for identifying many of the buildings.

31. For some of Dow's comments on photography, see his "Painting with Light," *Pictorial Photographers of America Year Book* (New York, 1921). Here he wrote, for example, "'What is design?' Ask Korin, Hiroshigè, Giotto, Rembrandt, Titian; ask the Master photographers who can build harmonies of line and space and texture." A connection to Dow was pointed out by Mike Weaver in a lecture delivered at the Center for Creative Photography, University of Arizona, Tucson, September 23, 1986. Weaver compared the language of Strand's press release to that of Dow's *Composition*, 1899. Weaver also dealt interestingly with the film's contradictory impulses and likened the use of smoke to the "fade-out effect" of traditional Japanese screen painting. For a study of Dow's influence on modernist American art, see Frederick C. Moffatt, *Arthur Wesley Dow*, (Washington, D.C., 1977) and Marianne W. Martin, "Some American Contributions to Early Twentieth Century Abstraction," *Arts Magazine* 54, no. 10 (June 1980): 158-65.

32. In Rourke, *Sheeler*, p. 90.

33. Horak, "*Manhatta*'s Mannahatta."

34. Tashjian, "The Soil and Contact," *Skyscraper Primitives*, pp. 72-73. In the first issue of *The Soil*, 1 (December 1916): 3, Coady praised a "young, robust, energetic, naive" American art, listing as examples, "The Panama Canal, the Sky-scraper and Colonial Architecture, The East River, The Battery and the 'Fish' Theatre, The Tug Boat and the Steam Shovel..."

35. Sheeler, "'Pictorial Beauty and the Screen,' by Victor O. Freeburg: New York, The Macmillan Company, 1924," *The Arts* 5, no. 5 (May 1924): 293.

36. The image was reproduced in Forbes Watson's "Charles Sheeler," *The Arts* 3 (May 1923): 341. In a letter to Stieglitz dated August 31, 1921 (Stieglitz Archive), Strand discusses his and Sheeler's inquiries with the Frank Presbrey Company. Sheeler also made the painting *Pertaining to Yachts and Yachting* (1922; Philadelphia Museum of Art) and a related series of drawings and lithographs based on sailboats in motion between 1922 and 1924. Conceivably, they resulted from a film investigation, although no film or photograph survives. In two letters to Stieglitz (June 1923 [?] and July 9, 1923, Stieglitz Archive), Strand mentioned filming the New York Yacht Club's August 1923 cruise; however, by this time Strand and Sheeler were no longer collaborators.

37. Stieglitz to Strand, September 16, 1920, Stieglitz Archive.

38. Stieglitz to Strand, September 13, 1920, Stieglitz Archive.

39. For example, Stieglitz, in his letter to Strand on September 13, 1921, wrote: "I don't know how much credit de Z. gives you in the reel. And really how much Sheeler does" (Stieglitz Archive).

40. Conversation with Anthony Montoya, Director, Paul Strand Archive, Millerton, New York, June 30, 1987.

41. H. G. Wells, in a foreword to Coburn's earlier *New York* volume (London and New York, c. 1910), had cited the Park Row as part of the remedy to the city's lateral expansion, rising up as one of "the splendid fountains of habitation" (p. 9). Once the tallest building in the world, it was depicted by Coburn from the Broadway side, where it stands unmistakably distinct amid the plumes of smoke that Sheeler and Strand also exploit.

42. Weston, *The Daybooks of Edward Weston*, ed. Nancy Newhall (Rochester, N.Y., 1966), pp. 6, 190, 242. Note also that Weston wrote a foreword to Merle Armitage's *Edward Weston* (New York, 1932).

43. *American Art News* 20, no. 25 (April 1, 1922): 6.

44. *New York Times*, April 9, 1922.

45. Strand, "Alfred Stieglitz and a Machine." This article was printed privately in New York in 1921, following Stieglitz's exhibition at the Anderson Galleries. It was reprinted in *MSS.* 2 (March 1922): 6-7.

46. Georgia O'Keeffe, "Can a Photograph Have the Significance of Art," *MSS.* 4 (December 1922): 17. Sheeler's comments appear on p. 3; De Zayas's remarks are on p. 18.

47. Thomas Craven, "Charles Sheeler," *Shadowland* 8 (March 1923): 11, 71-72.

48. Henry McBride, "Salons of America Now Include Art Specimens of Entire World," *New York Herald*, May 27, 1923, sec. 7, p. 7.

49. Sheeler, "Recent Photographs by Alfred Stieglitz," *The Arts* 3 (May 1923): 345.

50. See *The Second Exhibition of Photography by Alfred Stieglitz* (Anderson Galleries, New York [1923]).

51. Stieglitz, ibid.

52. Arthur Boughton, "Photography as an Art," letter to the editor, *New York Sun and The Globe*, June 10, 1923, p. 22.

53. Paul Strand, "Photographers Criticized; Support for View That They Do Not Understand Own Art," letter to the editor, *New York Sun and The Globe*, June 27, 1923, p. 20. The letter was written at the suggestion of Herbert Seligmann. See Strand to Stieglitz, Tuesday, (June 1923?), Stieglitz Archive.

54. Stieglitz to Strand, June 28, 1923, Stieglitz Archive. Stieglitz was responding here to Sheeler's letter (June 22, 1923) to Strand: "Any exception that Stieglitz may have taken, through you...is quite alright" (Stieglitz Archive).

55. Watson also used Sheeler's painting *Vermont Landscape* (1924; private collection) to illustrate *The Arts* review of the 1925 Tri-national Exhibition at Durand-Ruel Galleries, New York, in July.

56. Sheeler to Constance Rourke, undated reply to letter of January 12, 1938. This reply appears in a notebook Sheeler kept recording his answers to questions Rourke posed when writing the biography. The notebook is located in the Archives of American Art, Smithsonian Institution, Washington, D.C.

57. See Strand to Stieglitz, September, 17, 1924, Stieglitz Archive. As Strand put it, "White asked me to contribute a print or two for Paris. I think he said he wrote you. Sheeler gave him a couple of prints."

IV

Condé Nast and Ford

1. See Naomi Rosenblum, *Paul Strand: The Early Years, 1910-1932* (Ph.D. diss. City University of New York), pp. 82ff.

2. Charles W. Millard, "Charles Sheeler: American Photographer," *Contemporary Photographer* 6 (1967), says that Sheeler also worked for the Canada Dry Company and Koehler Plumbing accounts, but gives no source for this.

3. We are grateful to Thurman Naylor for kindly identifying the subject of this photograph.

4. Condé Nast himself began as advertising director of Collier's. In 1909 he purchasèd *Vogue*, which became, in the years before his death in 1942, the leading American fashion magazine, especially known for the quality and quantity of its advertising pages. Condé Nast purchased *Vanity Fair* in 1913; it won a distinguished reputation but never paid well, and in 1936 he merged it with *Vogue*. See Frank L. Mott, *A History of American Magazines*, 5 vols. (Cambridge, Mass., 1951).

5. *Vanity Fair*, May 1920, p. 80.

6. A photograph of the Park Row Building was illustrated in *Vanity Fair*, January 1921, p. 72; the painting *Church Street El* in the April 1921 edition; the *Manhatta* stills in April 1922; and the photograph *Open Door* (as *The White Door*) in April 1923. The caption for the last reads: "Shee-

ler is an American painter who has lately interested himself in photographing certain Pennsylvania interiors of the early eighteenth century. In this example of his camera work the painter is everywhere evident — as well as the tranquil and simplified beauty of the Dutch interior."

7. *Vanity Fair*, March 1923, p. 52. The artists included were Sheeler, William Zorach, Joseph Stella (shown with Marcel Duchamp), John Marin, Charles Demuth, Marsden Hartley, and Max Weber.

8. Sheeler to Arensberg, January 10, 1927, Arensberg Archives, Charles Sheeler Papers, Philadelphia Museum of Art, Twentieth Century Department.

9. Sheeler to Arensberg, October 25, 1927, Arensberg Archives, written on the stationery of the Detroit-Leland Hotel, Detroit.

10. Ibid.

11. Mary Jane Jacob and Linda Downs, *The Rouge: The Image of Industry in the Art of Charles Sheeler and Diego Rivera* (Detroit Institute of Arts, 1978), p. 7.

12. Allan Nevins and Frank Ernest Hill, *Ford: Expansion and Challenge, 1915-1933* (New York, 1957), p. 201.

13. Jacob and Downs, *The Rouge*, p. 7.

14. See Robert Lacey, *Ford: The Man and the Machine* (Boston, 1986), p. 285.

15. Ibid, p. 299.

16. Ibid, p. 298.

17. See Ralph M. Hower, *The History of An Advertising Agency: N. W. Ayer and Son at Work, 1869-1949* (Cambridge, Mass., 1949). On Vaughn Flannery (1898-1955), see the *Philadelphia Inquirer*, December 27, 1955, obituary; *Time*, October 29, 1951, p. 86. Other artists used by Ayer and Son included Georgia O'Keeffe, Edward Steichen, and Ansel Adams.

18. Susan Fillin-Yeh, "Charles Sheeler: Industry, Fashion and the Vanguard," *Arts Magazine* 54, no. 6 (February 1980): 154ff.

19. Sheeler to Arensberg, October 25, 1927, Arensberg Archives.

20. Sheeler to Arensberg, February 6, 1929, Arensberg Archives.

21. Sheeler, in Rourke, *Sheeler*, p. 130.

22. Nevins and Hill, *Ford*, p. 288. But according to Lacey (*Ford*, p. 302), "It was a minor miracle that any Model A's were completed by the car's launch date in December 1927, and the production line did not get up full speed for six months or more."

23. Sheeler to Arensberg, October 25, 1927, Arensberg Archives. Rourke (*Sheeler*, p. 24) implies that most of Sheeler's six weeks at the Rouge were spent looking and planning, and that the photographs were taken at the end, but this apparently was not the case.

24. Related panoramic views are also found in *Coke Oven Area* (fig. 41), and *Cranes at the Boat Slip* (cat. no. 47).

25. With regard to titles, it should be noted that Sheeler called all of this series simply *Ford Plant*, and the descriptive titles we use are those that have been generally accepted through traditional use or, where such traditional titles are lacking, have been assigned by the authors.

26. *Vanity Fair*, February 1928, p. 62.

27. Eugene Jolas, *Transition* 18 (1929): 123.

28. Jacob and Downs, *The Rouge*, p. 29.

29. *Arts et Métiers Graphiques* 16 (March 15, 1930): no. 93 (ill.); E. P. Norwood, *Ford: Men and Methods* (Garden City, N.Y., 1931), facing p. 12 (ill.).

30. Norwood, *Ford*, facing p. 156.

31. Sheeler to Arensberg, August 7, 1939, Arensberg Archives.

32. See Jacob and Downs, *The Rouge*, p. 31. The authors of this excellent catalogue make a similar analysis but apparently did not notice Sheeler's use of *Power House No. 1*.

33. Twenty-eight of the original thirty-two photographs of the Rouge series are known from original prints by Sheeler and are reproduced here, including fifteen photographs in the exhibition (nos. 43-57) and thirteen illustrations in the text (figs. 41 - 53). Four other Rouge images are known, however. They are: *Blast Furnace and Skip Bridge*, reproduced in E. P. Norwood, "Where Two Nickles Are No Dime," *World's Work* 60 (1931): 32-33, 107, and also in Jacob and Downs, *The Rouge*, fig. 89; *Storage Bins at the Boatslip*, in Jacob and Downs, *The Rouge*, fig. 14 (from a copy negative at Ford Archives, Henry Ford Museum, Dearborn, Michigan); *Pouring Molten Iron from Ladle*, known from Norwood, *Ford*, facing p. 156, and Jacob and Downs, *The Rouge*, fig. 11; and *Base of the Blast Furnace*, in Jacob and Downs, *The Rouge*, fig. 11 (from a copy negative at Ford Archives). In addition, it should be noted that two nearly identical negatives existed for *Blast Furnace and Dust Catcher* (cat. no. 48) (both prints are in The Lane Collection), in one, the man on the left has his arm down, while in the other it is raised.

34. Sheeler to Arensberg, January 11, 1928, Arensberg Archives. There are a number of Ford and Lincoln photographs in the newspaper of this year that may be by Sheeler, but they are not credited, and it is difficult to distinguish them from the work of other photographers on stylistic grounds.

35. See Jacob and Downs, *The Rouge*, pp. 40-41, for a discussion of *City Interior* and a small-sized variant — doubtless taken from yet another Rouge photo — showing the tracks and railway cars in the center of the composition.

36. It should be noted in addition that certain of the known Rouge photographs were used as compositional sources for works in other media. For example, *Pulverizer Building* (cat. no. 46) was the basis for the conté crayon drawing *Industrial Architecture* (1931; Coll. Ruth Wittenberg, New York), and *Blast Furnace and Dust Catcher* (cat. no. 48) was used, after cropping at the bottom and right, for *Industrial Forms* (1947; The Lane Collection).

37. Nevins and Hill, *Ford*, p. 295.

38. Samuel M. Kootz, "Ford Plant Photos of Charles Sheeler," *Creative Art* 8, no. 4 (April 1931): 265.

V

Chartres

1. Sheeler to Walter Arensberg, August 14, 1929, Arensberg Archives, Charles Sheeler Papers, Philadelphia Museum of Art, Twentieth Century Department.

2. Only fifteen of the twenty-one negatives (all The Lane Collection) were developed by Sheeler; fourteen images, printed both in sepia and on cool-toned paper, made up the series; the fifteenth image, depicting the cathedral from the Porte-Guillaume, with the foreground figure of a photographer seen from behind in the act of shooting Chartres, was printed but was never included in the series.

3. Herbert Lippmann, "The Machine Age Exposition," *The Arts* 11, no. 6 (June 1927): 324-26.

4. See also Alfred H. Barr's article advocating that modern architecture reject the decorative rhetoric of the Gothic revival: "The Necco Factory," *The Arts* 13, no. 5 (May 1928): 292-95.

5. Albert Gleizes, quoted in Patrick L. Stewart, "The European Art Invasion: American Art and the Arensberg Circle, 1914-1918," *Arts Magazine* 51, no. 9 (May 1977): 110.

6. Henry Adams, *The Education of Henry Adams*, ed. Ernest Samuels (Boston, 1974), pp. 304-5.

7. Adams, *Mont St. Michel and Chartres* (Boston, 1913), p. 56.

8. W. Frederick Stohlman, "A Window from Chartres," *The Arts* 12, no. 5 (November 1927): 271-74.

9. Sheeler, in Constance Rourke, *Charles Sheeler, Artist in the American Tradition* (New York, 1938), pp. 129-30.

10. Sheeler called all of this series simply *Chartres*; we have added descriptive titles in order to identify each image.

11. René Merlet, *The Cathédral of Chartres* (Paris, 1926), p. 11.

12. This dramatic sense of arrival, beginning with the distant view, was important for Sheeler, and his own recollections recapitulate the photographs: "The approach to the town with the Cathedral seen towering over from its elevation — the increasing emotional response — arrival at the portal — then the moment of entering — a sense of place that one had never known before, or since — the momentary illusion that by accepting the religion that brought it into being the union would be perpetuated — the realization that it was not a moment to be made captive. Out into the sunshine again — walking and looking but no photographs. Something of the ego of the artist must be restored before the illusion of equality could be established and work became possible" (Sheeler, unpublished autobiography, Archives of American Art, Smithsonian Institution, Washington D.C.).

Sheeler's strong emotional response to Chartres and its culture was not simply an isolated incident, for as late as 1959 he told an interviewer that he had considered becoming a Catholic, and had discussed it with a priest in the early fifties, saying, "I felt pretty much attracted at that time to the Church. I've gone in the other direction, since then" (interview by Bartlett Cowdrey, December 9, 1958, Archives of American Art, Smithsonian Institution, Washington, D.C., p. 42).

13. Sheeler to Arensberg, August 14, 1929, Arensberg Archives.

14. Adams, *Mont St. Michel and Chartres*, pp. 109, 111.

15. Jean Bony, *French Gothic Architecture of the 12th and 13th Centuries* (Berkeley, Calif., 1983), pp. 198, 233.

16. See Etienne Houvet, *Cathédrale de Chartres* (Chelles, 1919).

17. Adams, *The Education of Henry Adams*, p. 388.

18. Sheeler, in Rourke, *Sheeler*, p. 130. Sheeler made only

one known work on a Chartres theme in another medium: this was a conté drawing based on *Flying Buttresses at the Crossing*, which he presented to his dealer, Edith Halpert.

19. See Beaumont Newhall, "Photo Eye of the 1920s: The Deutsche Werkbund Exhibition of 1929," in *Germany: The New Photography, 1927-33*, ed. David Mellor, (London, 1978), p. 78. Weston restates the case for straight photography and rails against amateurs, impressionists, and "mere technicians."

20. Edward Weston, "America and Photography," in *Edward Weston on Photography*, ed. Peter C. Bunnell (Salt Lake City, 1983), p. 55.

21. The ten Americans included were: Berenice Abbott, Anton Bruehl, Imogen Cunningham, Paul Outerbridge, Charles Sheeler, Edward Steichen, Ralph Steiner, Roger Sturtevant, Brett Weston, and Edward Weston. Significantly, neither Strand nor Stieglitz was included.

22. See Newhall, "Photo Eye of the 1920s," p. 83.

23. "Photographs of New York by Charles Sheeler," *Cahiers d'Art* 4-5 (1927): 130-32. Four photographs were reproduced, including cat. nos. 35 and 38, and fig. 36.

24. Katherine Grant Sterne, "American Versus European Photography," *Parnassus* 4, no. 3 (March 1932): 16.

25. Sheeler to Arensberg, August 14, 1929, Arensberg Archives.

26. Ibid.

VI

The Thirties

1. Sheeler, taped conversation with William H. Lane, February 1, 1959 (The Lane Collection). It is also possible that Condé Nast was dissatisfied with Sheeler's work by this time, though there is no evidence of this.

2. Sheeler, "A Brief Note on the Exhibition," in *Charles Sheeler* (Museum of Modern Art, New York, 1939), p. 10.

3. See Susan Fillen-Yeh, *Charles Sheeler and the Machine Age* (Ph.D. diss., City University of New York, 1981), chap. 4.

4. Sheeler, in Constance Rourke, *Charles Sheeler, Artist in the American Tradition* (New York, 1938), p. 143.

5. Sheeler, taped conversation with Lane, February 1, 1959. Sheeler's other statements in this paragraph are from the same source.

6. See Julien Levy, *Memoir of an Art Gallery* (New York, 1977): "I was never truly a disciple of Alfred Stieglitz, unconvinced, certainly, of his mystique as an art dealer, which, at any rate, I did not entirely understand. His professed mission was to dismay the rich into uncalculated sacrifices at the altar of art, and to defend the sacred artist with selfless devotion. I was more inclined to think that capital and art were irreconcilable" (p. 47).

7. See David Travis, *Photographs from the Julien Levy Collection; Starting with Atget* (Chicago, 1976), p. 15. Also included was the work of Frank Eugene, Anne Brigman, Joseph T. Keiley, Gertrude Käsebier, and Paul Haviland. (See also *New York Times*, November 3, 1931, p. 29).

8. Walter Knowlton, "Around the Galleries," *Creative Art* 9 (December 1931): 49. (Knowlton goes on to say: "Thus even Paul Strand falls somewhat short of the achievement of Sheeler in that he is constantly reminding one of some wonder of nature.")

9. A Chartres photo (at the Eastman House, Rochester, N.Y.) was included in the "First Annual Philadelphia International Salon of Photography," March 1932, Pennsylvania Museum of Art, 69th Street Branch. At the Brooklyn Museum's "First International Photographers" show, March 8-31, 1932 (a scaled-down American-oriented version of *Film und Foto*). Sheeler was represented by *Pennsylvania Barn* (probably *Side of White Barn*), three Ford prints, and two of Chartres. There were ten Sheeler prints, again stressing Ford and Chartres, at the exhibition at the Albright Art Gallery in Buffalo, "Modern Photography at Home and Abroad," February 7-25, 1932. *Industry* (fig. 54) was in the Museum of Modern Art exhibition of "Murals by American Painters and Photographers," 1932, organized by Lincoln Kirstein and Julien Levy.

10. Sheeler to Adams, September 25, 1933, Ansel Adams Archive, Center for Creative Photography, University of Arizona, Tucson. See also Adams to Sheeler, September 30, 1933, urging Sheeler to reconsider so that his work would be seen in the west; and Sheeler to Adams, October 10, 1933, reaffirming his refusal. Quotation courtesy of Trustees of The Ansel Adams Publishing Rights Trust.

11. Halpert to Edsel Ford, March 7, 1934, Downtown Gallery Papers, Archives of American Art, Smithsonian Institution, Washington, D.C.

12. Sheeler to Arensberg, June 27, 1933, Arensberg Archives, Charles Sheeler Papers, Philadelphia Museum of Art, Twentieth Century Department.

13. See Carol Troyen "From the Eyes Inward," in Troyen and Erica E. Hirshler, *Charles Sheeler: Paintings and Drawings* (Museum of Fine Arts, Boston, 1987), chap. 4, n. 6, 7.

14. See Susan Fillen-Yeh, *Charles Sheeler: American Interiors* (Yale University Art Gallery, New Haven, Conn., 1987), p. 67, citing Sheeler's letter to Kenneth Chorley, September 29, 1936 (Archives of Colonial Williamsburg).

15. Sheeler declined an invitation to have "a small display" of his Williamsburg photographs at Colonial Williamsburg, writing that they were "of the nature of notes for possible future reference, rather than photographs of pictorial interest" (Sheeler to B. W. Norton, August 16, 1939, Archives of Colonial Williamsburg).

16. Sheeler to Weston, January 27, 1939(?), Edward Weston Archive, Center for Creative Photography, Tucson. Here Sheeler also noted having recently acquired a 9-by-12-cm. Linhoff camera. ("I've used [it] just enough to know it offers future pleasure.")

17. Sheeler to Arensberg, June 4, 1940, Arensberg Archives.

18. *Wheels* was doubtless one of a series of photographs made in preparation for the painting *Rolling Power* (1939; Smith College Museum of Art, Northampton, Mass.). Another photograph, now lost, taken within minutes of *Wheels* (judging from the slight changes in the shadows) and which included a second large drive wheel and gear assembly, would have been used as Sheeler's compositional blueprint for the painting.

19. Edward Weston, "Photographic Art," *Encyclopaedia Britannica*, 1942, p. 796. See esp. pl. 2.

20. See Brian Hollingsworth, *Illustrated Encyclopedia of the World's Steam Passenger Locomotives* (London, 1982), p. 125.

21. Ibid.

22. See Troyen and Hirshler, *Charles Sheeler: Paintings and Drawings*, chap. 4.

23. *Life*, August 8, 1938, pp. 42-45. The heading "Painter Sheeler's Second Love Is Photographing Plain Things" appears on p. 45.

24. Edwin Alden Jewell, "Sheeler in Retrospect," *New York Times*, October 8, 1939.

25. Royal Cortissoz, "Types American, British and French/ Charles Sheeler," *New York Herald Tribune*, sec. 6, p. 3 (October 8, 1939).

26. The attack on patronage came from Emily Genauer, "Charles Sheeler in One Man Show," *New York World*, October 7, 1939, p. 34. Elizabeth McCausland criticized his work for lacking realism and social comment in "New Season Underway: Charles Sheeler show at the Modern Art Museum," *Springfield Sunday Bulletin and Republican*, October 8, 1939; see also the review by Howard Devree in *Magazine of Art* 32 (November 1939).

27. See Sheeler to Arensberg, June 4, 1940, Arensberg Archives. Sheeler contributed two photographs to this large group exhibition directed by Adams, including *Side of White Barn* (cat. no. 21) and *Stacks* (fig. 65). He also had a one-man exhibit, along with Clarence Kennedy, László Moholy-Nagy, Ansel Adams, and Edward Weston.

28. Sheeler to Weston, January 27, 1937, Weston Archive.

29. Sheeler to Weston, August 9, 1954, Weston Archive.

30. See Sheeler to Weston, (1940?), Weston Archive. Sheeler wrote: "It's a lasting regret that I couldn't go on and see you last fall. The requirements of the work [did not permit it]."

31. Musya Sheeler's specialty in photography was figurative work. *Vogue* magazine published her photo-essay, "Fitzwilliam, New Hampshire" in its February 1, 1951, issue (pp. 206-11) and Edward Steichen selected her photograph depicting nuns on a merry-go-round for *The Family of Man* exhibition (Museum of Modern Art, 1955). She and Sheeler were married in Rutherford, New Jersey, April 2, 1939, with Florence and William Carlos Williams acting as witnesses. In addition, because she was a photographer, historians have speculated about whether Musya could have printed some of Sheeler's late work; however, William H. Lane recalls a conversation with her in which she said she printed only one of her husband's photographs (his print of Brancusi's sculpture, *Portrait of Mrs. Eugene Meyer, Jr.*).

32. Weston to Mary Weston Seaman, October 20, 1941, in Kathy Kesley Foley, *Edward Weston's Gifts to his Sister* (Dayton Art Institute, Ohio, 1977), p. 56.

33. Illustrated in Foley, *Weston's Gifts*, p. 57.

34. Sheeler used a different photograph of the same building in painting *Powerhouse with Tree* (1943; private collection, Scarsdale, N.Y.).

35. Sheeler to Weston, January 27, 1939, Weston Archive.

36. Sheeler to Weston, August 8, 1942, Weston Archive.

37. Sheeler to Weston, August 9, 1954, Weston Archive. We are most grateful to Thurman Naylor for his assistance in identifying these cameras.

VII

The Late Years

1. See Wendy W. Belser, "Charles Sheeler at the Metropolitan Museum of Art" (unpublished manuscript, 1980), p. 9 and n. 22. Belser points out that Sheeler photographed Degas's *Race-Course at the Met* in 1920, at the request of its owner, the collector Lillie P. Bliss. We are most grateful to Ms. Belser for sharing her excellent study on Sheeler's Met years with us.

2. See Beaumont Newhall to Sheeler, December 24, 1957, Sheeler Papers, Archives of American Art, Smithsonian Institution, Washington, D.C. Newhall wrote: "Why doesn't someone do the real story of Charles? . . . The doubts of the war years and then the wonderful discovery of your powers . . . the friendships and the recognition."

3. Belser, "Sheeler at the Metropolitan," p. 10. Sheeler did little photography aside from his work at the Met in these years, but in about May 1943, he undertook "a photographic mission for the government," which he mentioned in a letter to Edward and Charis Weston dated June 11, 1943 (Edward Weston Archive, Center for Creative Photography, University of Arizona, Tucson).

4. Sheeler to Weston, August 8, 1942, Weston Archive.

5. Metropolitan Museum of Art, *Seventy-third Annual Report*, 1942, p. 20, quoted in Belser, p. 30.

6. See Belser, "Sheeler at the Metropolitan," p. 31.

7. See ibid, pp. 35-36. Belser is our source for the information in this paragraph. Note that the negatives Sheeler made became the property of the Met; also that each negative went into an envelope marked "to be printed only under the direction of Charles Sheeler." He was frequently, but not always, credited when his photographs appeared in Met publications.

8. Sheeler, in "Notes," *The Metropolitan Museum of Art Bulletin*, 1, no. 2 (October 1942), preceding p. 93.

9. Sheeler, in "Notes," *The Metropolitan Museum of Art Bulletin*, 1, no. 8 (April 1943) following p. 260.

10. Sheeler, in A. L. Chanin, "Charles Sheeler: Purist Brush and Camera Eye," *Art News* 54, no. 4 (Summer 1955): 71.

11. *The Great King: King of Assyria*, with essays by Susanna Hare and Edith Porada (Metropolitan Museum of Art, New York, 1945). See also Charles W. Millard, "Charles Sheeler, American Photographer," *Contemporary Photography* 6 (1967); and Martin Friedman, *Charles Sheeler*, (New York, 1975): 145.

12. Nora Scott, in Belser, "Sheeler at the Metropolitan," pp. 55-56.

13. For the original list, see the Metropolitan Museum of Art Archives; transcript in Belser, "Sheeler at the Metropolitan," Appendix B.

14. Sheeler to Mr. Laurence Harrison, in Belser, "Sheeler at the Metropolitan."

15. Sheeler to Strand, undated, Paul Strand Archive, Center for Creative Photography, University of Arizona, Tucson.

16. Strand to Charles Millard, October 13, 1965, Strand Archive.

17. Sheeler signed, dated, and titled several of the New York prints, including *Lever Building* (1953), *U.N. Building* (1951), and *RCA Building* (1950). Titles for other prints in the series have been assigned by the authors.

18. Sheeler, in Frederick S. Wight, *Charles Sheeler: A Retrospective Exhibition* (Art Galleries, University of California at Los Angeles, 1954), p. 26.

19. Wight, *Sheeler*, p. 17; Williams, "Foreword," in Wight, *Sheeler*, p. 8.

20. Alfred Frankenstein, "The Drawings, Photographs and Paintings of Sheeler," *San Francisco Chronicle*, November 18, 1954, "This World" sec., pp. 19-22.

21. Sheeler to Weston, August 9, 1954, Weston Archive.

22. Sheeler to Arensberg, December 10, 1928, Arensberg Archives.

23. Sheeler to Adams, November 17, 1956(?), Ansel Adams Archive, Center for Creative Photography, University of Arizona, Tucson.

24. Adams, with Mary Street Alinder, *An Autobiography* (Boston, 1985), p. 205.

25. Sheeler to Adams, August 23, 1961, Adams Archive.

26. *New York Times*, May 8, 1965, p. 31.

27. Edith Halpert to Musya Sheeler, April 11, 1967, Downtown Gallery Papers, Archives of American Art, Smithsonian Institution, Washington, D.C.

28. Millard, "Charles Sheeler, American Photographer."

29. Abraham Davidson, *Arts Magazine* 43, no. 5 (March 1969): 39-41.

30. Hilton Kramer, "Charles Sheeler: American Pastoral," *Artforum* 7 (January 1969): 39. See also John Canaday, *New York Times*, March 14, 1969: Canaday concludes, "Sheeler was a very important painter, but he was a great photographer."

31. Millard, "Charles Sheeler, American Photographer."

Selected Bibliography:
Sheeler's Photography

Archival Material

Ansel Adams Archive, Center for Creative Photography, University of Arizona, Tucson.

Arensberg Archives, Charles Sheeler Papers, Philadelphia Museum of Art, Twentieth Century Department.

Archives, Colonial Williamsburg, Va.

Downtown Gallery Papers, Archives of American Art, Smithsonian Institution, Washington, D.C.

Agnes Meyer Papers, Library of Congress, Washington, D.C.

John Quinn Memorial Collection, New York Public Library, New York.

Charles Sheeler interview by the Brooklyn Museum, April 27, 1965, Brooklyn Museum, N.Y.

Charles Sheeler interview by Bartlett Cowdrey, December 9, 1958, Archives of American Art, Smithsonian Institution, Washington, D.C.

Charles Sheeler interview by Martin Friedman, June 18, 1959, Archives of American Art, Smithsonian Institution, Washington, D.C.

Charles Sheeler taped conversation with William H. Lane, October 24, 1958, The Lane Collection

Charles Sheeler taped conversation with William H. Lane, February 1, 1959, The Lane Collection

Charles Sheeler Papers, Archives of American Art, Smithsonian Institution, Washington, D.C.

Archives, Steichen Study Center, Museum of Modern Art, New York

Alfred Stieglitz Archive, Beinecke Rare Book and Manuscript Library, Yale University, New Haven, Conn.

Paul Strand Archive, Center for Creative Photography, University of Arizona, Tucson.

Paul Strand Archive, Millerton, N.Y.

Edward Weston Archive, Center for Creative Photography, University of Arizona, Tucson.

Archives, Whitney Museum of American Art, New York.

Writings by Charles Sheeler

"Notes on an Exhibition of Greek Art." The Arts 7 (March 1925): 153-58.

"'Pictorial Beauty and the Screen,'" Victor O. Freeburg: New York, The Macmillan Company, 1924. The Arts 5 (May 1924): 293

"Recent Photographs by Alfred Stieglitz." The Arts 3 (May 1923): 345.

Sheeler Exhibition Catalogues

Charles Sheeler: Paintings, Drawings, Photographs. Statements by Sheeler and William Carlos Williams. Museum of Modern Art, New York, 1939.

Friedman, Martin, et al. Charles Sheeler. National Collection of Fine Arts, Smithsonian Institution, Washington, D.C., 1968.

Wight, Frederick S. Charles Sheeler: A Retrospective Exhibition. Art Galleries, University of California at Los Angeles, 1954.

Yeh, Susan Fillin-. Charles Sheeler: American Interiors. Yale University Art Gallery, New Haven, Conn., 1987.

Other Sources

African Negro Sculpture, Photographed by Charles Sheeler. Preface by Marius de Zayas. Privately published, c. 1918.

Belser, Wendy W. "Charles Sheeler at the Metropolitan Museum of Art." Unpublished paper, 1980.

Davies, Karen. "Charles Sheeler in Doylestown and the Image of Rural Architecture." Arts Magazine 59 (March 1985): 135-39.

Driscoll, John. "Charles Sheeler's Photography." Unpublished paper, 1981, The Lane Collection.

Marcel Duchamp, ("Rrose Sélavy"), Some French Moderns Says McBride, Melomime Publications Inc., Société Anonyme Inc., 1922 (Photographs by Charles Sheeler).

Friedman, Martin. Charles Sheeler. New York, 1975.

Hammen, Scott. "Sheeler and Strand's Manahatta: A Neglected Masterpiece." Afterimage 6 (January 1979): 6-7.

Hare, Susanna, and Porada, Edith. The Great King: King of Assyria (photographs by Sheeler). New York, 1945.

Horak, Jan-Christopher, "Manhatta's Mannahatta; or, The Romantic Impulse in American Film Modernism." Forthcoming in Afterimage 15, no. 4 (November, 1987).

Hyland, Douglas K. S. "Agnes Ernst Meyer, Patron of American Modernism." American Art Journal 12 (Winter 1980): 64-81.

Jacob, Mary Jane, and Linda Downs. The Rouge: The Image of Industry in the Art of Charles Sheeler and Diego Rivera. Detroit Institute of Arts, 1978.

Kootz, Samuel M. "Ford Plant Photos of Charles Sheeler." Creative Art 8 (April 1931): 264-67.

Kramer, Hilton. "American Pastoral." Artforum 7 (January 1969): 36-39.

"Manhattan — The Proud and Passionate City." Vanity Fair, April 1922, p. 51.

Millard, Charles W. "Charles Sheeler: American Photographer." Contemporary Photographer 6 (1967).

Naef, Weston J. The Collection of Alfred Stieglitz: Fifty Pioneers of Modern Photography. Metropolitan Museum of Art, New York, 1978.

Naumann, Francis. "Walter Conrad Arensberg: Poet, Patron and Participant in the New York Avant-Garde, 1915-20." Philadelphia Museum of Art Bulletin 76 (Spring 1980): 1-32.

——. intro. and notes. "Marius de Zayas, 'How, When, and Why Modern Art Came to New York.'" Arts 54 (April 1980): 96-126.

Norwood, E. P. Ford: Men and Methods. Garden City, N.Y., 1931.

O'Keeffe, Georgia, Charles Sheeler et al. "Can a Photograph Have the Significance of Art," MSS. 4 (December 1922): 1-18.

"Photographs of New York by Charles Sheeler," Cahiers d'Art 4-5 (1927): 130-32

Pultz, John, and Catherine B. Scallen. Cubism and American Photography, 1910-1930. Williamstown, Mass., 1981.

Rosenblum, Naomi. Paul Strand: The Early Years, 1910-1932. Ph.D. diss., City University of New York, 1978.

Rourke, Constance. Charles Sheeler, Artist in the American Tradition. New York, 1938.

Scott, Nora E. Egyptian Statues (photographs by Sheeler). New York, 1945.

——, Egyptian Statuettes (photographs by Sheeler). New York, 1945.

Stebbins, Theodore E., Jr., and Carol Troyen. The Lane Collection: 20th Century Paintings in the American Tradition. Museum of Fine Arts, Boston, 1983.

Stewart, Patrick L., Jr. Charles Sheeler, William Carlos Williams, and the Development of the Precisionist Aesthetic. Ph.D. diss., University of Delaware, 1981.

——. "Charles Sheeler, William Carlos Williams, and Precisionism: A Redefinition." Arts Magazine 58 (November 1983): 100-114.

Wilson, Richard Guy, Dianne H. Pilgrim, and Dickran Tashjian. The Machine Age in America, 1918-1941. Brooklyn Museum, New York, 1986.

Wolf, Ben. Morton Livingston Schamberg. Philadelphia, 1963.

Yeh, Susan Fillin-. Charles Sheeler and the Machine Age. Ph.D. diss., City University of New York, 1981.

Zilczer, Judith. "The World's New Art Center: Modern Art Exhibitions in New York City, 1913-1918." Archives of American Art Journal 14, no. 3 (1974): 2-7.

The Photographs

All of the photographs in the exhibition are reproduced to scale, with the exception of No. 74, which has been reduced to 77% of actual size.

Dimensions of the prints are given in inches, with height before width. In cases where Sheeler's original overmat alters the size of the image, the sight size is also given in parentheses.

All of the photographs have been lent by The Lane Collection, with the exception of No. 78, which is lent by the Museum of Fine Arts.

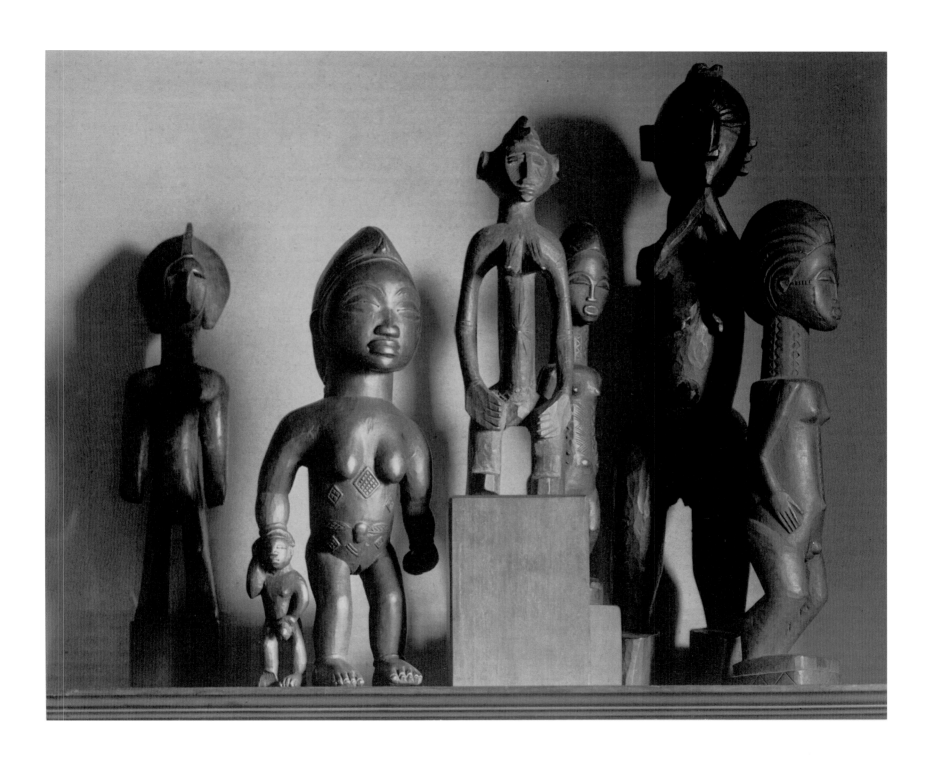

1. *Six West African Figures*, c. 1916-17

2. *Twin-Headed Sceptre (Congo)*, c. 1916-17

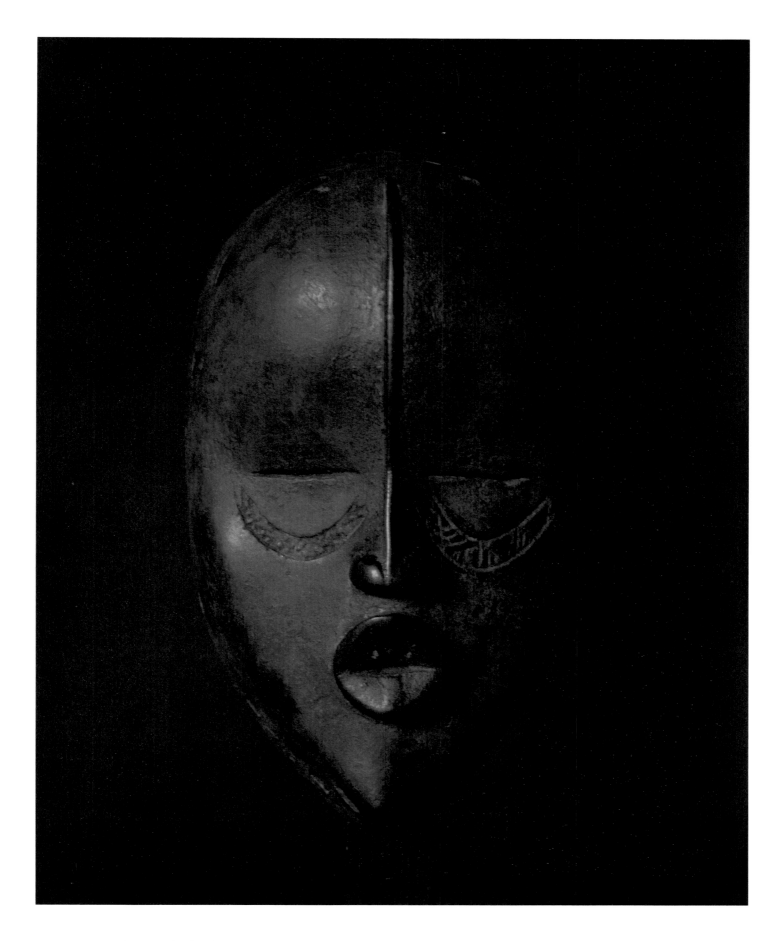

3. *Dan Mask, Female Style, (Ivory Coast)*, c. 1918

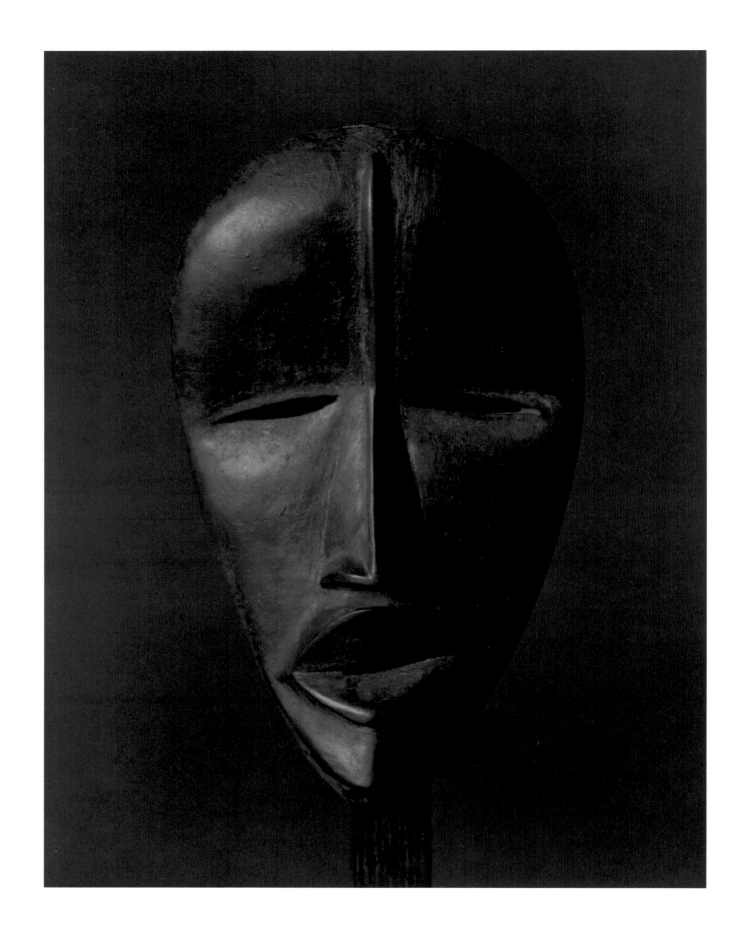

4. *Dan Mask, Female Style, (Ivory Coast)*, c. 1918

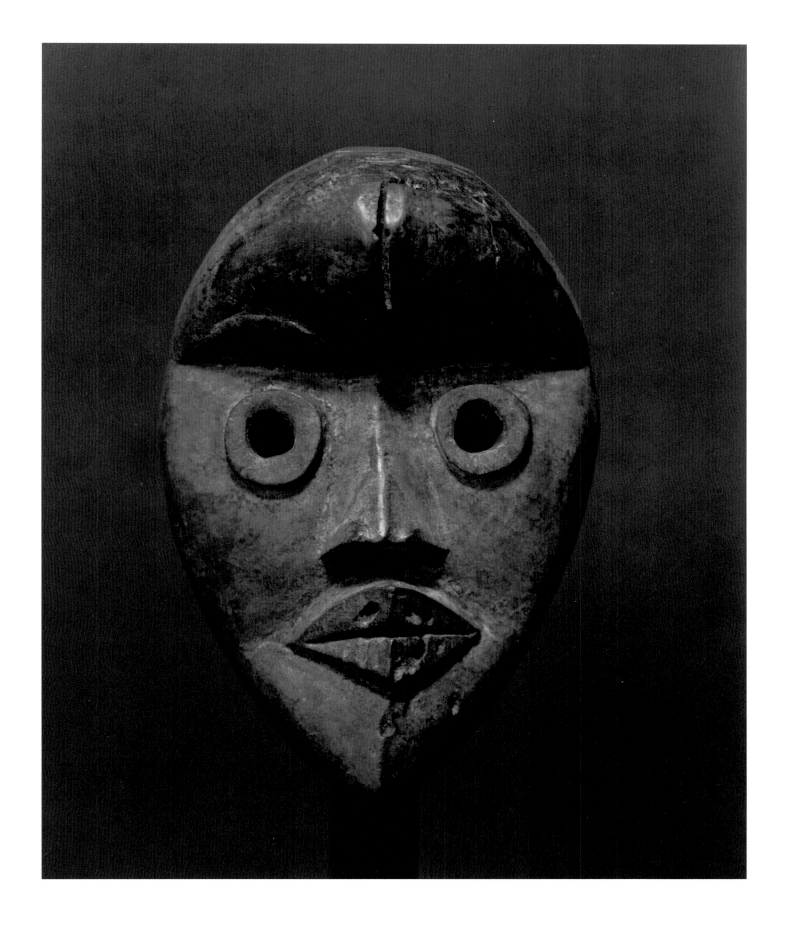

5. *Dan Mask, Entertainer-Type, (Ivory Coast)*, c. 1918

6. *Duchamp's Bride Stripped Bare by Her Bachelors, Even,* c. 1920

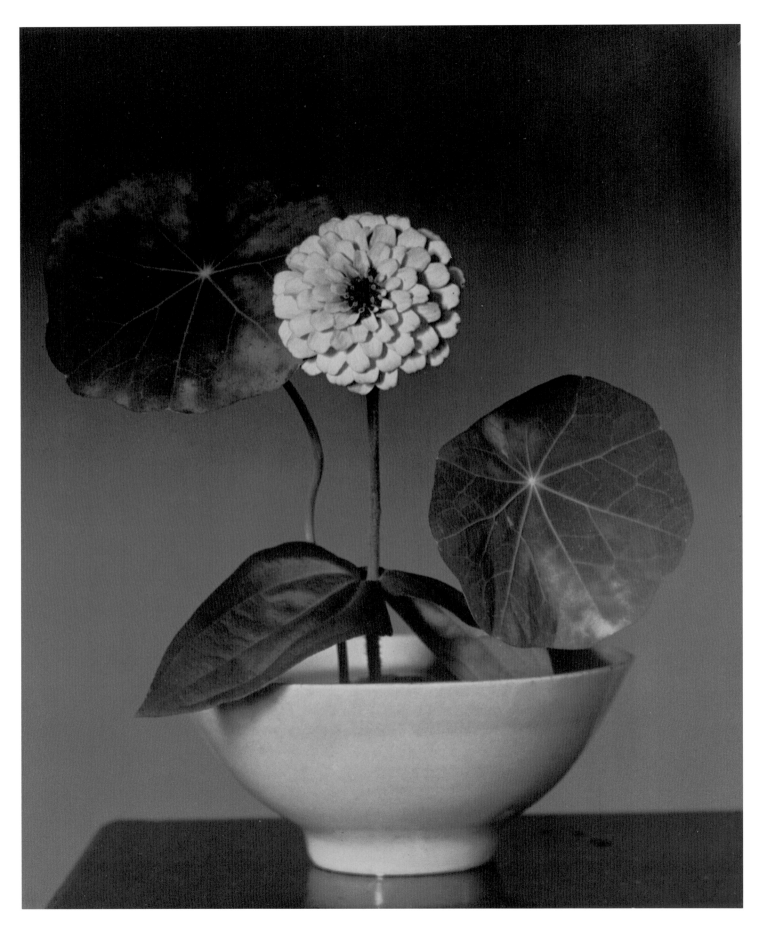

7. *Zinnia and Nasturtium Leaves*, 1916-17

8. *The Lily — Mt. Kisco*, 1918-19

9. *Doylestown House – Exterior View*, 1917

10. *Doylestown House – Old Kitchen*, 1917

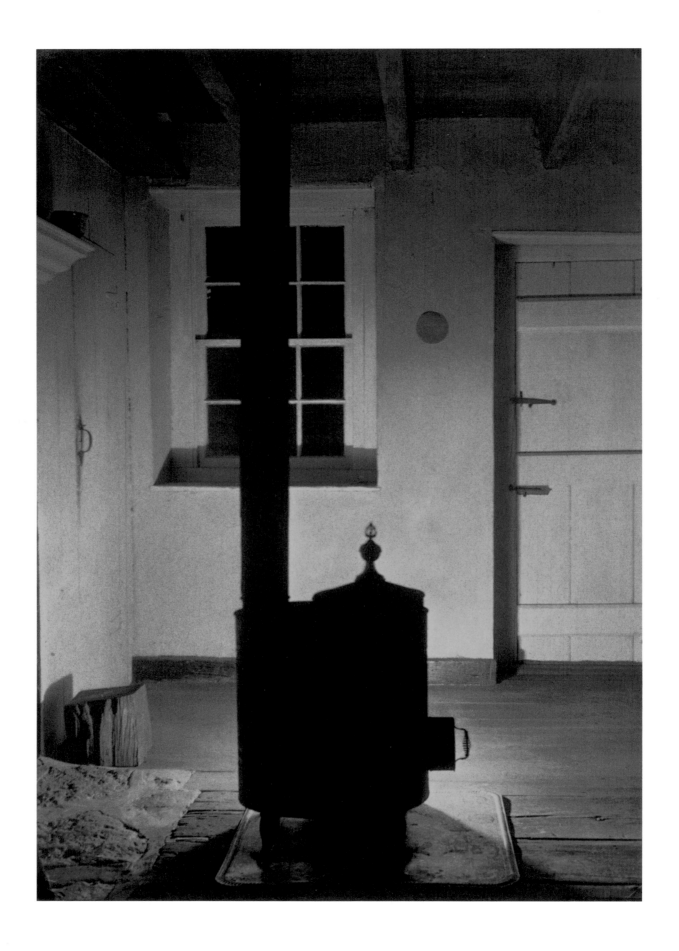

11. *Doylestown House – The Stove*, 1917

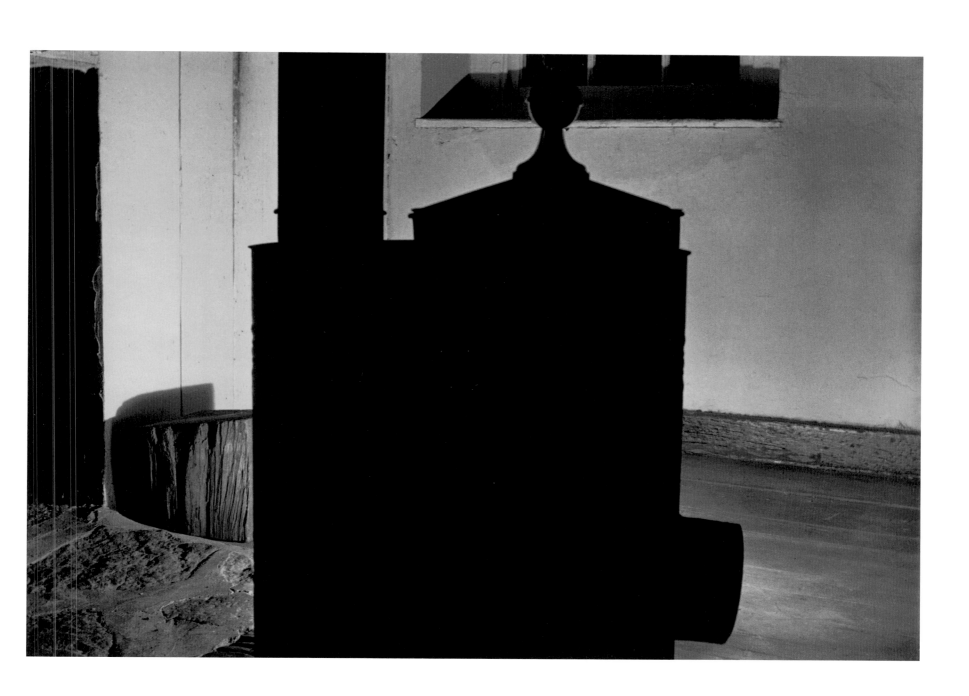

12. *Doylestown House – Stove, Horizontal*, 1917

13. *Doylestown House – Closet Door with Scythe,* 1917

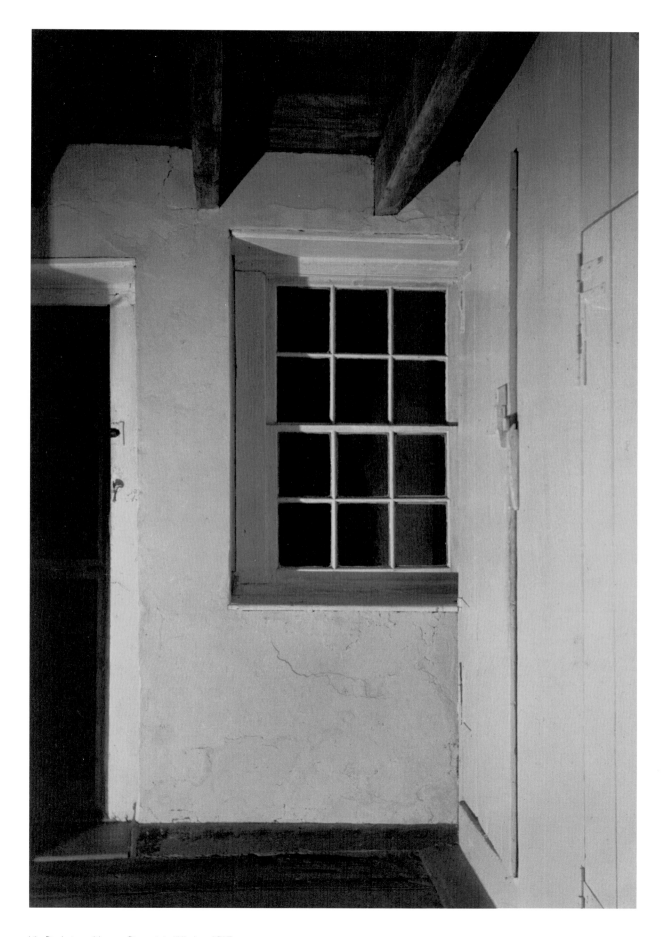

14. *Doylestown House – Downstairs Window, 1917*

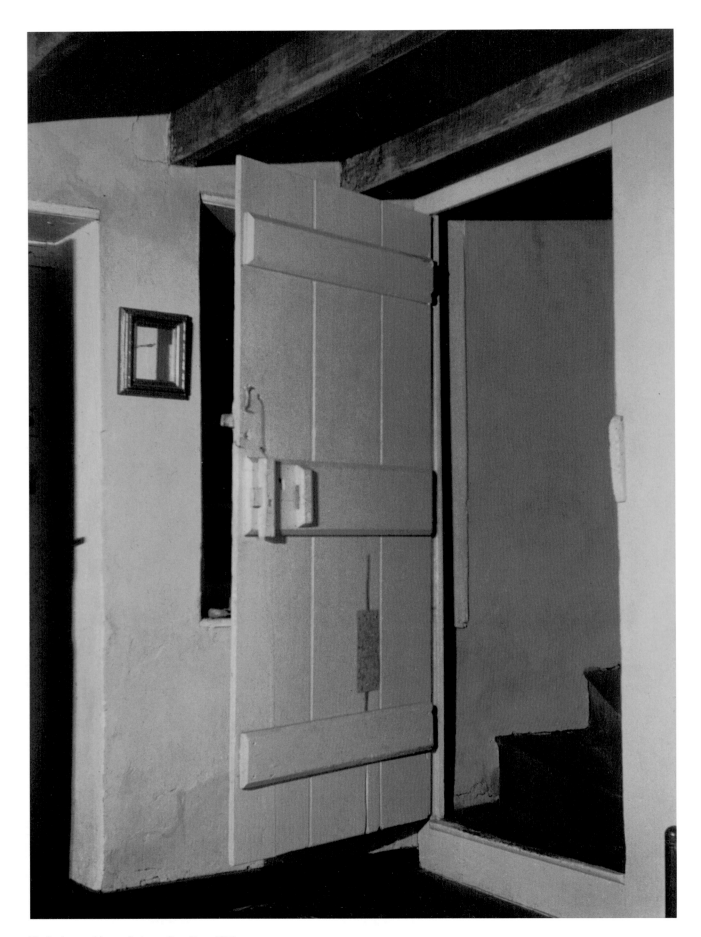

15. *Doylestown House – Stairway, Open Door*, 1917

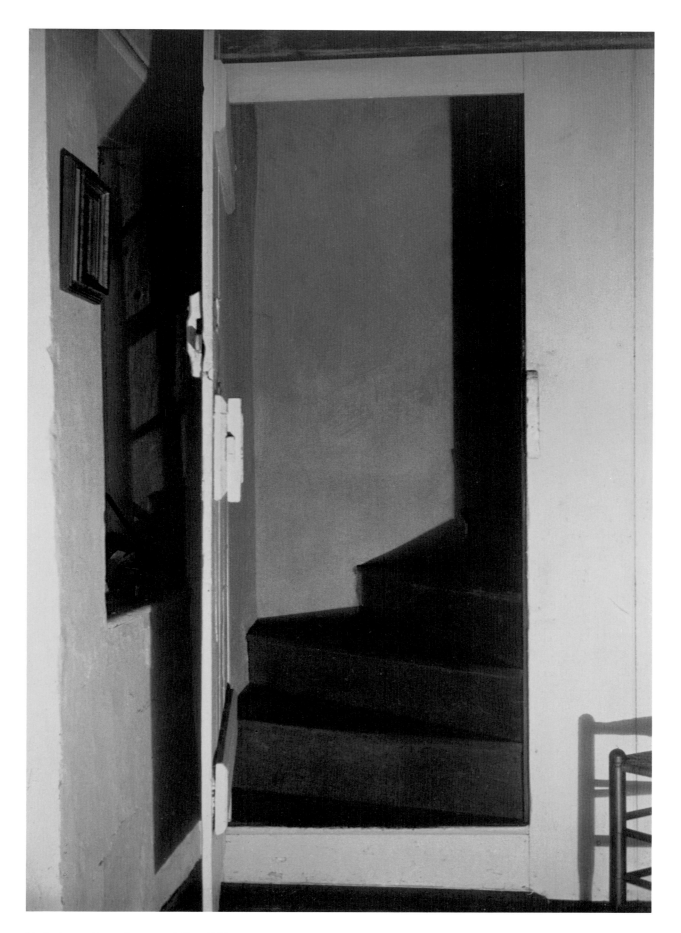

16. *Doylestown House – Stairway with Chair*, 1917

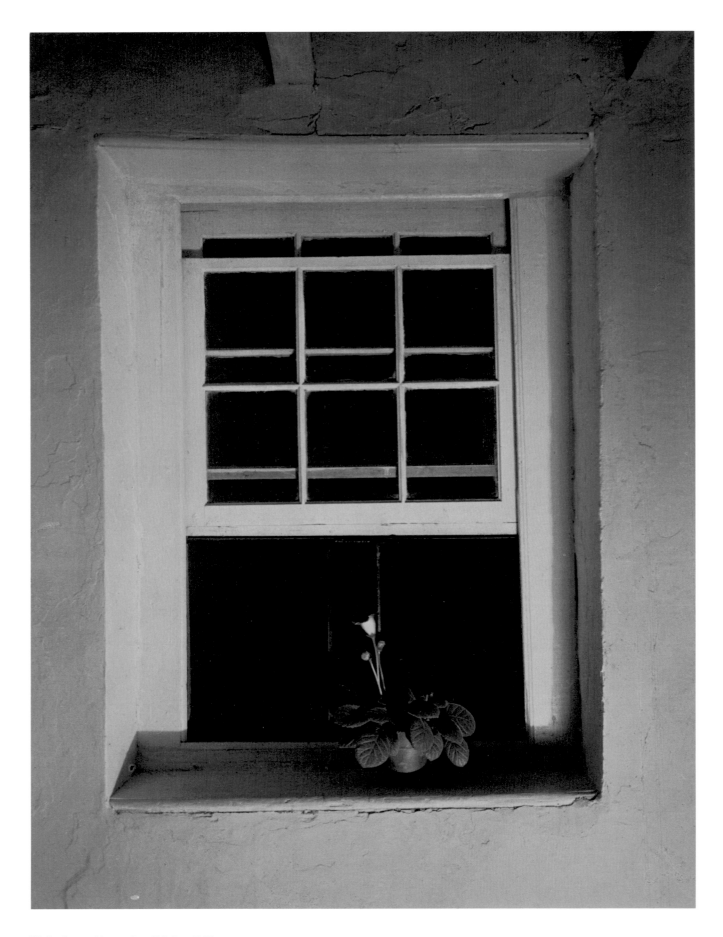

17. *Doylestown House – Open Window*, 1917

18. *Doylestown House – Closet, Stairs*, 1917

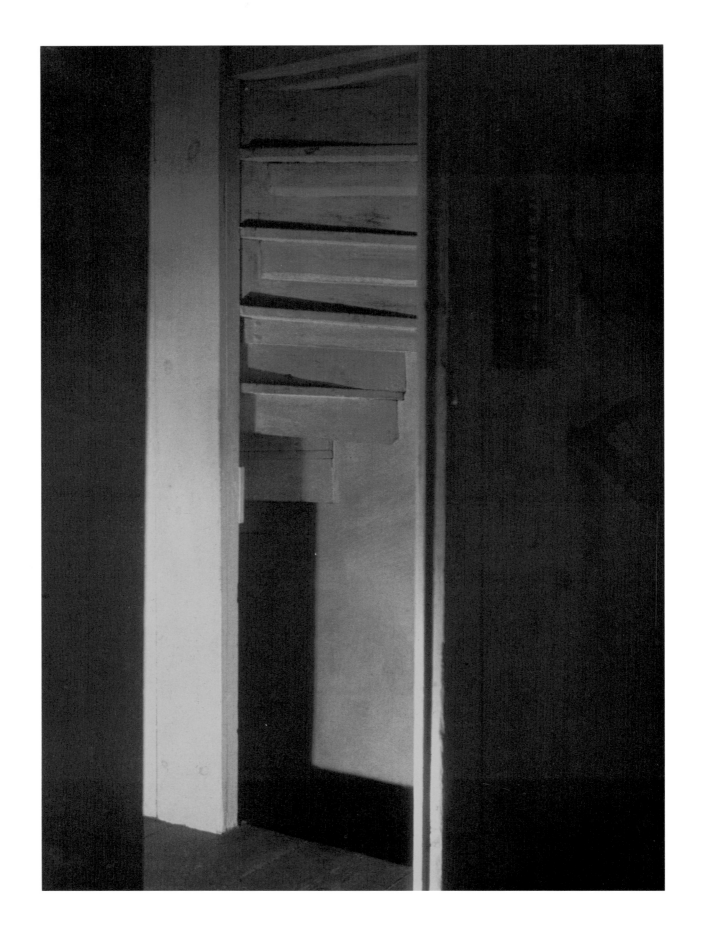

19. *Doylestown House – Stairwell*, 1917

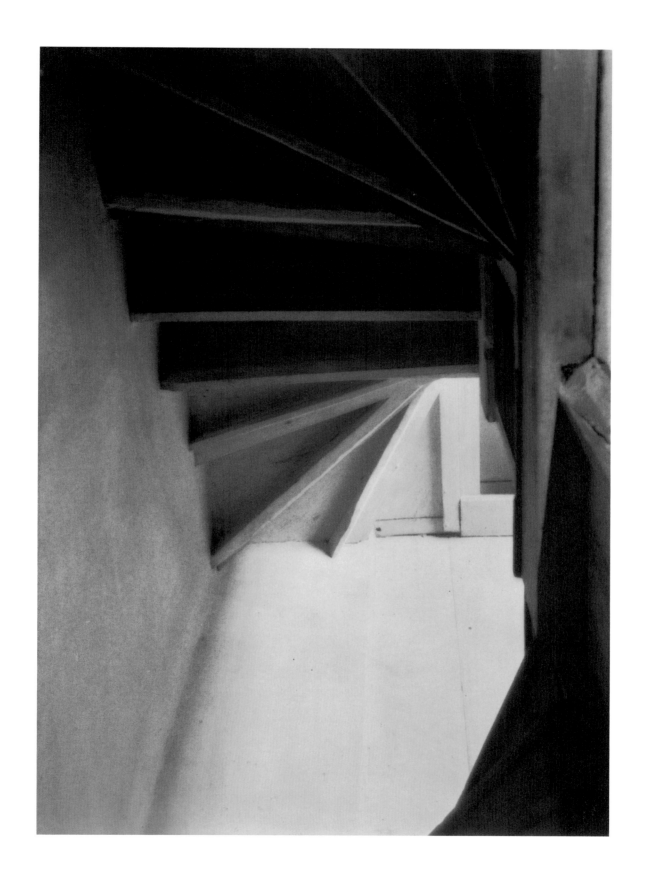

20. *Doylestown House – Stairs from Below*, 1917

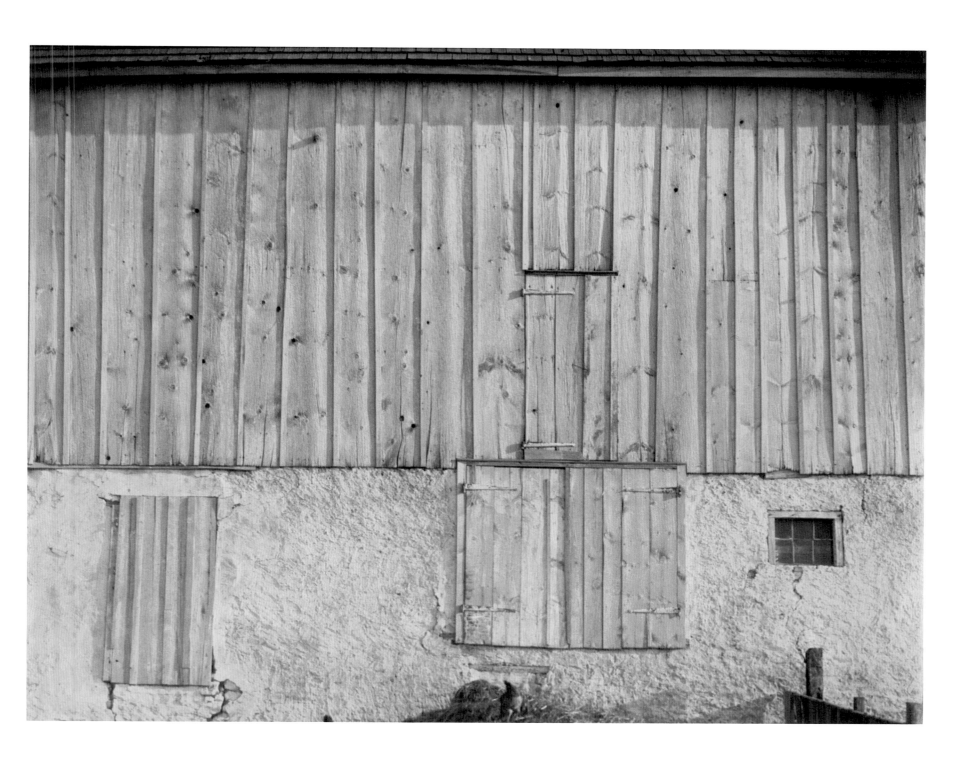

21. *Side of White Barn,* 1917

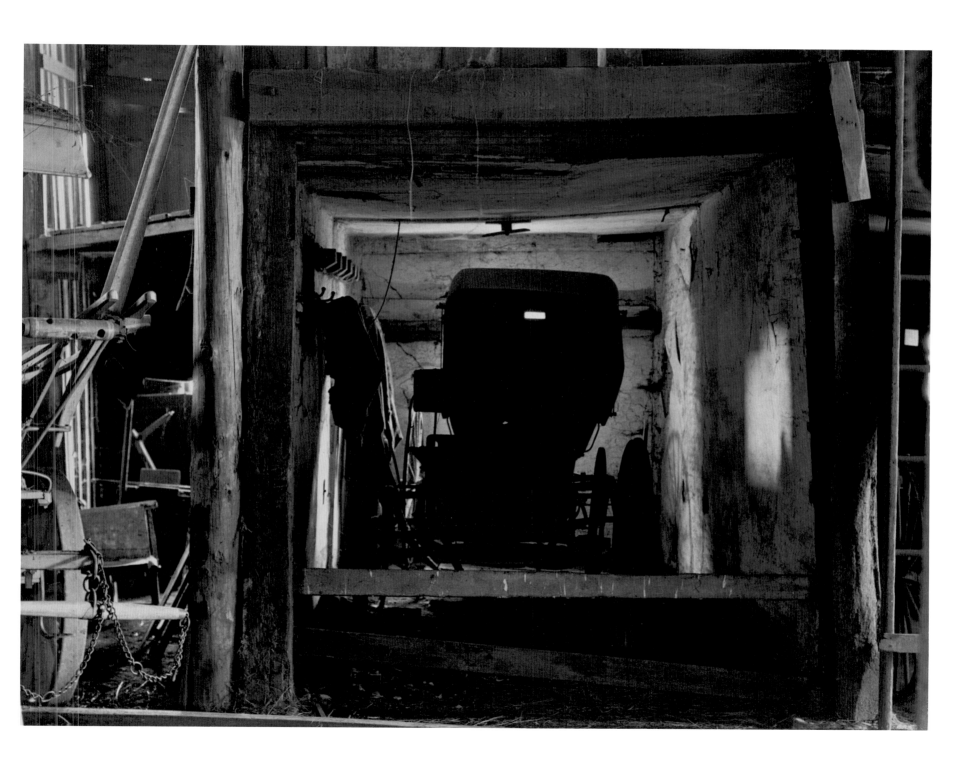

22. *Buggy*, 1917

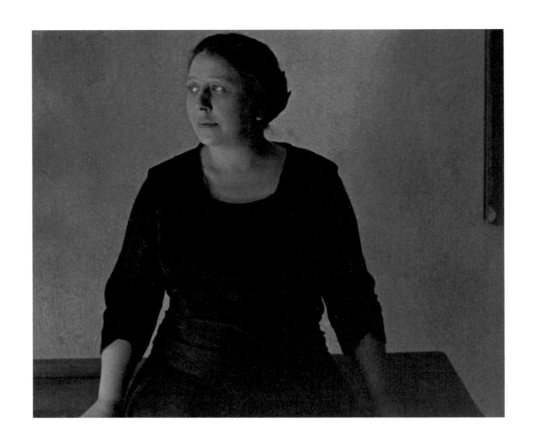

23. *Katharine*, 1918-19

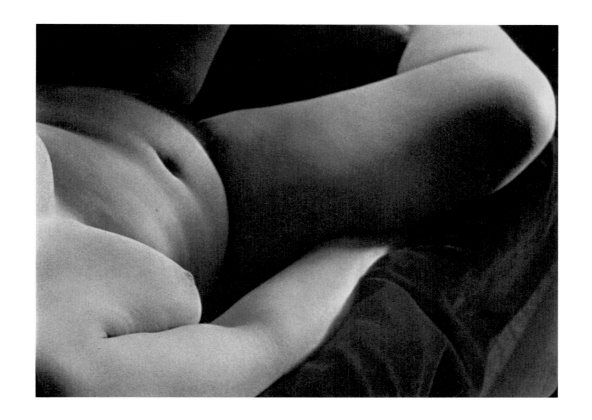

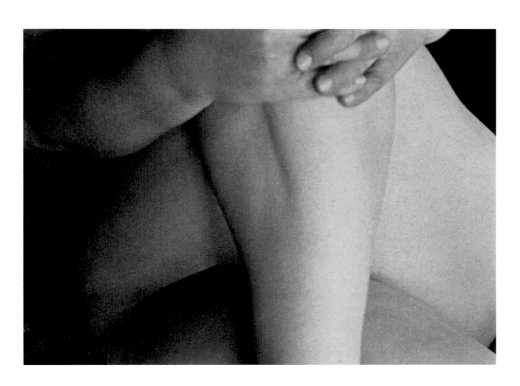

24. *Nude #1*, 1918-19
25. *Nude #2*, 1918-19

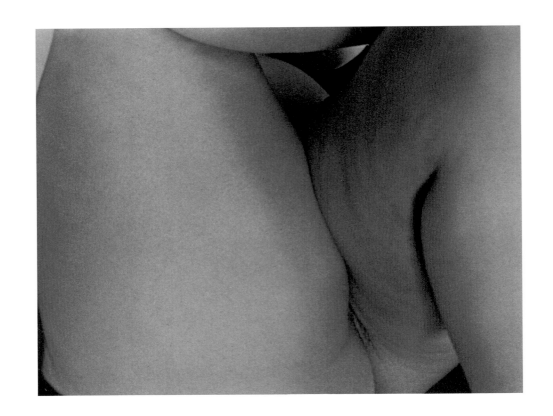

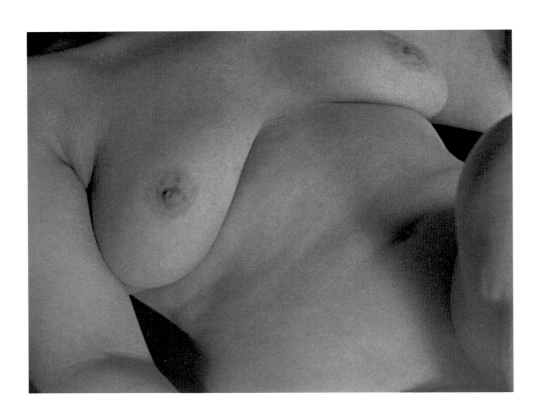

26. *Nude #3*, 1918-19
27. *Nude #4*, 1918-19

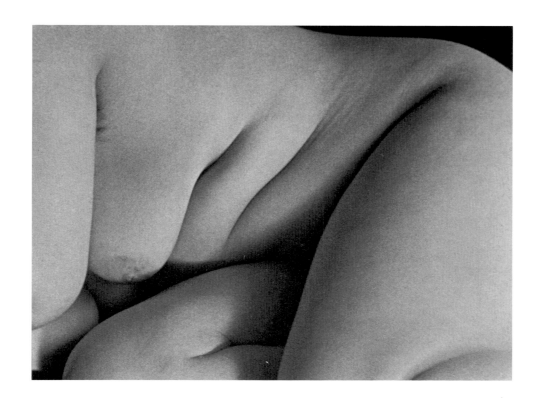

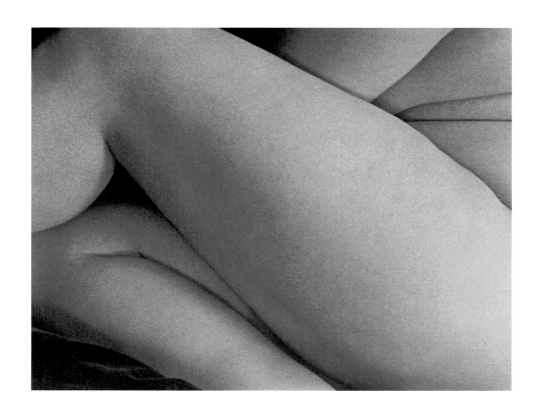

28. *Nude #5*, 1918-19
29. *Nude #6*, 1918-19

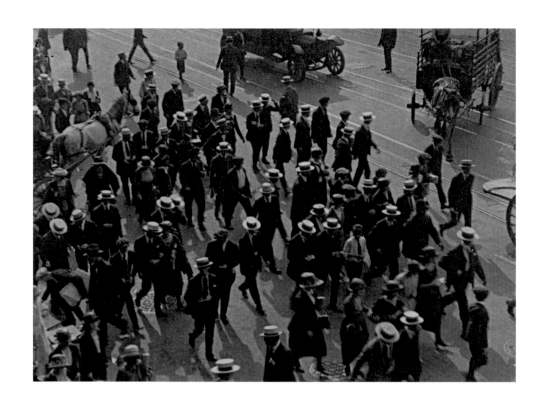

30. *Manhatta — Men in Boaters,* 1920

31. *Manhatta — Through a Balustrade,* 1920

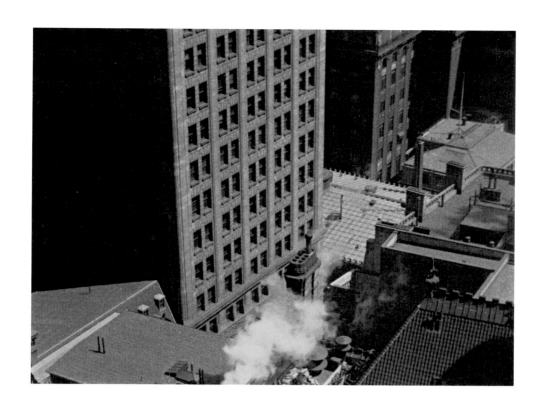

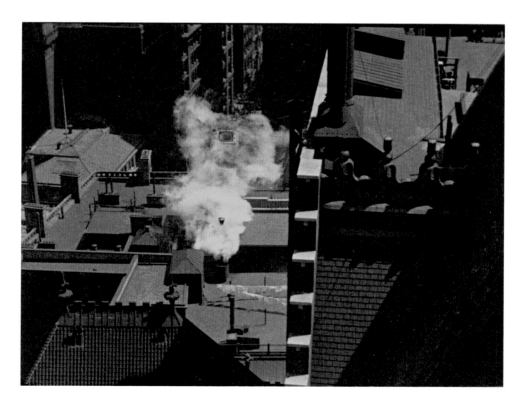

32. *Manhatta – From the Empire Building*, 1920
33. *Manhatta – Rooftops*, 1920

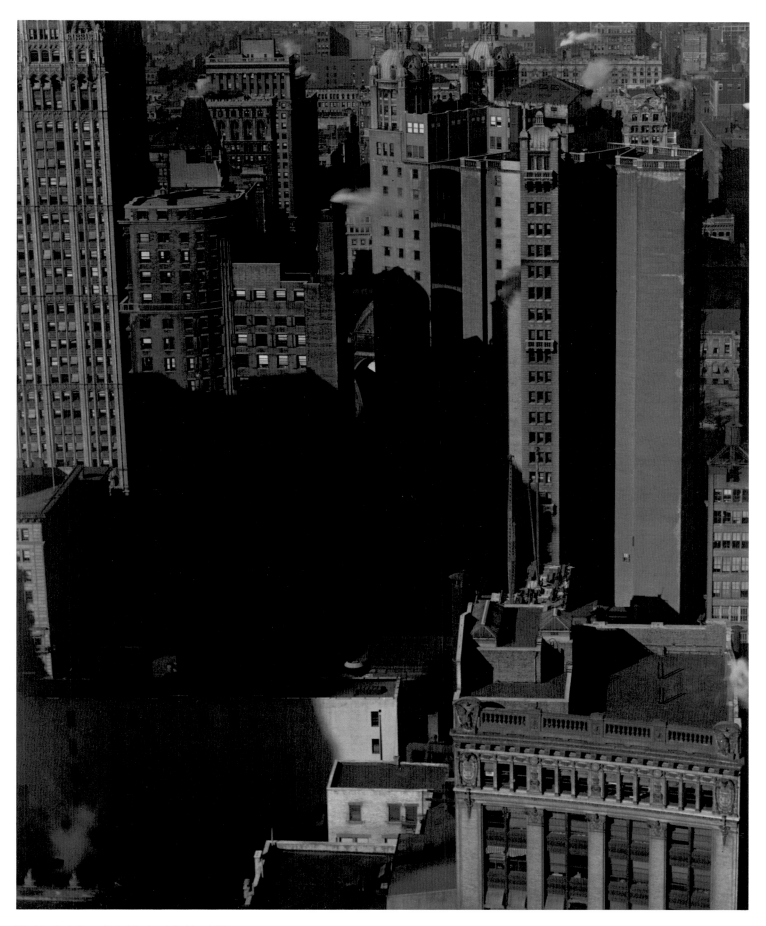

34. *New York, Towards the Woolworth Building, 1920*

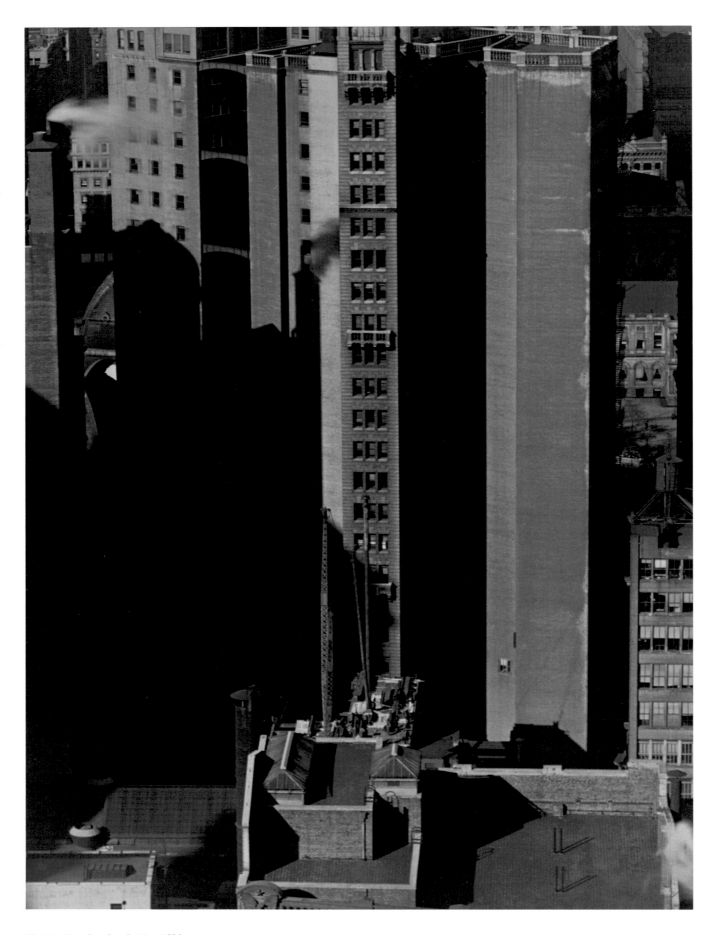

35. *New York, Park Row Building, 1920*

36. New York, *Buildings in Shadows*, 1920

37. *New York, Temple Court,* 1920

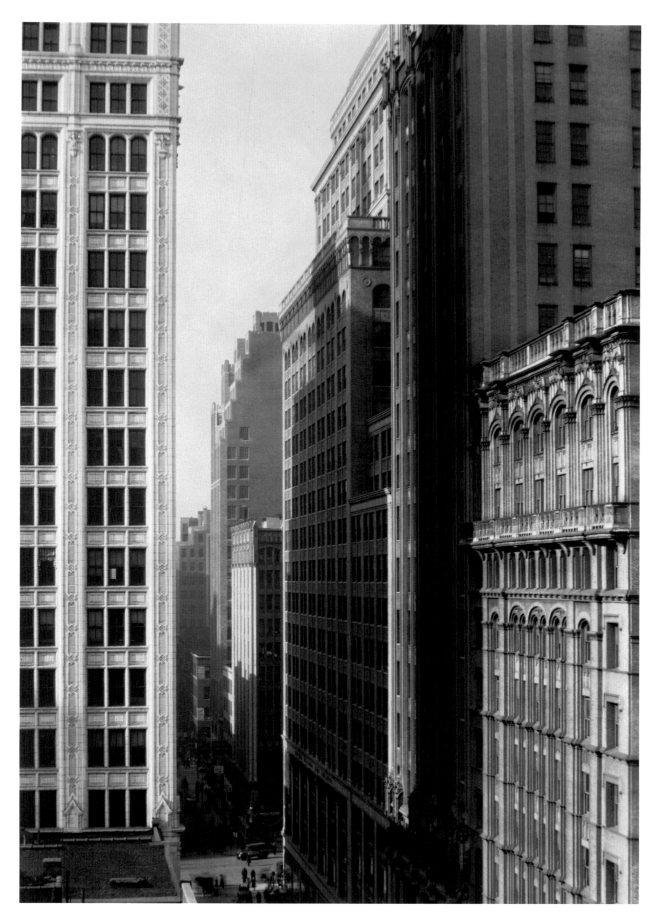

38. *New York, Broadway at Fortieth Street*, c. 1920

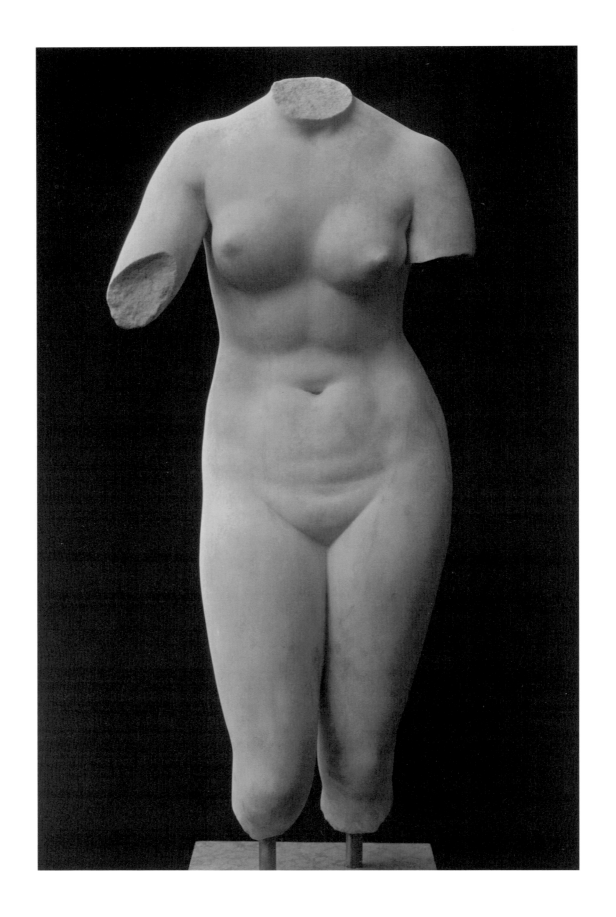

39. *Aphrodite*, c. 1924

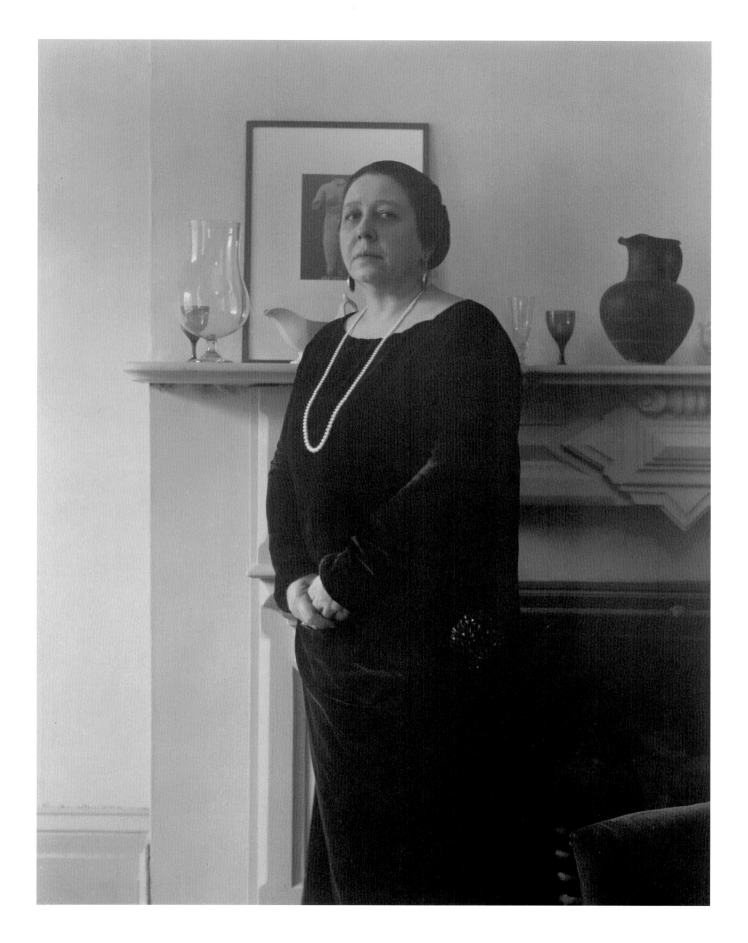

40. *Katharine by the Mantel*, c. 1925

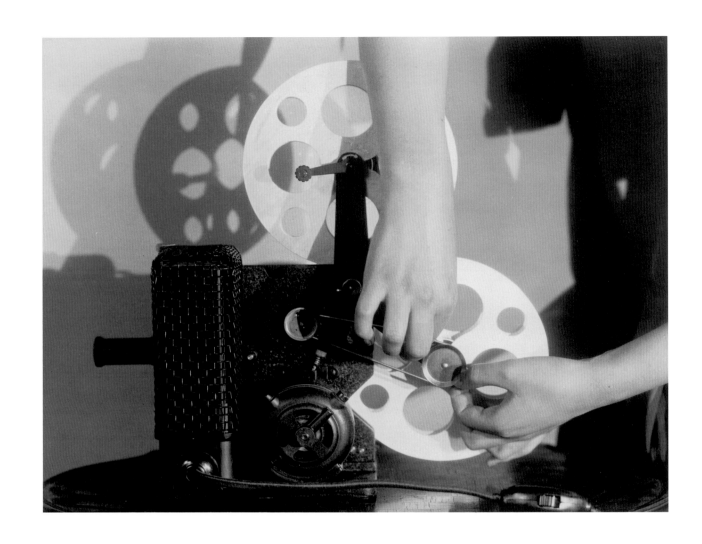

41. *Kodak Projector*, 1924

42. *Aldous Huxley,* 1926

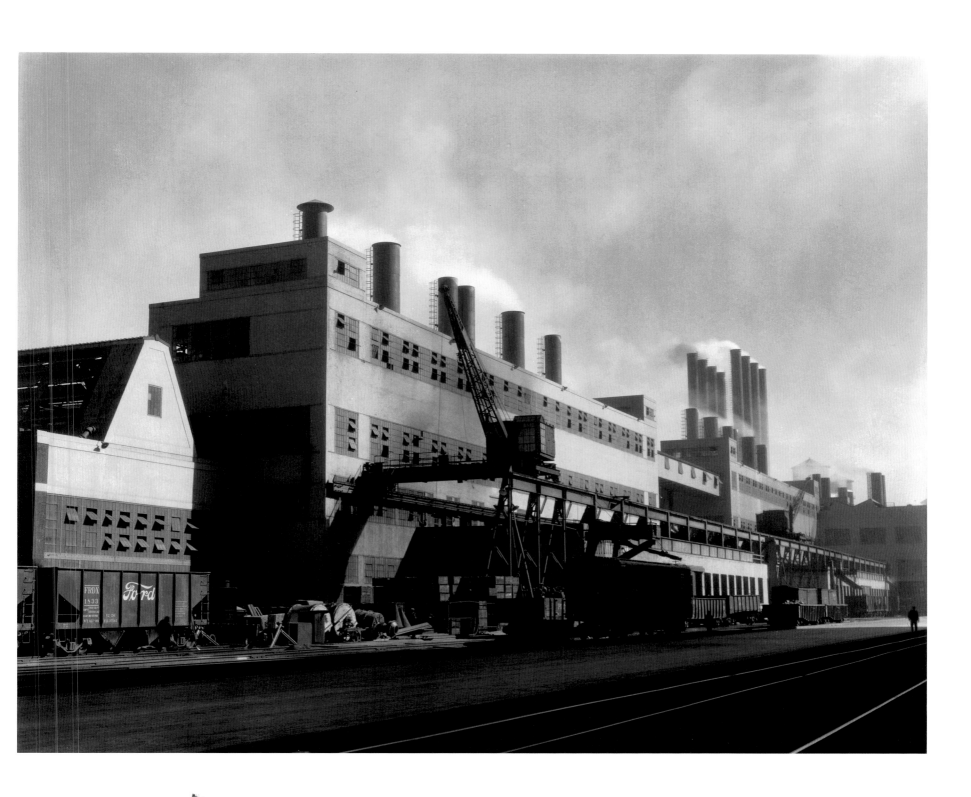

43. *Production Foundry – Ford Plant, 1927*

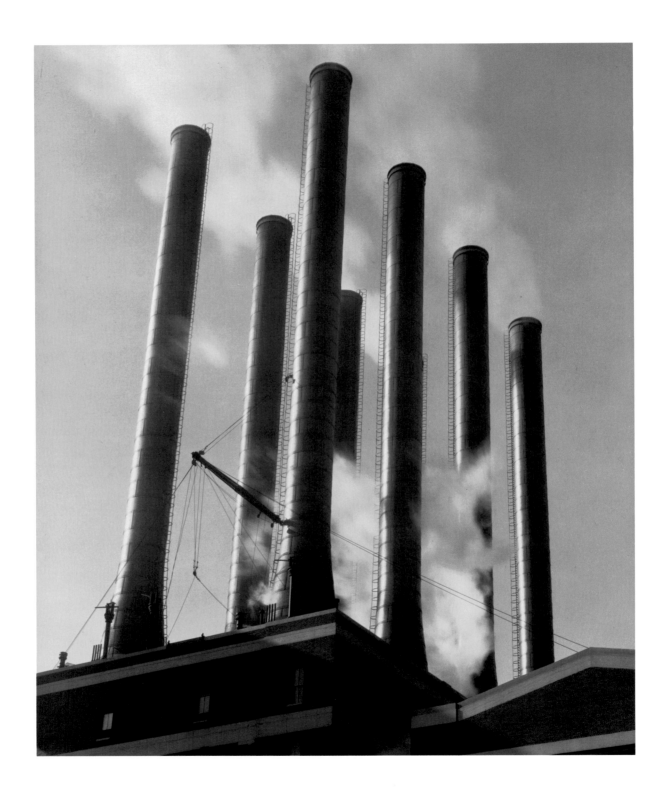

44. *Power House No. 1 — Ford Plant, 1927*

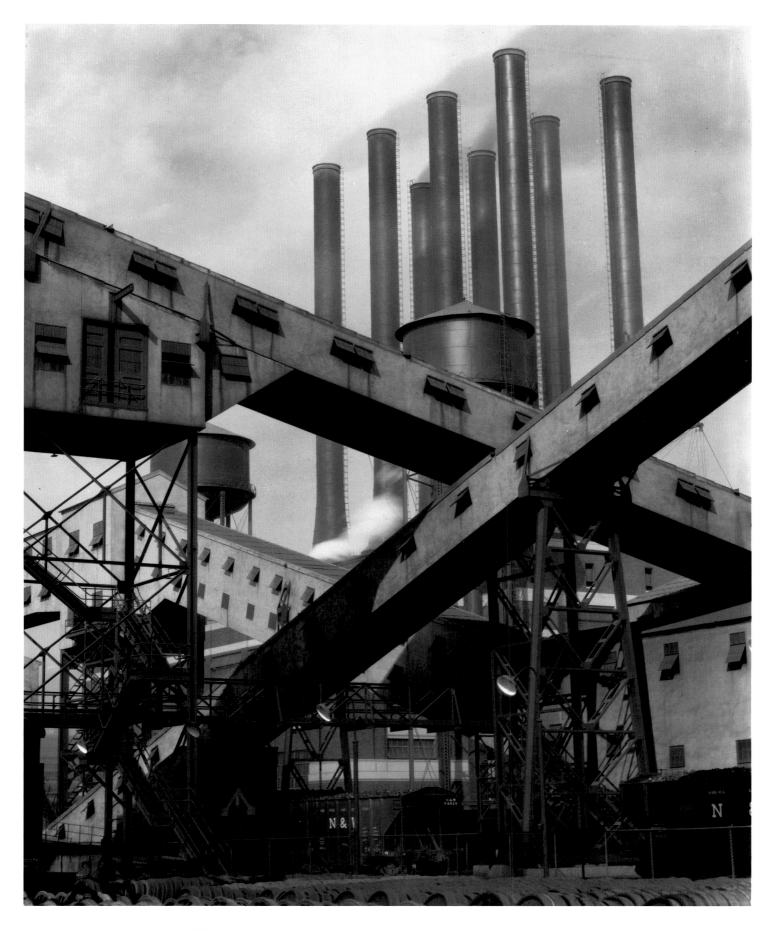

45. *Criss-Crossed Conveyors – Ford Plant, 1927*

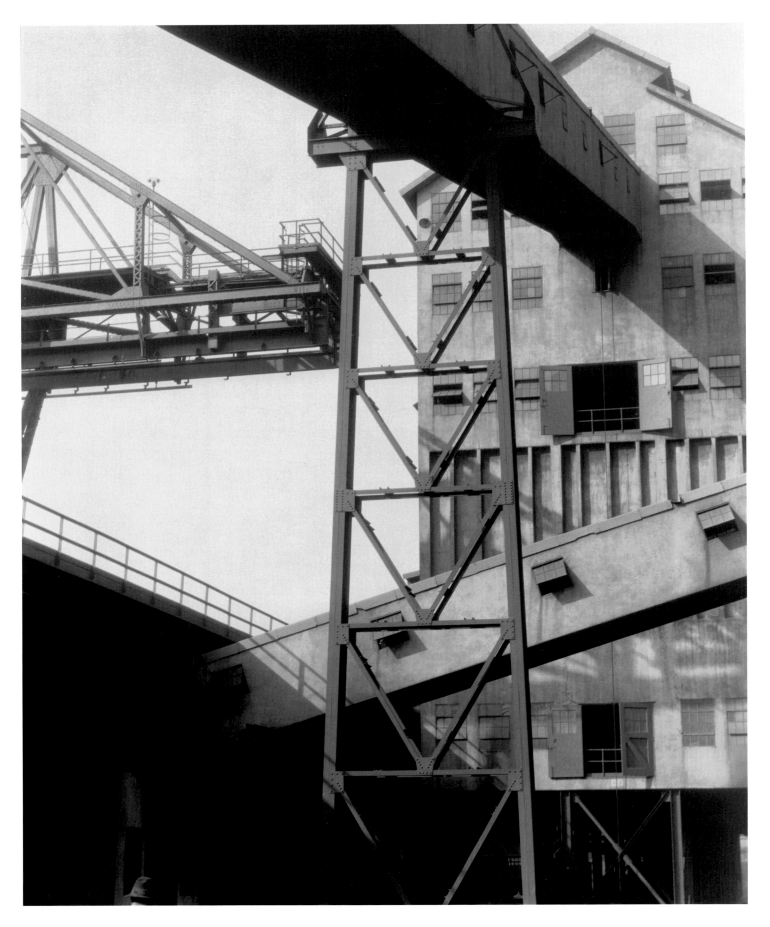

46. *Pulverizer Building – Ford Plant*, 1927

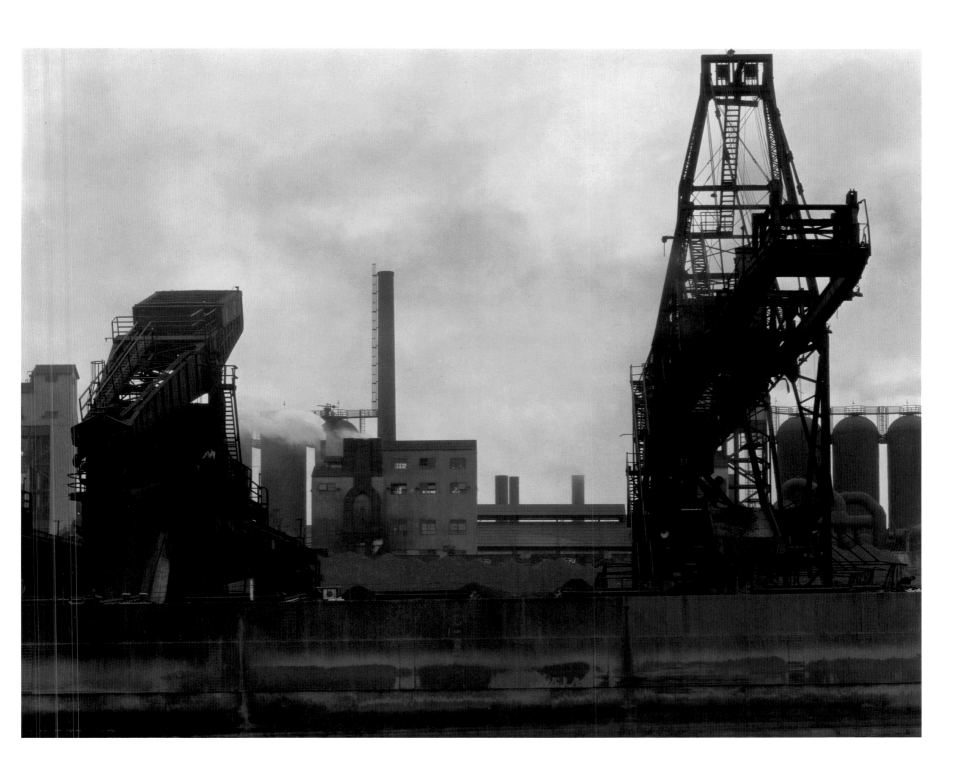

47. *Cranes at the Boat Slip – Ford Plant, 1927*

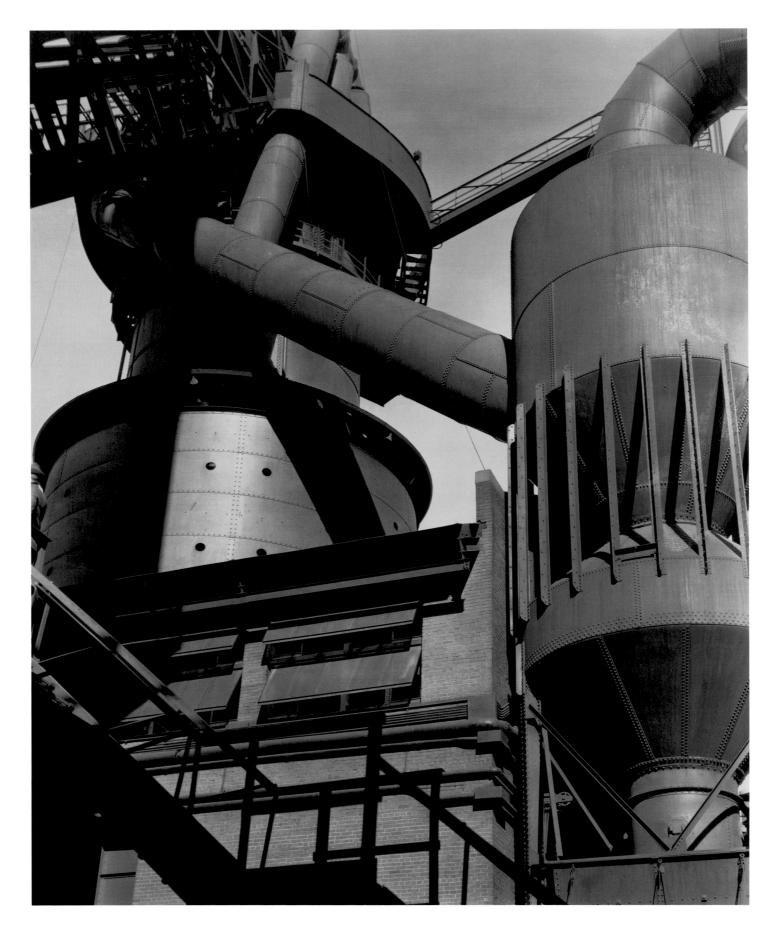

48. *Blast Furnace and Dust Catcher – Ford Plant*, 1927

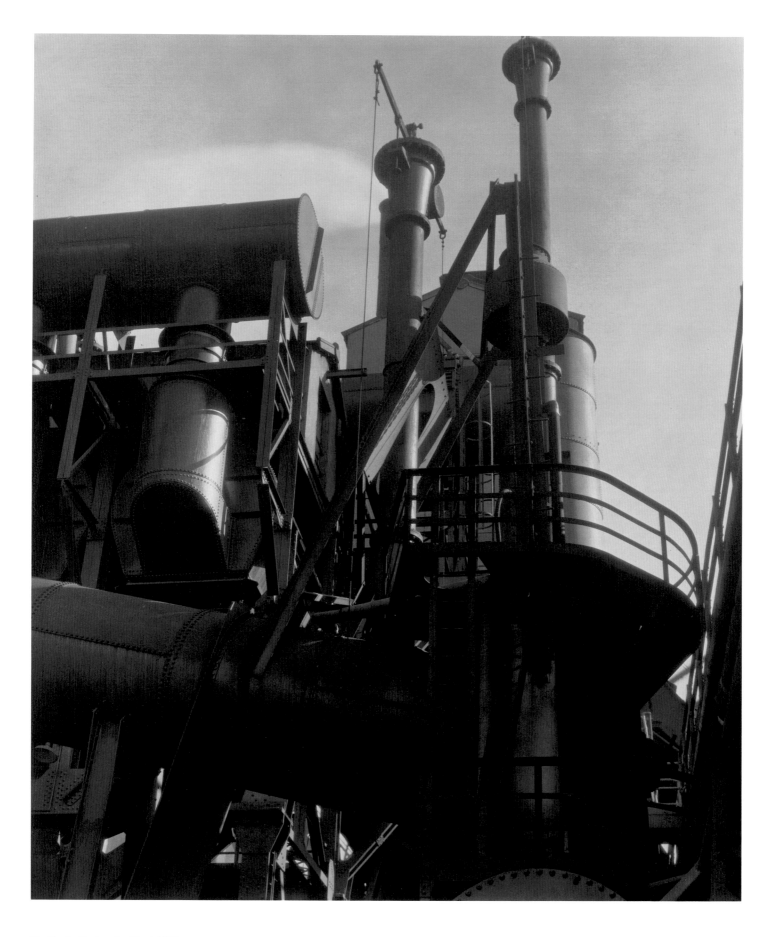

49. *Bleeder Stacks – Ford Plant,* 1927

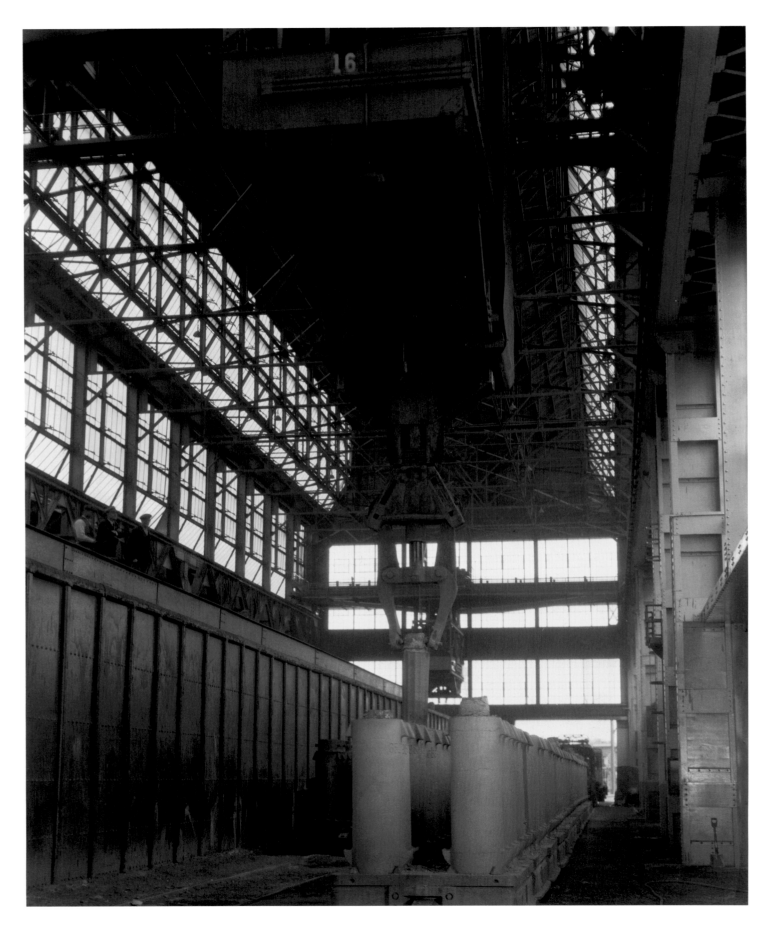

50. *Ingot Molds, Open Hearth Building – Ford Plant,* 1927

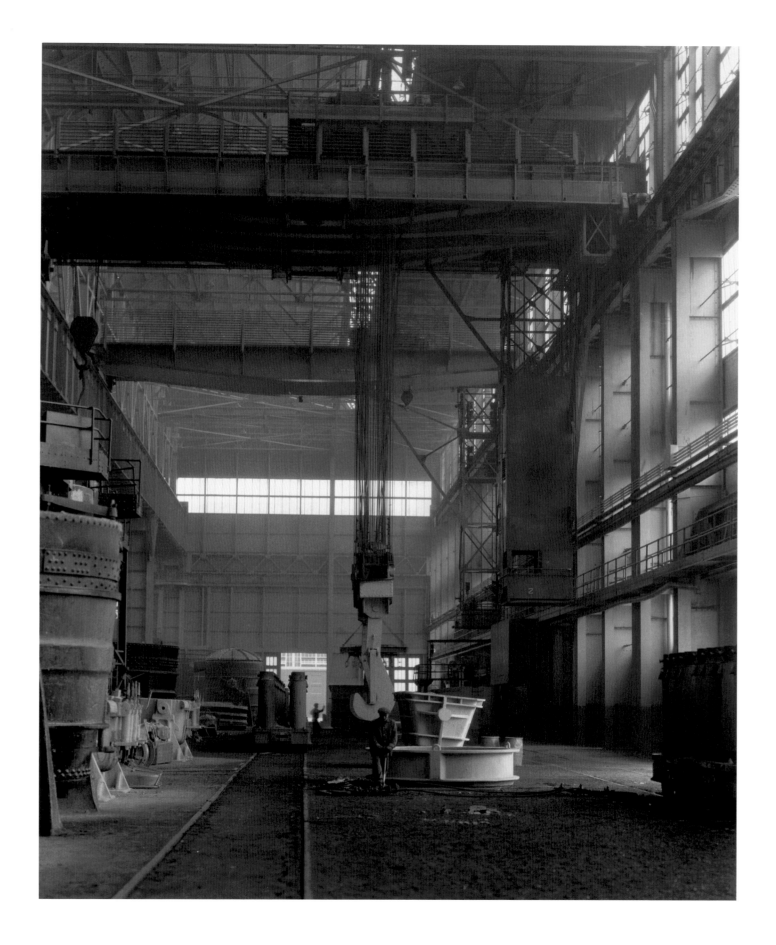

51. *Ladle Hooks, Open Hearth Building — Ford Plant*, 1927

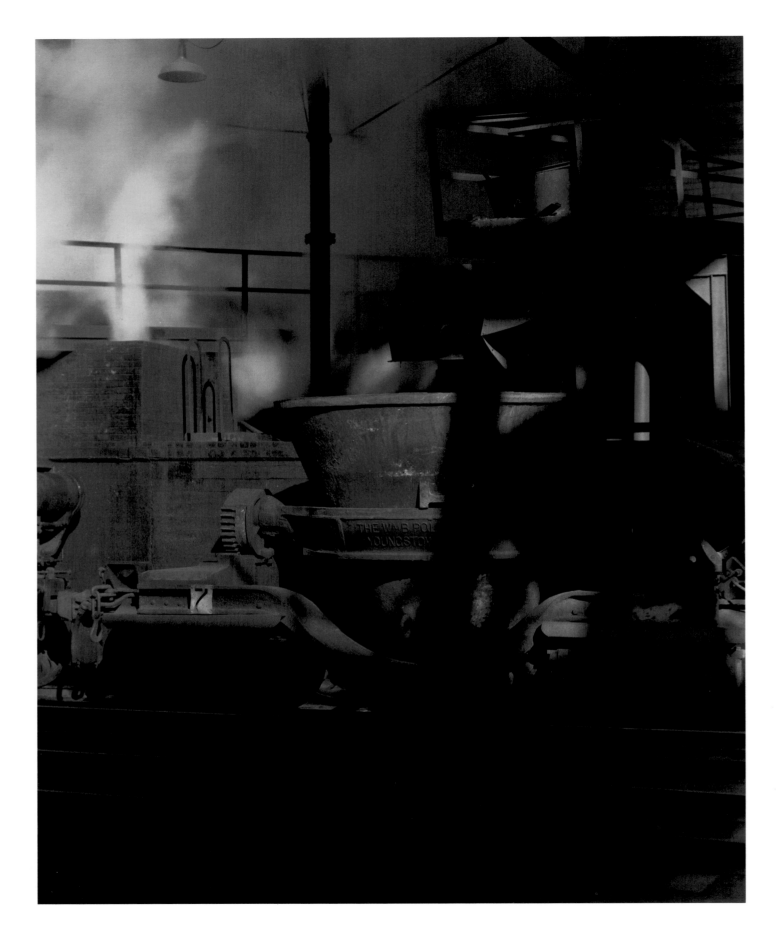

52. *Slag Buggy – Ford Plant*, 1927

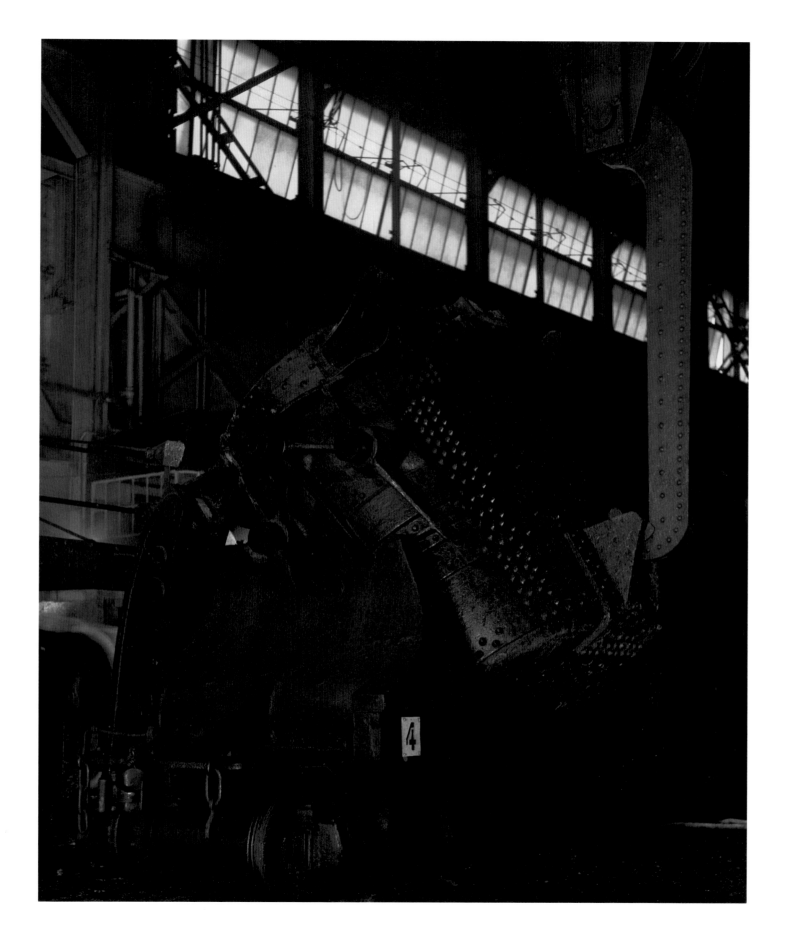

53. *Ladle on a Hot Metal Car — Ford Plant*, 1927

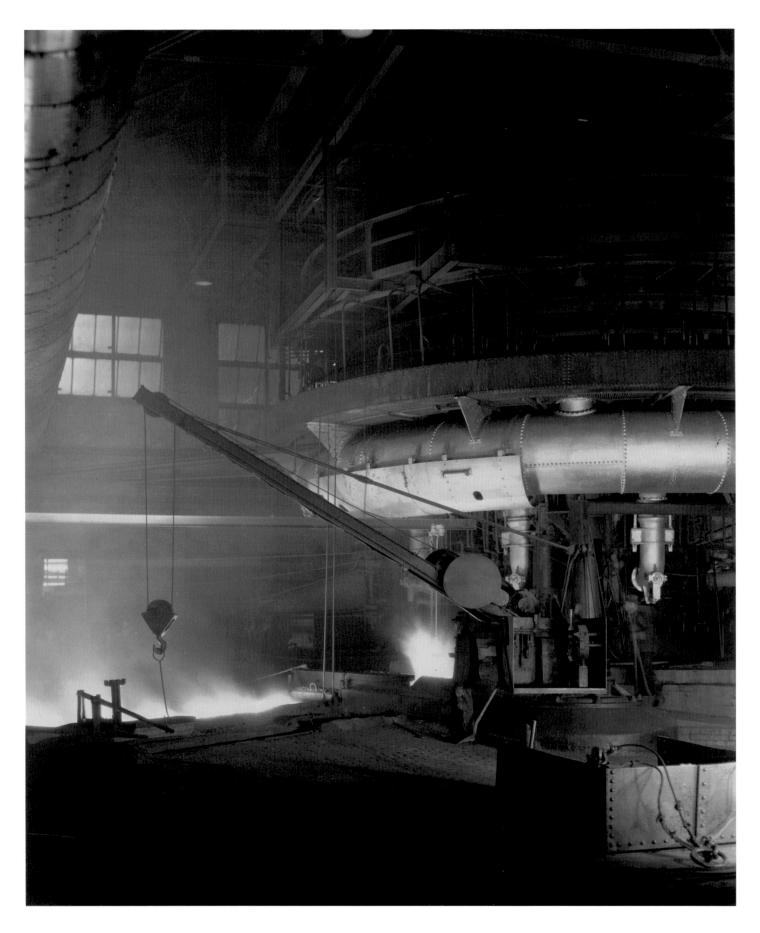

54. *Blast Furnace Interior – Ford Plant*, 1927

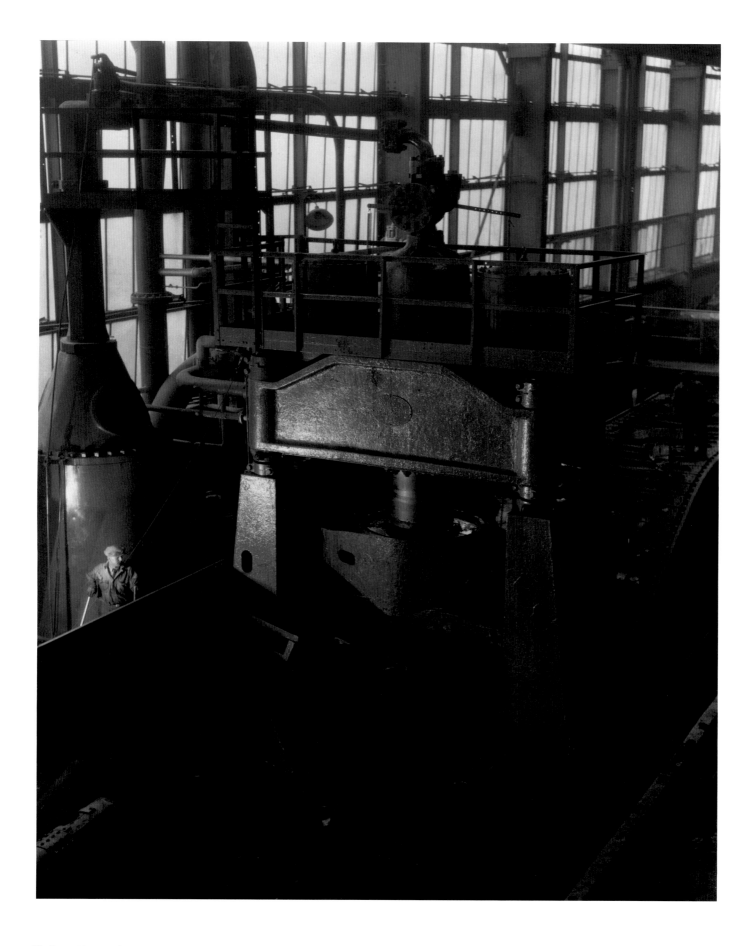

55. *Steam Hydraulic Shear – Ford Plant,* 1927

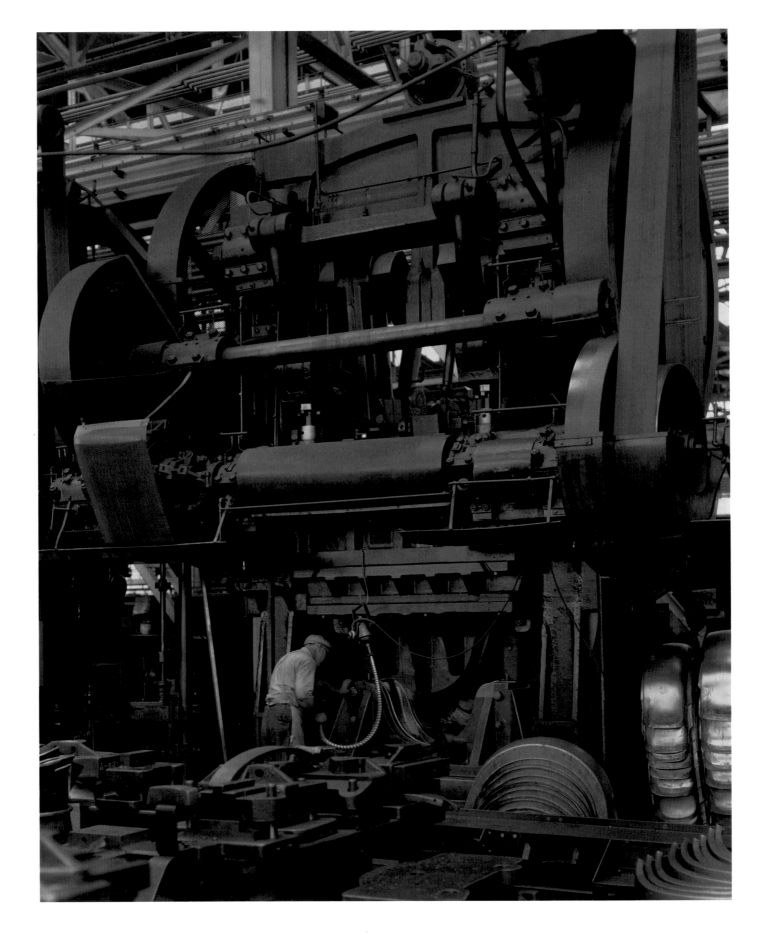

56. *Stamping Press – Ford Plant*, 1927

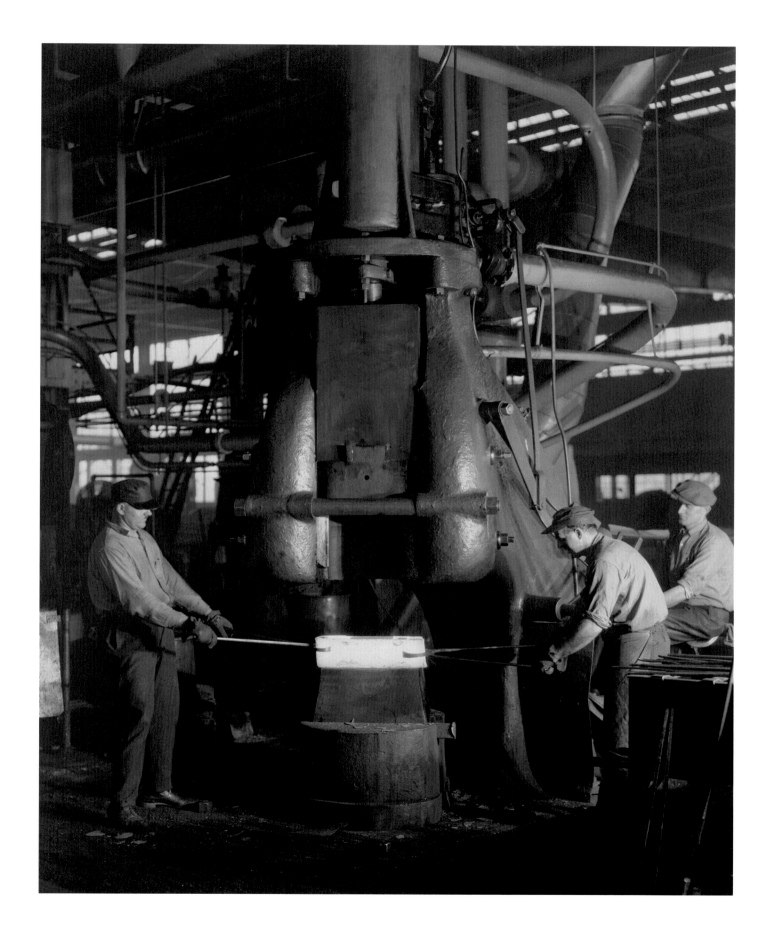

57. *Forging Die Blocks – Ford Plant, 1927*

58. *South Salem, Living Room, 1929*

59. *South Salem Interior*, 1929

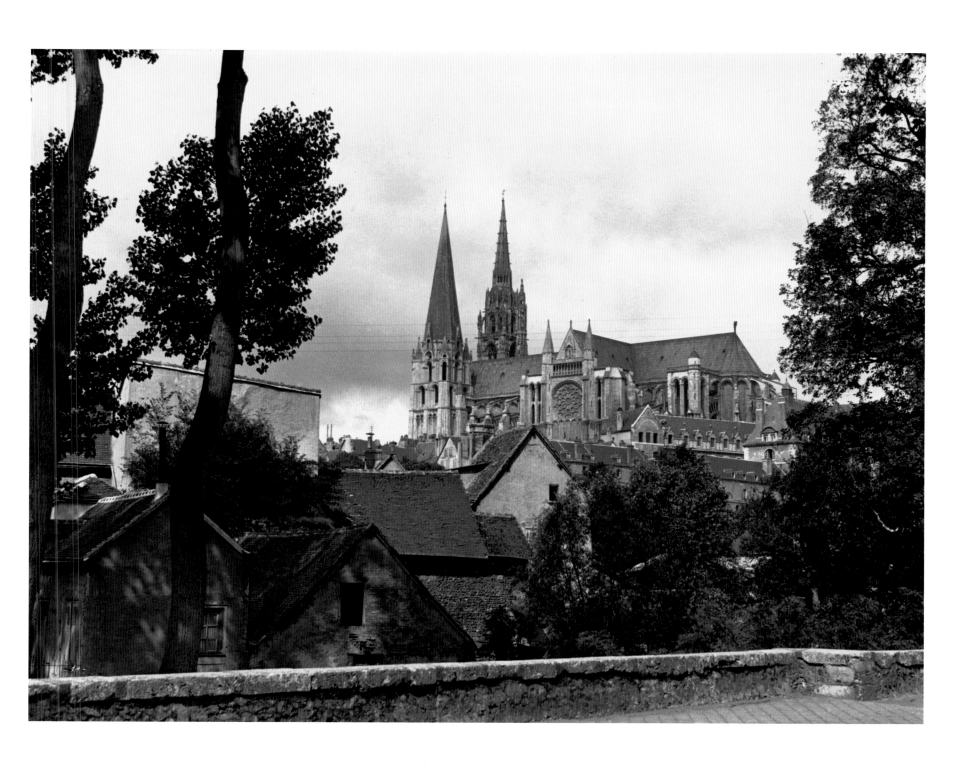

60. *Chartres – View from Near Porte-Guillaume, 1929*

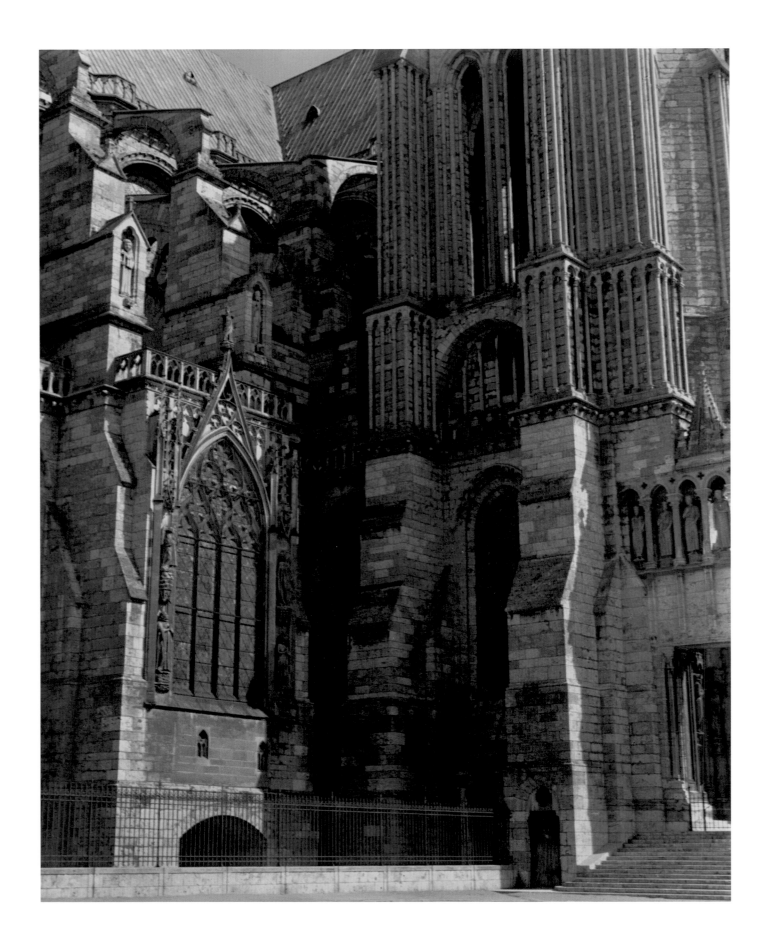

61. *Chartres – Vendôme Chapel Exterior*, 1929

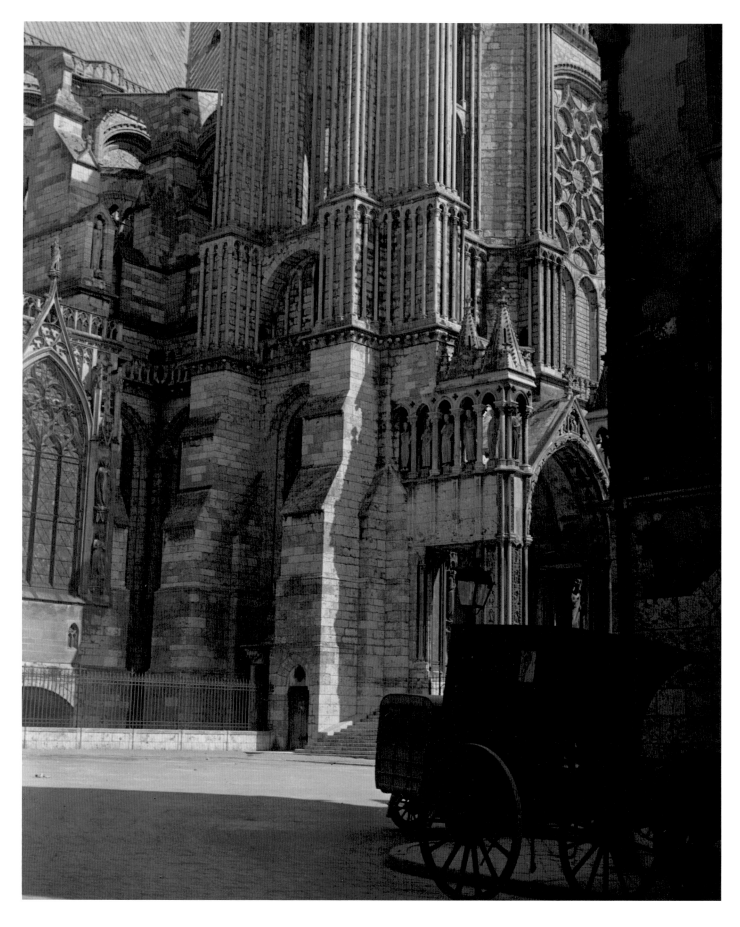

62. *Chartres – South Porch with Carriages, 1929*

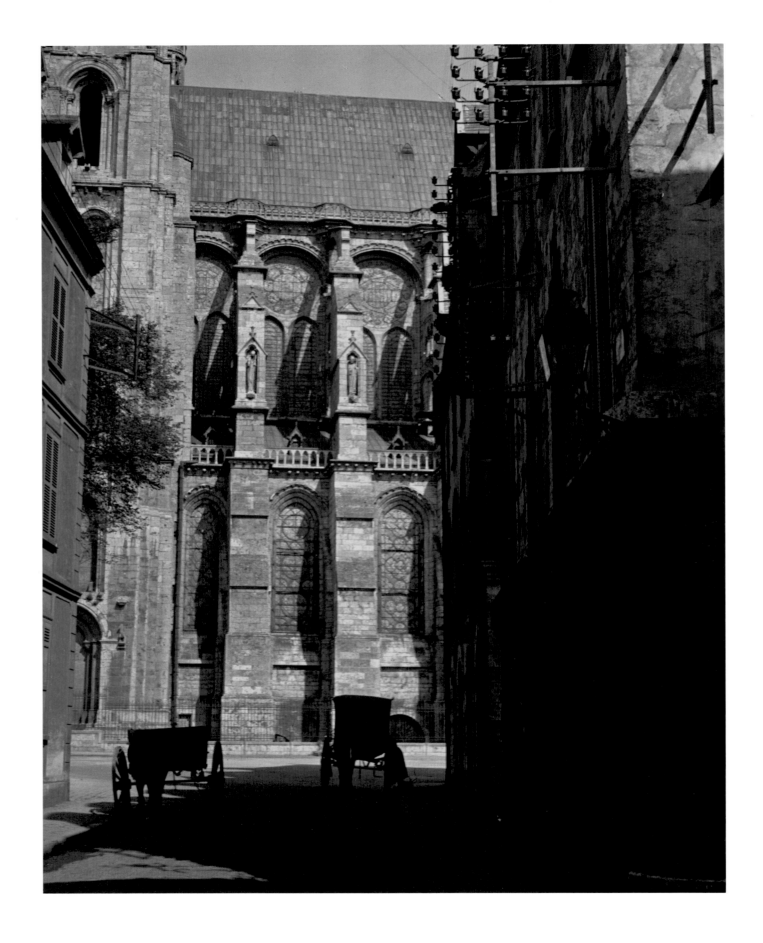

63. *Chartres – South Side from Street*, 1929

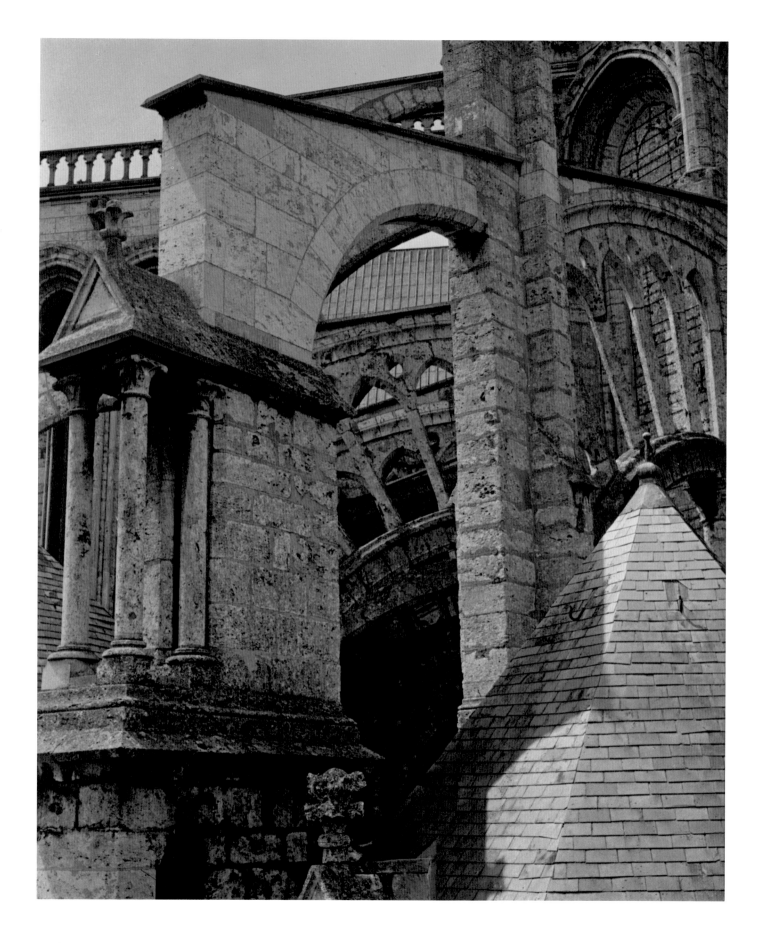

64. *Chartres – Flying Buttresses, East End, with Chapel Roof, 1929*

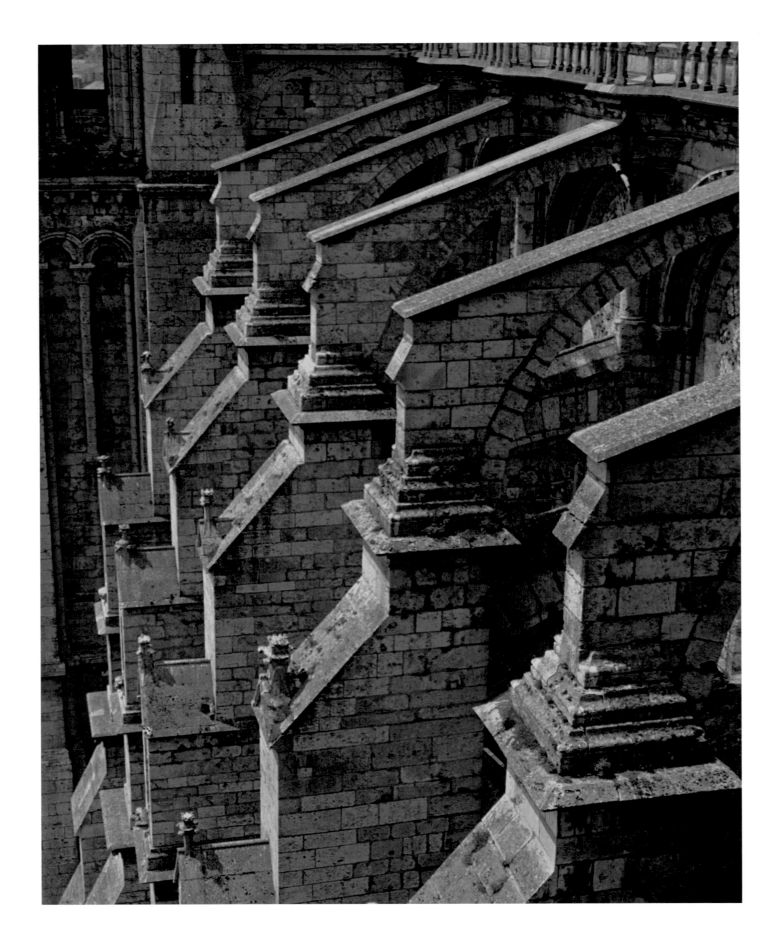

65. *Chartres – Buttresses, from South Porch*, 1929

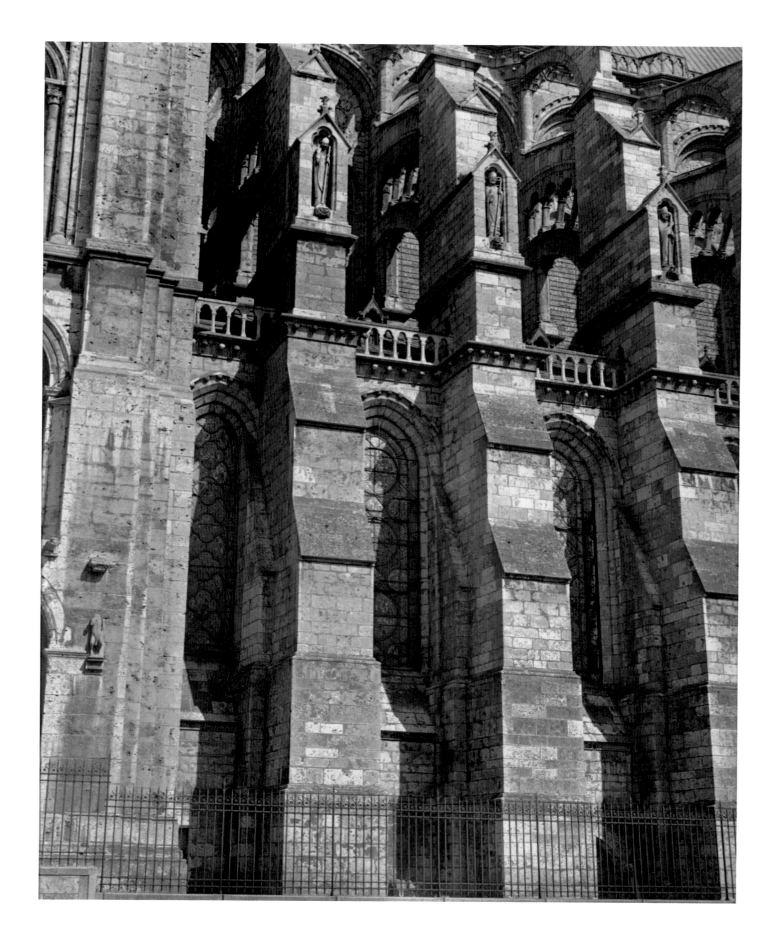

66. *Chartres – Buttresses on South Side,* 1929

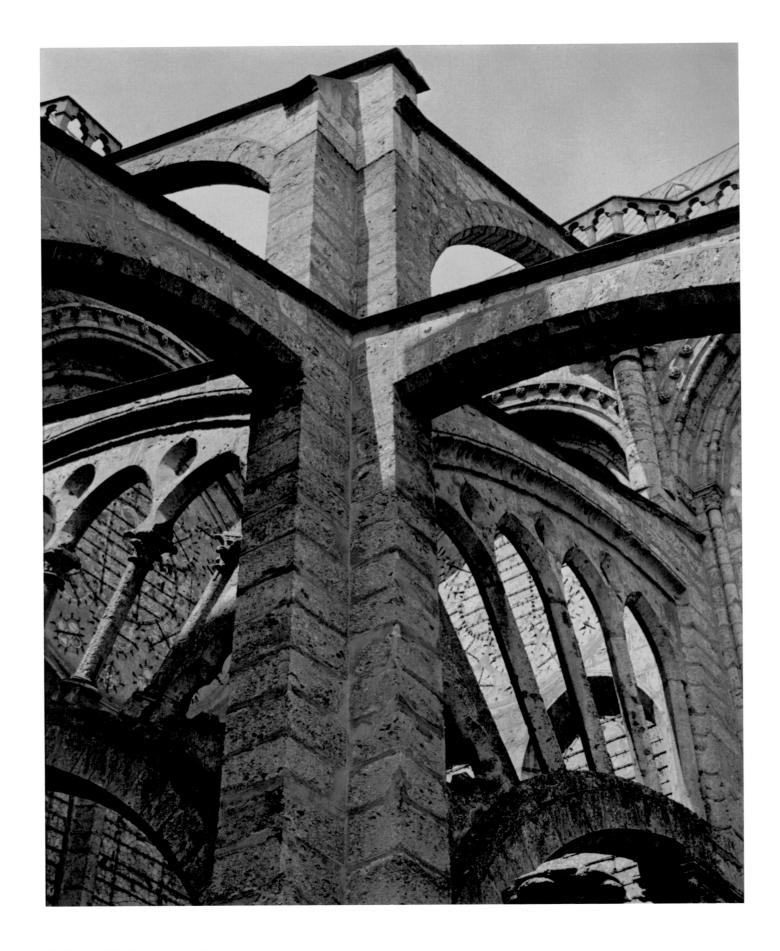

67. *Chartres – Flying Buttresses at the Crossing*, 1929

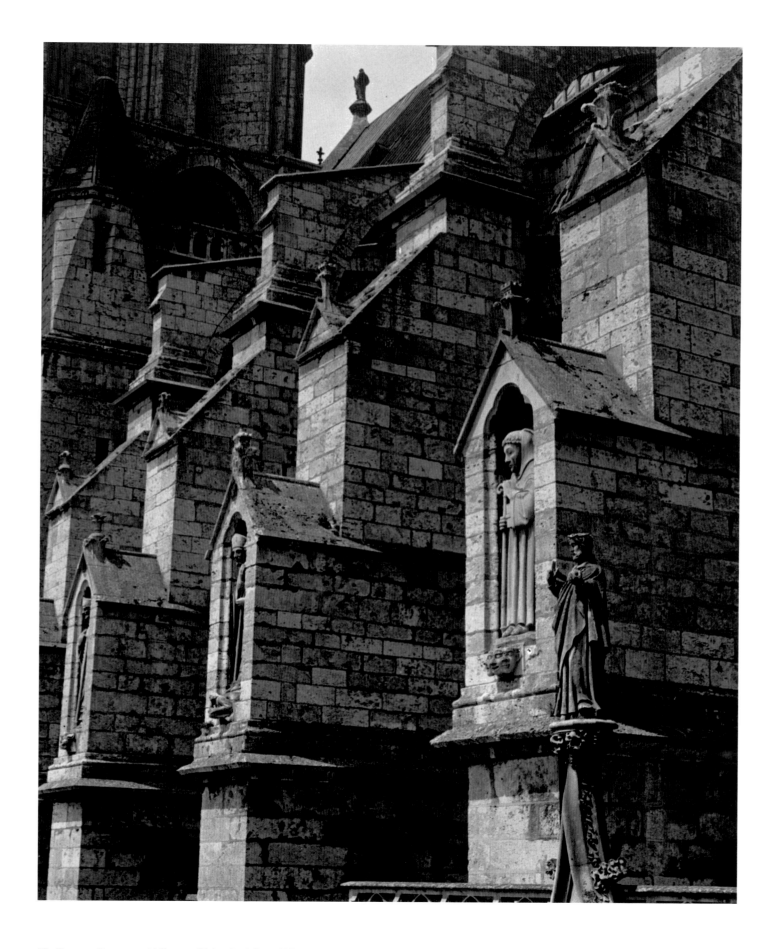

68. *Chartres — Buttresses with Figures in Niches, South Side*, 1929

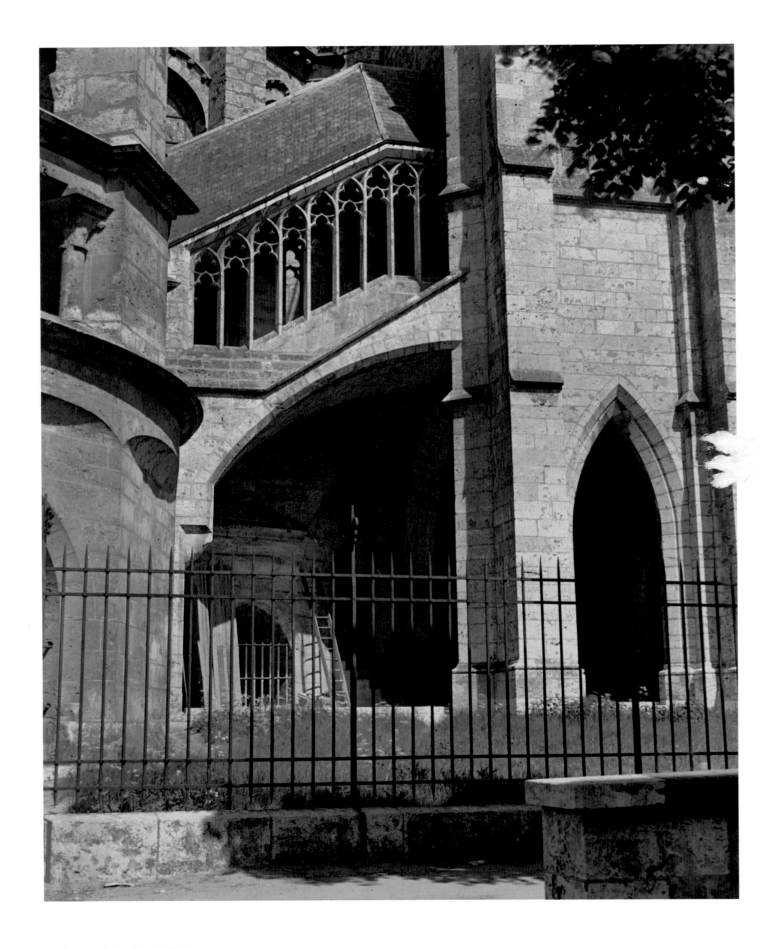

69. *Chartres – St. Piat Chapel, 1929*

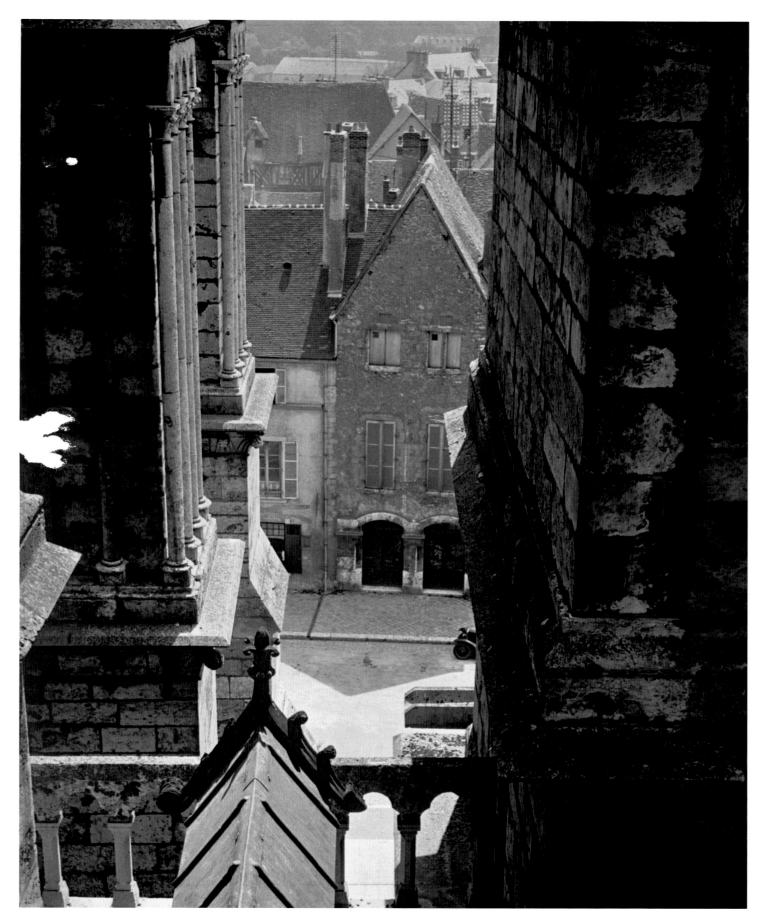

70. *Chartres – View to Street from South Porch*, 1929

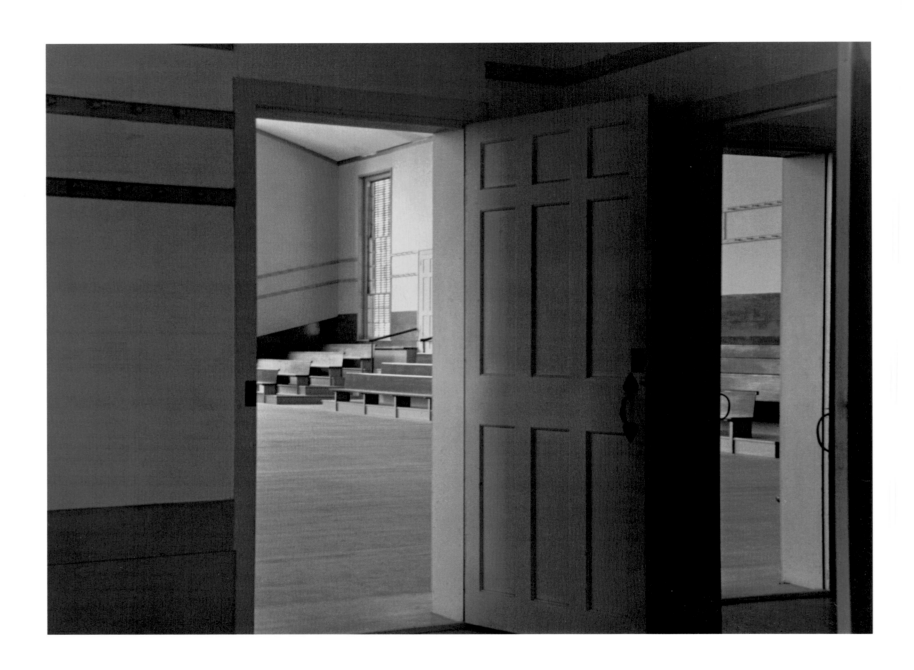

71. *Doors to Meeting Hall, Mt. Lebanon Shaker Village,* c. 1934

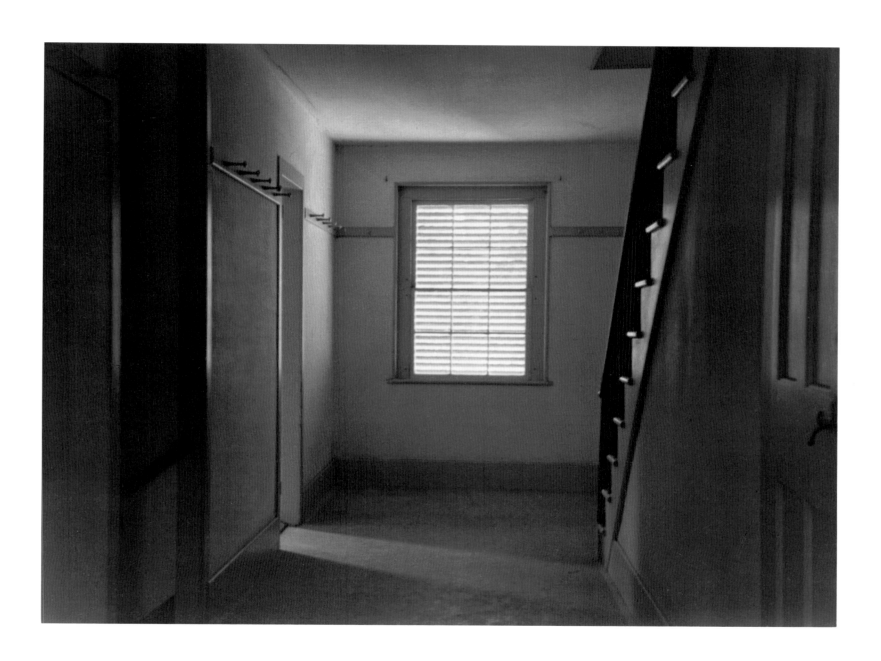

72. *Ministry Hallway, Mt. Lebanon Shaker Village*, c. 1934

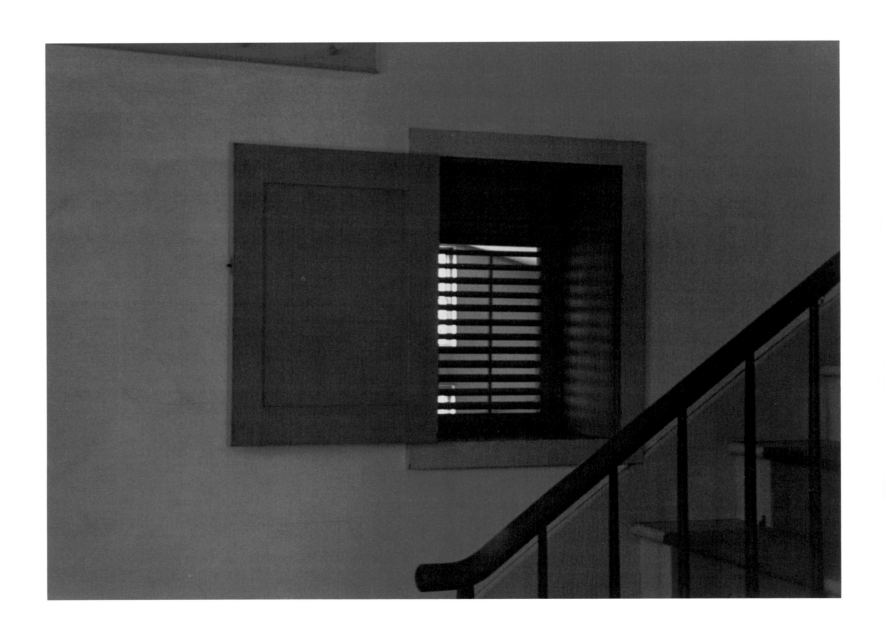

73. *Meeting Hall Window, Mt. Lebanon Shaker Village,* c. 1934

74. *Stairwell, Williamsburg*, 1935 (reduced)

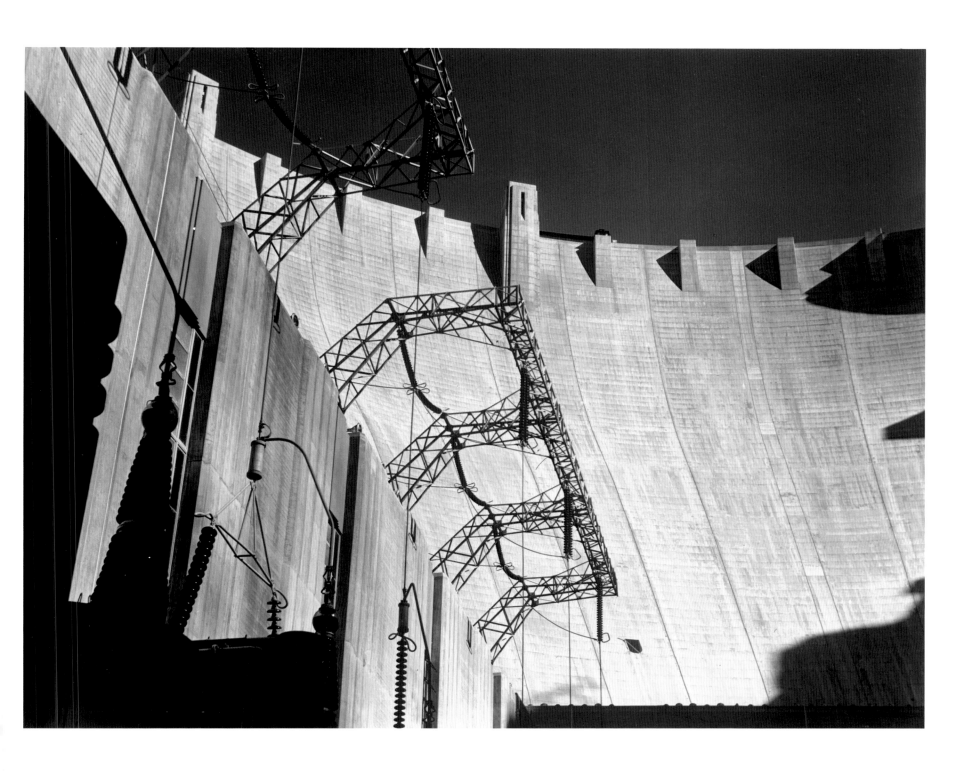

75. *View of Boulder Dam, 1939*

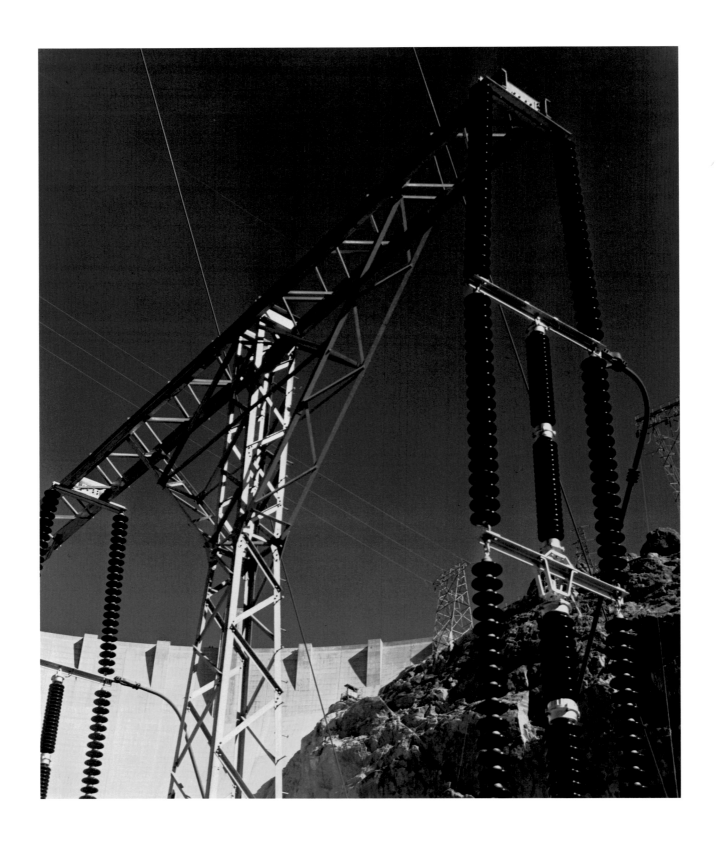

76. *Boulder Dam, Transmission Towers, 1939*

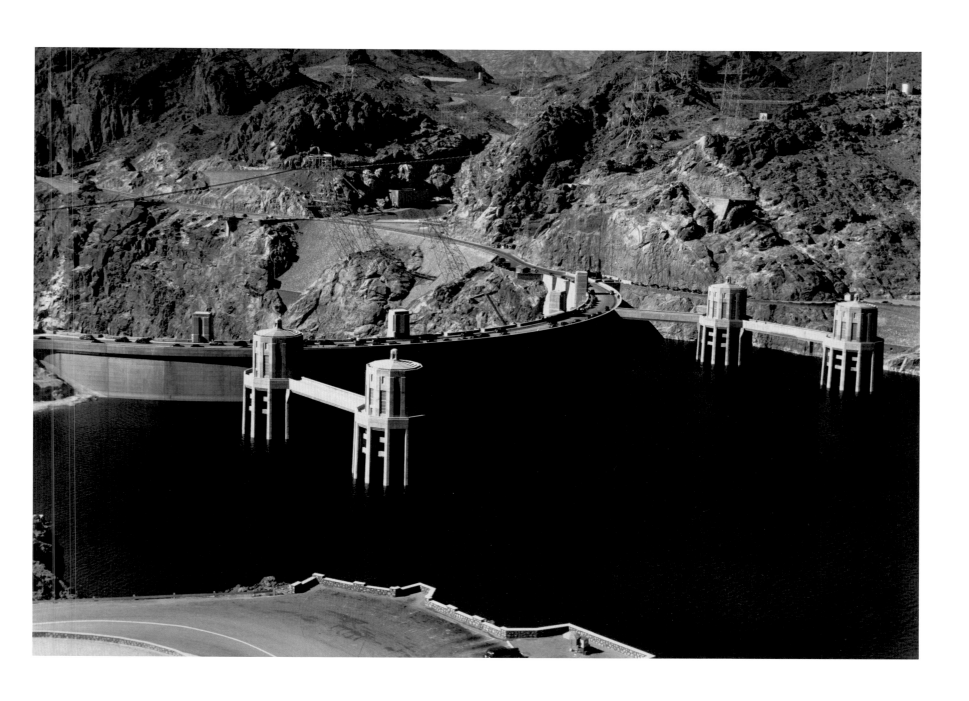

77. *Boulder Dam, Water Intake Towers*, 1939

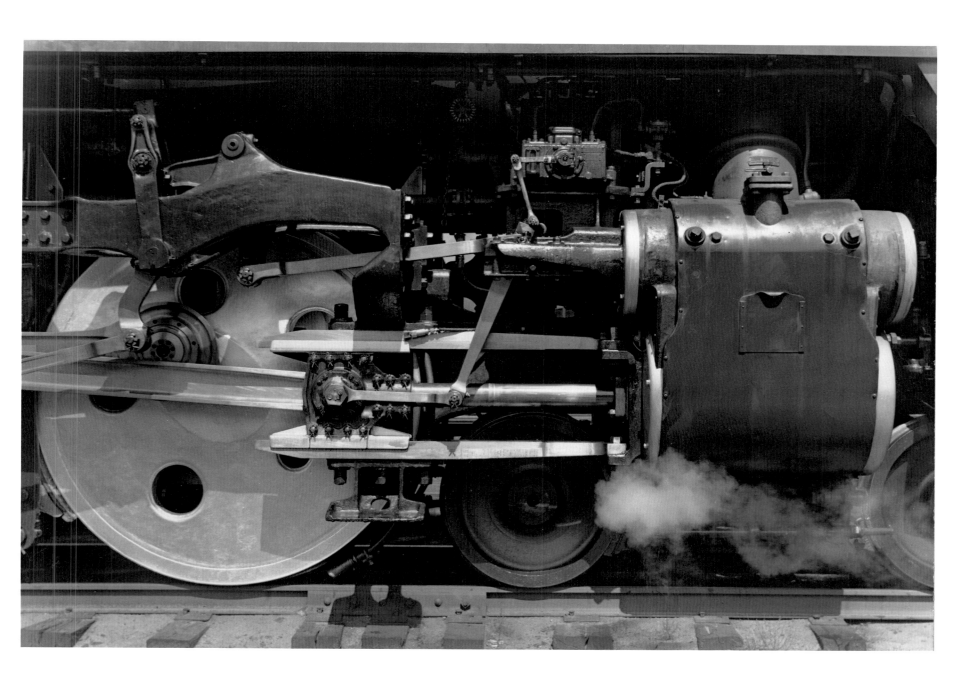

78. *Wheels,* 1939

79. *Cast of Michelangelo's Guiliano de Medici,* 1942

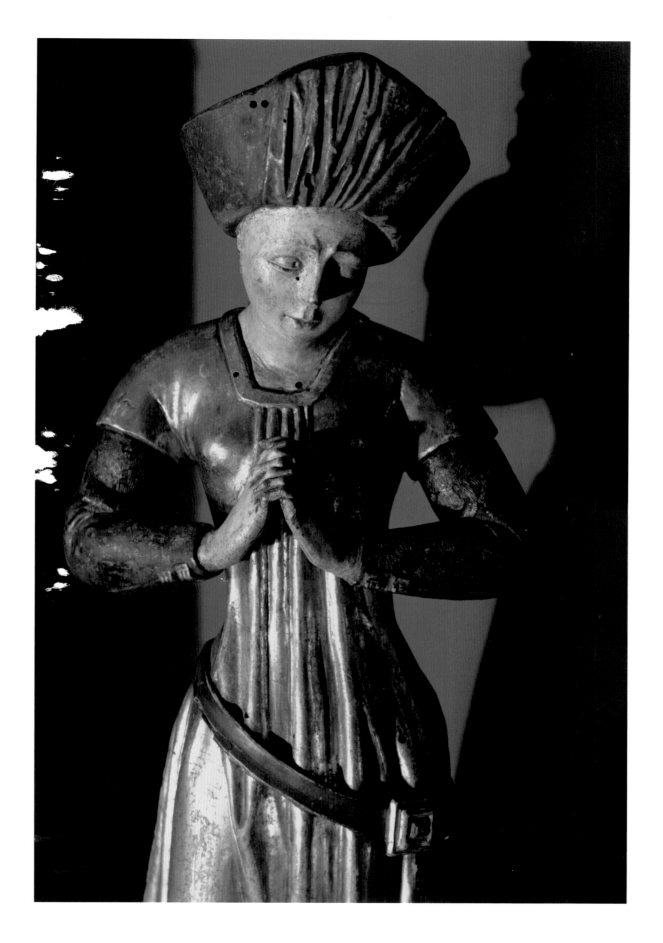

80. *Mourning Woman, Netherlandish,* c. 1942-43

81. *Assyrian Relief: Attendant's Hand and Elbow,* 1942

82. *Assyrian Relief: King Holding Bowl*, 1942

83. *Beech Tree – Roots*, 1951

84. *Beech Tree – Shadows*, 1951

85. *Beech Tree – Near the Base, 1951*

86. *Shadows on St. Patrick's, New York*, 1950

87. *Figures on Fifth Avenue, New York, 1950*

88. *Radio City Tower, New York*, 1950

89. *Flags, Radio City, New York*, 1950

90. *RCA Building, New York, 1950*

Index of Photographs

51. *Ladle Hooks, Open Hearth Building – Ford Plant*, 1927
 10 x 8 in. (9¼ x 7⁵⁄₁₆ in.)

52. *Slag Buggy – Ford Plant*, 1927
 10 x 8 in. (9⅜ x 7½ in.)

53. *Ladle on a Hot Metal Car – Ford Plant*, 1927
 10 x 8 in. (9⁵⁄₁₆ x 7⁷⁄₁₆ in.)

54. *Blast Furnace Interior – Ford Plant*, 1927
 10 x 8 in. (9½ x 7⁷⁄₁₆ in.)

55. *Steam Hydraulic Shear – Ford Plant*, 1927
 10 x 8 in. (9¼ x 7¼ in.)

56. *Stamping Press – Ford Plant*, 1927
 10 x 8 in. (9¼ x 7¼ in.)

57. *Forging Die Blocks – Ford Plant*, 1927
 10 x 8 in. (9⅛ x 7¼ in.)

58. *South Salem, Living Room*, 1929
 7³⁄₁₆ x 9⁵⁄₁₆ in.

59. *South Salem Interior*, 1929
 7⁵⁄₁₆ x 9½ in.

60. *Chartres – View from Near Porte-Guillaume*, 1929
 8 x 10 in. (7³⁄₁₆ x 9¼ in.)

61. *Chartres – Vendôme Chapel Exterior*, 1929
 10 x 8 in. (9³⁄₁₆ x 7¼ in.)

62. *Chartres – South Porch with Carriages*, 1929
 10 x 8 in. (9⅜ x 7¼ in.)

63. *Chartres – South Side from Street*, 1929
 10 x 8 in. (9³⁄₁₆ x 7¼ in.)

64. *Chartres – Flying Buttresses, East End, with Chapel Roof*,
 1929
 10 x 8 in. (9⅛ x 7¼ in.)

65. *Chartres – Buttresses, from South Porch*, 1929
 10 x 8 in. (9¼ x 7¼ in.)

66. *Chartres – Buttresses on South Side*, 1929
 10 x 8 in. (9¼ x 7¼ in.)

67. *Chartres – Flying Buttresses at the Crossing*, 1929
 10 x 8 in. (9¼ x 7¼ in.)

68. *Chartres – Buttresses with Figures in Niches, South Side*,
 1929
 10 x 8 in. (9⅛ x 7¼ in.)

69. *Chartres – St. Piat Chapel*, 1929
 10 x 8 in. (9¼ x 7¼ in.)

70. *Chartres – View to Street from South Porch*, 1929
 10 x 8 in. (9⅝ x 7⅝ in.)

71. *Doors to Meeting Hall, Mt. Lebanon Shaker Village*, c.
 1934
 6⅜ x 8⁹⁄₁₆ in.

72. *Ministry Hallway, Mt. Lebanon Shaker Village*, c. 1934
 6¼ x 8¼ in.

73. *Meeting Hall Window, Mt. Lebanon Shaker Village*, c.
 1934
 6 x 8¼ in.

74. *Stairwell, Williamsburg*, 1935
 12⅜ x 8⅞ in. (illustration reduced)

75. *View of Boulder Dam*, 1939
 7⅜ x 9⁷⁄₁₆ in.

76. *Boulder Dam, Transmission Towers*, 1939
 8 x 6⅝ in.

77. *Boulder Dam, Water Intake Towers*, 1939
 6⅝ x 9⁵⁄₁₆ in.

78. *Wheels*, 1939
 [Collection of the Museum of Fine Arts, Boston. Gift
 of William H. and Saundra B. Lane]
 6⁹⁄₁₆ x 9⁹⁄₁₆ in.

79. *Cast of Michelangelo's Guiliano de Medici*, 1942
 9⅝ x 7⅜ in.

80. *Mourning Woman, Netherlandish*, c. 1942-43
 9⁵⁄₁₆ x 6¼ in.

81. *Assyrian Relief: Attendant's Hand and Elbow*, 1942
 10 x 8 in. (9½ x 7⅝ in.)

82. *Assyrian Relief: King Holding Bowl*, 1942
 7⅝ x 9⅝ in.

83. *Beech Tree – Roots*, 1951
 5½ x 7¼ in.

84. *Beech Tree – Shadows*, 1951
 9⁷⁄₁₆ x 6⁷⁄₁₆ in.

85. *Beech Tree – Near the Base*, 1951
 6¹⁵⁄₁₆ x 4¾ in.

86. *Shadows on St. Patrick's, New York*, 1950
 8¹³⁄₁₆ x 6 in.

87. *Figures on Fifth Avenue, New York*, 1950
 9¼ x 6¼ in.

88. *Radio City Tower, New York*, 1950
 9³⁄₁₆ x 6³⁄₁₆ in.

89. *Flags, Radio City, New York*, 1950
 9¼ x 6³⁄₁₆ in.

90. *RCA Building, New York*, 1950
 9¼ x 6¼ in.

Chronology

1883
Born Charles Rettew Sheeler, Jr., July 16 in Philadelphia, to Charles Rettew Sheeler and Mary Cunningham Sheeler

1900
Enters School of Industrial Art, Philadelphia

1903
Enters Pennsylvania Academy of the Fine Arts, Philadelphia

1904
Travels to London and Holland with William Merritt Chase

1905
Travels to Spain with Chase

1906
Graduates from Pennsylvania Academy; summer at Gloucester, Mass.

1907
Address: 1626 Chestnut Street, Philadelphia

1908
Begins to share Chestnut Street studio with Morton Schamberg

First solo paintings exhibition at McClees Gallery, Philadelphia (November)

Exhibits five paintings at William Macbeth Gallery, New York (November)

Travels in Europe with his parents and Schamberg: Naples, Rome, Venice, Milan, Florence (December); Paris (January and February)

c. 1910
Begins career as a photographer

1910
Rents Worthington House in Doylestown, Pa. (to 1926)

1911
Begins to correspond with Alfred Stieglitz

1913
Exhibits six paintings in the Armory Show, New York

1915
Address: 1822 Chestnut Street, Philadelphia

1916
Exhibits nine paintings and drawings in the Forum Exhibition, New York

Begins to work as an assistant at Marius de Zayas's Modern Gallery, New York

1917
First exhibition of photographs, with Schamberg and Paul Strand, at the Modern Gallery (March 29-April 9)

Solo exhibition at Modern Gallery of Doylestown House photographs (December 3-15)

1918
Wins first and fourth prizes in thirteenth John Wanamaker photography exhibition (March)

Schamberg dies, October 13

1919
Moves to New York (Address: 160 East 25th Street) by September

Sells first paintings to Ferdinand Howald, through Charles Daniel

1920
Films *Manhatta* with Paul Strand

Solo exhibition of paintings, drawings, and photographs at de Zayas Gallery (February 16-28)

1921
Marries Katharine Baird Shaffer, April 7

Address: 344 8th Avenue, New York

Spends summer in Louise and Walter Arensberg's apartment at 33 West 67th Street, moves to 450 West 147th Street by the fall

1922
Solo exhibition of paintings, drawings, and photographs at the Daniel Gallery

Meets Edward Weston

1923
Address: 10 West 8th Street, in apartment above Whitney Studio Club

Breaks with Stieglitz

1924
Solo exhibition of paintings and drawings at Whitney Studio Club

1925
Studio address: 17 West 8th Street

Essay on Greek art published in *Arts* (March)

1926
Begins to work for Condé Nast Publications, Inc. (to 1929)

Moves to South Salem, New York, late in the year; maintains New York City studio on 8th Street

Exhibits photographs at Art Center and paintings at J.B. Neumann's Print Rooms, New York

1927
Spends six weeks in Detroit photographing the Ford Motor Company's River Rouge Plant for N.W. Ayer and Son (October-December)

1928
Short trip to Detroit (January)

Moves studio from 80 West 40th Street to 47 West 49th Street

Abby Aldrich Rockefeller purchases first Sheelers

1929

Last trip to Europe: Paris, Chartres (does photographic series); Stuttgart (work included in "Film und Foto" exhibition); Bavaria (April-August)

Paints *Upper Deck*

1930

Moves studio to 310 East 44th Street

1931

First solo exhibition at Edith Halpert's Downtown Gallery; begins exclusive affiliation with that gallery (November)

Exhibits photographs in inaugural show at Julien Levy Gallery (November)

1932

Moves from South Salem, N.Y., to Ridgefield, Conn.

1933

Katharine Sheeler dies (June)

1935

Travels to Colonial Williamsburg on commission

1938

Constance Rourke's biography, *Charles Sheeler, Artist in the American Tradition*, published, making use of Sheeler's autobiographical notes

1939

Marries Musya Metas Sokolova, April 2, in Rutherford, N.J.

"Power" series of paintings commissioned by *Fortune* – travels to New York, Pennsylvania, Tennessee, and Alabama (Spring), Boulder Dam (October)

Retrospective exhibition of paintings, drawings, and photographs at the Museum of Modern Art, New York (October)

1940

Solo exhibition of photographs in "Pageant of Photography," in Golden Gate International Exhibition, San Francisco

1941

Works with Weston in Connecticut (October)

1942

Moves from Ridgefield, Conn., to "Bird's Nest," Dow's Lane, Irvington-on-Hudson, N.Y.

Begins to work at Metropolitan Museum of Art, New York, as Senior Research Fellow in Photography (July)

1944

Solo exhibition of paintings at Dayton Art Institute

1945

Ends affiliation with Metropolitan Museum of Art (July)

1946

Works as artist-in-residence, Phillips Academy, Andover, Massachusetts (October)

1948

Works as artist-in-residence, Currier Gallery of Art, Manchester, N.H. (May)

Commissioned by Kodak to produce a series of color photographs of Shaker buildings and the U.N. building

1952

Travels on commission to U.S. Steel Co. in Pittsburgh and to Cedarburg, Wisc. (May)

1954

Flies to Los Angeles with William H. Lane for retrospective exhibition of paintings, drawings, and photographs at UCLA

Visits Ansel Adams in San Francisco and Weston in Carmel; photographs Pacific Gas and Electric power plant at Morro Bay

1955

Summers in Cape Split, Maine, at home of John Marin, Jr. (June - August)

Travels on commission to Warren, Michigan to General Motors Research Laboratory (Fall)

1956

Visits Adams in San Francisco and Weston in Carmel; photographs Tidewater Oil Company refinery at Avon with photographer Pirkle Jones; travels to Yosemite, Sequoia national parks, Utah, Colorado Rockies (June – August)

1958

Revisits Williamsburg, travels to Jamestown and Yorktown

1959

Incapacitated by a stroke (October)

1961

Retrospective exhibition at Allentown (Pa.) Art Museum

1962

Receives Award of Merit Medal for Painting, American Academy of Arts and Letters

1963

Elected to membership in National Institute of Arts and Letters

Retrospective exhibition at University of Iowa Art Galleries, Iowa City

1965

Dies, May 7